Photoshop CS5 and Lightroom 3 A Photographer's Handbook

Photoshop CS5 and Lightroom 3

A Photographer's Handbook

Stephen Laskevitch steve@luminousworks.com

Editor: Jimi DeRouen

Copyeditor: Cynthia Anderson

Layout and Type: Stephen Laskevitch

Cover Design: Helmut Kraus, www.exclam.de

Printer: Friesens Corporation

Printed in Canada

ISBN 978-1-933952-67-3

1st Edition
© 2010 by Stephen Laskevitch
Rocky Nook
26 West Mission Street Ste 3
Santa Barbara, CA 93101-2432

www.rockynook.com

Library of Congress Cataloging-in-Publication Data

Laskevitch, Stephen.

Photoshop CS5 and Lightroom 3: a photographer's handbook / Stephen Laskevitch. -- 1st ed.

p. cm.

ISBN 978-1-933952-67-3 (alk. paper)

1. Adobe Photoshop. 2. Photography--Digital techniques. 3. Adobe Photoshop lightroom. I. Title.

TR267.5.A3L3722 2010

006.6'96--dc22

2010011161

Distributed by O'Reilly Media 1005 Gravenstein Highway North Sebastopol, CA 95472-2811

All product names and services identified throughout this book are trademarks or registered trademarks of their respective companies.

They are used throughout this book in editorial fashion only and for the benefit of such companies. No such uses, or the use of any trade name, is intended to convey endorsement or other affiliation with the book.

No part of the material protected by this copyright notice may be reproduced or utilized in any form, electronic or mechanical, including photocopying, recording, or by any information storage and retrieval system, without written permission from the copyright owner.

This book is printed on acid-free paper.

Acknowledgements

The folks at Rocky Nook have been so supportive and have made this project as pleasant as it could possibly be. Thanks for being the most gracious publishers and for having such sharp eyes. Jimi DeRouen, you're a great human to work with!

Hearty thanks go to my students. There have been many of you who've shaped not only my teaching, but my humanity as well. You make it obvious that I found the right career. I wrote this book to be a complement to the time you spend in my classroom. I hope you and the educators who use this book find it a means to great creative ends.

Many thanks as well to the supportive folks at Adobe, like Marc Madenwald and Deborah Prewitt, who really look out for their training partners.

Craig Swanson, the welcome prod I need so often, your energy is terrifying like a good carnival ride. Thanks for the many opportunities and the reminders that they're there.

To my fellow teachers, Jennifer, Navin, David, David, and David! (That would be Mr. Johnson, Mr. Julian, and Mr. Moise.) You have each done much to nourish, inspire, and encourage me.

Of course I must thank the other great teachers in my life, and of life.

Colin Fleming, not a day goes by that I don't smile with a thought of you. That's a great gift: especially on those hard days.

To Anne and Don Fraga, for use of the "writing room", and the rest of the house, for a few months. Although I have to say your daughter is the greatest gift of all!

And that leads to my wife, Carla Fraga. Since you're the best and greater part of all we do together, gratitude is not enough. At least many of your lovely images grace these pages, fortunately for us all. Thank you and happy tenth anniversary, just a little early.

Thanks to you, too, reader, for choosing this book.

Steve Laskevitch Spring 2010 www.luminousworks.com

Table of Contents

Introduction

		-
	About the Photographer's Handbook	2
	Who Should Use This Book	2
	Steps for Using This Book	2
	Conventions	3
	Photoshop Versions	3
	Mac vs. Microsoft Windows Operating Systems	3
	The Setup	
1	Terms & Concepts	9
	Some Background	10
	What is a Digital Image?	10
	Pixels	10
	Dots & Sensors	10
	Image Size	11
	Resolution	11
	Resampling/Interpolation	12
	Native Resolution	13
	Color and Tone	13
	Bits and Bytes	13
	Bit Depth	14
	Channels/Color Models	15
	Color Management	17
	File Formats for Digital Imaging	22
	DNG & RAW Files	22
	Photoshop (*.PSD)	23
	TIFF (*.TIFF, *.TIF)	23
	JPEG (*.JPG, *.JPEG)	24
	PDF Files	24
	The Lightroom Catalog	24
2	System Configuration	27
	Computer Requirements	28
	Work Environment	28
	Light	28
	Colors	29
	Application Preferences	29
	Color Settings	34

viii Table of Contents

3	The Interface: A Tour	43
	Finding Your Way in Photoshop	44
	Panels & Workspaces	44
	The Tools	48
	Keyboard Shortcuts and Modifiers	49
	Menu Customization	49
	Vital Features	52
	Finding Your Way in Bridge	60
	What is Bridge?	60
	Exploring Bridge—A Guided Tour	61
	Metadata	62
	Searches & Collections	63
	Integration with Other Applications	63
	Finding Your Way in Adobe Camera Raw	64
	Tools	64
	Image Adjustment Tabs	64
	Finding Your Way In Lightroom	66
	Panels & Modules	67
	Grid vs. Loupe vs. Compare	68
	Vital Keyboard Shortcuts	68
	The Workflow	1. 18 14 14
	A Brief Overview	72
	Capture & Image Import	72
	Organize & Archive	73
	Global Adjustments	73
	Local Adjustments	74
	Cleanup and Retouching	74
	Creative Edits and Alternates	74
	Output—Print, Web, and Presentation	74
4	Capture & Import	77
	Capture	78
	Shoot RAW	78
	Lens Profile Creator	78
	Standard Practices	79
	For Panoramas	80
	For High Dynamic Range Images	80
	Passerby Removal	80
	Import	81
	Digital Negative	81

Table of Contents ix

	Deferred Import	81	
	Configure Bridge	82	
	Adobe Photo Downloader	82	
	Automatic Import	84	
5	Organizing and Archiving Images		87
	Rating Systems & Methods	88	
	Keywords and Metadata	91	
	Keywords	91	
	Copyright and Contact Data: Bridge Metadata Templates	92	
	Keywords in Bridge	92	
	Copyright and Contact Data: Lightroom Metadata Presets	93	
	Keywords in Lightroom	93	
	Labels: Workflow Landmarks	95	
	File Management	97	
	Folders vs. Collections	97	
	Metadata Challenges	98	
	Moving & Archiving Files	99	
	Multi-Computer Image Management: Two Examples	101	
5	Global Adjustments	1	03
	General Approach	104	
	Nondestructive Editing	104	
	Cropping and Straightening	105	
	Adjusting Color & Tone—Things to Know	107	
	White Balance	107	
	Histograms	108	
	Tone Curves	109	
	Hue, Saturation, and Luminance	110	
	Split Toning	110	
	Applying Adjustments to Color & Tone	111	
	Pacia Adjustments	111	
	Basic Adjustments	111	
	HSL & Grayscale	125	
	-		
	HSL & Grayscale	125	
	HSL & Grayscale Split Toning	125 133	
	HSL & Grayscale Split Toning More Photoshop Adjustments: Simple and Complex	125 133 136	
	HSL & Grayscale Split Toning More Photoshop Adjustments: Simple and Complex Photo Filters	125 133 136 136	
	HSL & Grayscale Split Toning More Photoshop Adjustments: Simple and Complex Photo Filters Shadows/Highlights Adjustment	125 133 136 136 136	

Table of Contents

	Reference Color	141
	Color Correction by the Numbers	142
	Noise Reduction and Sharpening	145
	Noise Reduction	145
	Sharpening	146
	Lens Corrections	149
	Barrel and Pincushion Distortions	149
	Convergence	149
	Vignetting	149
	Chromatic Aberration	149
	Lens Correction Tools	150
	Lens Correction Filter	151
	Saving and Using Develop Settings	152
	Presets	152
	Copying Color Corrections	155
7	Local Adjustments	157
	Graduated Filters	158
	A Graduated Adjustment	160
	Graduated Photoshop Filters	162
	Painting Adjustments	164
	Understanding Photoshop's Painting Tools	166
	Painting Adjustments Example: Dodging & Burning	169
	Precise Area Adjustments: Photoshop Only	172
	A To-Do List	173
	Selection Tools & Methods	174
	Choose Your Adjustment	186
	Refining the Mask	186
	Reducing Local Color Casts (e.g., Teeth Whitening)	188
8	Cleanup and Retouching	191
	Removing Dust & Blemishes	192
	Cloning	192
	Healing	192
	Filling	192
	Spot Removal Tool	193
	Clone Stamp Tool	197
	Healing Brush	199
	Spot Healing Brush	200
	Save the Clean Image	200

хi

	Very Large Defects	201
	Patch Tool	201
	Content-Aware Fill	203
	Transformations	204
	Free Transform	204
	Liquify Filter	205
	Content Aware Scaling (Seam Carving)	206
9	Creative Edits & Alternates	209
	Combining Images	210
	Compositing Two or More Images	210
	Blending	216
	Opacity	216
	Blending Modes	219
	Merging Images	221
	HDR: High Dynamic Range Images	221
	Panoramic Images	224
	Depth of Field Merge	226
	Passerby (and Noise) Removal	227
	Smoothing Motion	228
	Photographic Effects	229
	Lens Blur	229
	Film Grain	231
	Virtual Copies	233
10		225
	and Presentation	235
	Print Output	236
	Components of a Good Print	236
	The Final Print	239
	Test Prints	246
	1 Collect Your Images	249
	2 Choose a Template	249
	3 Layout Settings	250
	4 Print Job Panel	253
	5 Printer Driver Settings	254
	6 Print	254
	Web	255
	A Note on Web Images	255
	A Fully Manual Approach	255
	Save for Web & Devices	257

1 Collect the Images	259
2 Choose a Template and/or Engine	259
3 Fine-Tune Layout and Output Settings	259
4 Configure Upload Settings	261
5 Preview in Browser	261
6 Upload or Export	261
Slideshows	262
Overview	262
Create a Collection	262
Slide Layout	263
Playback	263
Exporting Slideshows	263
Impromptu Slideshow	264
Slideshow with Options	264
Have Fun!	264
Index	267

Introduction

In some ways, digital technology has fundamentally changed photography and printing. Photographers have almost unlimited options to achieve the precise image that they intend. Printing has become infinitely more flexible and pushed closer to the control of the image creator—you. The level of control at our disposal now exceeds even some of the most powerful darkroom techniques used in the past. This power and flexibility is dazzling, even confusing, to many.

The Adobe Photoshop products are some of the most complex programs many of us will ever use. There is a reason "Photoshop" has become a verb! Despite that, my goal is to present them in a reasonably accessible way. Although we are provided with thousands of complex techniques for editing images, most users (and most images) don't need all of that complexity. In fact, only a few steps are needed to get the vast majority of images to shine. In this book, I'll introduce you to the processes that I and my students have found most valuable: from organizing a large image library, through editing density, contrast, and color, to more detailed processing like converting images from color to black & white and the sharpening of images, and basic retouching. The workflow discussed is complete, but I will not discuss the more bizarre techniques common to the Photoshop marketplace.

In this book's two sections, you'll find both the foundational concepts and vocabulary you'll need to use the software discussed, and the pieces you'll need to build your full photographic workflow from capture through print or online output. Let's get working!

About the Photographer's Handbook

Who Should Use This Book

This book is for those who want to learn the basic tools and image editing steps within Photoshop and Lightroom to create professional looking images. This, of course, includes photographers and graphics designers, but also a wide range of technicians and office workers who simply want to do more effective image editing. This book provides insight into the creation of good images, but doesn't showcase wow-factor Photoshop techniques. I also don't pull any punches. I include all the key techniques necessary for good image editing: using layers and layer blending, color correction, printer profiles, and more.

Most readers should have a good grasp of working with computers so they will have no problem navigating the computer menus, dialog boxes, or dragging a mouse. I do not demand that the reader have any experience with Photoshop, although many readers with a good, basic understanding by having played with Photoshop will find that this book deepens their understanding.

Steps for Using This Book

This book has two key sections. The first includes three chapters: Terms & Concepts, System Configuration, and The Interface: A Tour. The first chapter familiarizes the reader with the key concepts behind color and digital images, as well as some thoughts on how cameras convert light to data. The brief second chapter will help you decide how to configure your hardware and software settings, including certain application preference settings you'll want to configure correctly early in your use of them for the kinds of images you work with. The third chapter, the most likely to earn dog ears on its pages, covers the layout and general use of the software applications we'll be using.

The second section focuses on the key steps in a complete photographic workflow. Each chapter highlights those steps: Capture & Import; Organizing and Archiving Images; Global Adjustments; Local Adjustments; Cleanup and Retouching; Creative Edits & Alternates; and Output—Print, Web, and Presentation.

This book is of greatest benefit when read cover to cover. However, those looking for a reference on Photoshop can flip through the pages to find the specific tasks of interest.

Conventions

Some helpful conventions are used throughout the book. Important terms are in bold type, making it easier to skim through for specific information.

Conventional notation for choosing items from a menu is used throughout: e.g., File>Browse to select the Browse *command* from the File *menu*.

The icons and vocabulary used in the application are used in this book for identifying different types of information. Application logos (including one invented for Adobe Camera Raw) will appear on pages which feature discussion of that software. Processes that are specific to Bridge, Camera Raw, Photoshop, or Lightroom will begin with headers colored like that application's logo.

Note: The red "Note" text identifies text in a chapter that summarizes or emphasizes a key point.

Photoshop Versions

At the heart of modern photographic workflows are the Adobe® Photoshop® family of products. From the online and very simple Photoshop Express, to the capable but still entry-level Photoshop Elements, to the fully capable Photoshop and Photoshop Extended, which includes tools for scientific analysis, 3-D, and video. There is also the photography workflow tool, Adobe Photoshop Lightroom. In this book, I'll outline my workflow steps in Photoshop CS5 Extended (released April 30, 2010) and its companions Bridge and Adobe Camera Raw 6, as well as Lightroom 3 so you can decide which is most appropriate to the work you do.

For the most part, the workflows and techniques described in this book still work well with the previous versions of these products.

Mac vs. Microsoft Windows Operating Systems

Although most of the screen shots in the book are taken from a computer running Mac OS 10.6.2, Photoshop is completely platform indifferent. The interface is almost identical on both Windows and Mac. In fact, Photoshop happens to be one of the best cross-platform programs ever developed. With very few exceptions, every step on the Mac is identical to the same command on Windows. The differences that exist are identified in the text.

Look for text and icons like these:

Photoshop

For processes that involve Photoshop or Photoshop Extended.

Adobe Camera Raw

For "developing" images in Adobe Camera Raw.

Bridge

For information regarding organizing images in Adobe Bridge

Lightroom

For Lightroom's methods of achieving the processes discussed.

Keys

Two differences throughout are in regard to keyboard modifiers and mouse clicks. The two keyboards have essentially the same function keys, but with different names. The Mac Command key (%) functions the same as the Windows Ctrl key. This keyboard modifier is identified as #+[other key(s)] /Ctrl+[other key(s)]. #+N /Ctrl+N, for example, means you would hold down the modifier key then press the N key. As you can see, we'll be using dark gray for Windows and light gray for Mac or as part of a Mac-specific shortcut.

Similarly, the Mac option key, identified in application menus by the cryptic symbol " Σ ", functions the same as the Windows Alt key. This keyboard modifier is identified as option+[other key(s)] / Alt+[other key(s)].

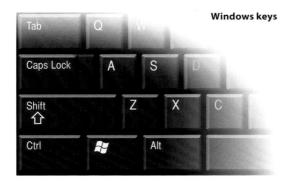

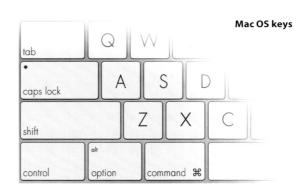

The Windows mouse includes a second mouse button for additional functionality—often a Context menu. Mac users can achieve this same functionality on an old, single-button mouse by holding down the control key when clicking the mouse. This mouse modifier is identified by control+click / Right-click. The newer "Mighty Mouse" and "Magic Mouse" can have two-button functionality within their single shells. I recommend enabling that "Secondary Button" functionality in your Mac mouse's System Preferences. Mac users should update older mice and turn on the right click functionality. Ironically, a Microsoft mouse works great when plugged into a Mac.

As of this writing, Photoshop CS5 works on *Intel Macs only* running OS 10.5 (latest), and 10.6 "Snow Leopard". Windows computers running Windows XP Service Pack 3; Windows Vista Home Premium, Business, Ultimate, or Enterprise SP 2; or Windows 7 are compatible. A "qualified", hardware-accelerated OpenGL graphics card is also needed.

It is best to see the following for full requirements:

www.adobe.com/go/photoshop systemreqs www.adobe.com/go/photoshopextended systemreqs

Section 1 The Setup

Terms & Concepts

1

There's an old joke in computer graphics circles. The biggest geek in the room utters a long sentence referencing PDF, EPS, PSD, GIF, RAM, HDR, DNG, ACR, RGB, L*a*b, "and other TLAs".

"What's a 'TLA?" someone asks.

"A Three Letter Acronym", replies the geek, to groans from those still listening.

A challenger pipes up, "What about CMYK?"

"Oh, that's an ETLA—Extended Three Letter Acronym." Despite the fact that this is intended as a joke, the language of computer graphics, even when restricted to digital photography, is still specialized. Of course, photographers have used special words, or common words in novel ways, for almost two centuries.

"Sharp" to a medical technician is a biohazard, but to an imagemaker, it's something to embrace. "Flat" may describe an easy path to walk, but it could also be the descriptive characteristic in a boring photo. In this chapter, I hope to decipher many of the terms one encounters perfecting images.

I also intend to answer some of the most common questions about digital imaging: is shooting digitally more like slide or negative film? What is "bit depth" and why should one care? What's a color profile? Hopefully, by the end of this chapter, you'll feel ready to take on the software.

Some Background

This section covers many technical details of how computers and software deal with digital images. Many people just want to skip the technical details because they are about the geeky inner workings of the computer. But it is useful to have a basic understanding of how Photoshop 'sees' your digital image.

We'll break down these details into a fairly straight-forward glossary of terms: Digital Images, Pixels, Resolution, Bits, etc. As much as software engineers try to hide the technical details of image editing, these terms still popup over and over again in digital photography. You may already know many of the details of computers, but review the terms as I define them here anyway. They're often used misleadingly in regard to digital imaging.

What is a Digital Image?

Computer software programs (including Photoshop) see digital images as a rectangular array of pixels. Each pixel (a shortening of "Picture Element") is merely a tiny square of color and light. This image of ornate stonework is composed of an array of 511 x 332 pixels—or 169,652 pixels. A typical digital camera image often has at least 2000 x 3000 pixels—or 6 million total. Most digital images contain millions of pixels—thus the common term "Megapixels".

Summary: Digital images are merely a rectangular array of pixels that represent an image. Digital images typically contain millions of pixels.

Pixels

Pixels are, therefore, the most basic elements of a digital image—visually, small squares of color. If you've ever seen a mosaic tiling, you get the idea. In the computer, which lives in a world of math, pixels are a simple set of numbers used to describe a color. For most images, each pixel contains a Red (R), Green (G), and Blue (B) value. The computer uses these RGB values to create the color for that particular pixel. Grayscale images use only one number for each pixel to represent the density or level of black. It is useful to remember that as computers are used to manipulate an image, they're only adjusting these values.

Dots & Sensors

What about the resolution of pixels in scanners, digital cameras, monitors, and printers? Although the term "pixels" is often used in regard to these devices, it is best to think of the "sensors" in our input devices as the "dots" of ink produced by printers. Usually, scanners and digital cameras produce

one pixel for each sensor, but not always. And printers print many dots for each pixel. The following examples illustrate these phenomena. Since a typical scanner might have 3000 sensors per inch, scanning a $1'' \times 1^{1/2}$ " piece of film produces a digital image of 3000 x 4500 pixels. Similarly, a printer doesn't print with pixels, but rather converts pixels into ink dots that are sprayed onto the paper. There are almost always significantly more ink dots printed per digital image pixel.

Thus, a printer with a resolution of 2880 *dots* per inch (DPI) prints an image with only 300 *pixels* per inch (PPI). In practice, the term "DPI" is commonly used for the resolution of a wide number of devices. We can't change the usage of this word completely, but remember there is a difference between the computer's "pixels", the scanner's and camera's "sensors", and the printer's "dots".

Summary: Pixels are not the same as dots & sensors: Even though "pixel" and "dot" are commonly used interchangeably, pixels actually exist only within a computer.

Image Size

The size of a digital image is referred to in several different ways. The most informative, and least common, method is to refer to its horizontal and vertical dimensions—a typical image might have a size of 2000 x 3000 pixels. This provides information about the shape of the image as well as its size. But the most common way to refer to image size is to refer to its overall number of pixels—multiplying the horizontal by the vertical dimensions, which in this example results in 6,000,000 pixels or 6 megapixels.

Finally, it is also common to refer to image size in terms of megabytes. Traditionally, computers used 3 bytes of information to store one pixel. By multiplying the number of megapixels by 3, you get the size in megabytes (MB), or 18MB in this example.

Resolution

A convenient way to understand resolution is as the density of pixels in an image. We might express this as 300 pixels per inch or 115 pixels per centimeter.

Remember, our objective is to transform a physical scene or image into a digital image and, likely, into a physical image (i.e., take a piece of slide film, scan it into the computer creating a digital image, edit the digital image, and print it back out to paper). To generate an acceptable print, we need to send a sufficient number of pixels to the printer for each inch or centimeter of dots it will produce.

For example, our image of 2400 x 3600 pixels image "maps" to a size of 24" x 36" at 100 pixels per inch—or to a size of 8" x 12" at 300 pixels per inch. Resolution is further complicated by the difference between dots and pixels.

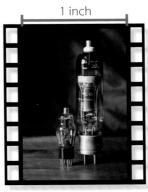

Scanned at 2400 ppi 2400 pixels x 3600 pixels

Digital Image

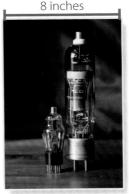

Printed at 300 **ppi** or 1200 **dpi**

Typically, scanners produce an image with one pixel for each scanner sensor. But, as noted previously, printers almost always print with many more dots than pixels; often 6, 8, or more dots print for each pixel in the digital image.

Here's a concrete example demonstrating the transformation of a piece of 35mm film to a larger printed image:

The 35mm film has an image area of about 1" x $1\frac{1}{2}$ ". If your scanner scans at 2400 samples per inch (sensors per inch) and produces a file with 2400ppi (pixels per inch)—that's one pixel for each sensor.

1" x 1½" at 2400ppi produces a file of 2400 x 3600 pixels.

While this file is in Photoshop, you can edit it without much regard for the resolution—it is simply a 2400 x 3600 pixel image.

However to output an $8" \times 12"$ image, we would change the image resolution to approximately 300ppi, a typical printer resolution. The image is still 2400 x 3600 pixels, even though the printer might print at 1200dpi (here four *dots* for each pixel).

Considering an ancient mosaic floor tiling, artists would use many small tiles to construct what appeared to be an image when viewed from sufficiently far away: when standing upon it, or perhaps on a balcony above. To enhance the illusion for viewers, or to keep the illusion when viewers approach more closely, the artist had to use smaller tiles, so there would be more under each foot. One might say a mosaic with a resolution of 12 tiles per human foot is not as compelling when viewed as closely as one with 24 tiles per foot.

If that artist could only afford a certain number of tiles of any size, he might choose to make either a small mosaic of high resolution or a large one of low resolution.

Note: An image with a set number of pixels can have any resolution if its size is changed: higher resolution (defined as pixel density) for a smaller size, lower resolution for a larger size.

Resampling/Interpolation

But, what if you want to print an image that is 4" x 6" instead of 8" x 12"? By changing the digital image size to 1200 x 1800 pixels, the image prints at 4" x 6" at 300ppi. Changing the actual number of pixels of a digital image size causes Photoshop to **resample** (or interpolate) the image. In other words, Photoshop takes the existing pixel information and estimates the appropriate pixel colors for the same image with the new image size. Interpolation is a good thing; it makes it possible to change the size of the image from various source sizes (different film sizes, different scanners, or different digital cameras) to various output sizes (different print sizes, different printers, or the web).

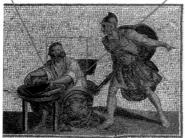

Photoshop is generally very good at resampling digital images. However, each time an image is resampled, there is wear on it. It is best to keep your original archived with its original pixels intact and have copies, real or virtual, with other needed resolutions. More on that "virtual" part later!

Native Resolution

Often, when we discuss interpolation, many people suggest that they can avoid interpolation merely by changing the scanning resolution and/or the printing resolution. For the 2400 x 3600 pixel example—couldn't you also change the print resolution to 750ppi if you wish to print a 4" x 6" image? The math is correct, but most digital imaging devices (like scanners and printers) only operate at a single fixed resolution—their native resolution. For scanners, the native resolution is based on the number of actual sensors in the scanner. A typical film scanner has a 1" wide sensor with perhaps 3000 actual elements for measuring light across the sensor. The software for most scanners allows you to set the resolution to any value, but the scanner merely scans at its native resolution and then interpolates to the resolution you set. Similarly, most printers only print with a resolution of approximately 300ppi. But, if you send the printer a digital image at a different resolution, the printer software will interpolate to 300ppi. In almost all cases, Photoshop does a better job of performing this interpolation. Don't interpolate in the scanner or printer software—do it in Photoshop.

Many professional scanner or printer operators disagree and recommend scanning at the specific resolution for the desired print size or sending a file with any resolution to the printer. In the case of very expensive scanners or printers (in the \$100,000 range), this is true—the issues of native resolution don't apply rigidly. But the vast majority of desktop scanning and printing devices have a single native resolution.

Color and Tone

Bits and Bytes

Computers are binary devices. At the simplest level, all numbers within a computer are made up of **bits** (Binary Digits). A bit can have a value of only 1 or 0; that is, yes or no, on or off, black or white.

Bits are grouped together into bytes. There are 8 bits in a typical byte, providing a range of values from 0000 0000 to 1111 1111, or 0 to 255 in decimals that we commonly understand. Traditionally, the color represented by a pixel is stored in three bytes—one each for red, green, and blue. This is the reason that Photoshop often represents the values of colors with the range from 0 to 255—the range of values for one byte. We'll see this range of 0 to 255 throughout Photoshop and digital imaging. A color pixel has three such

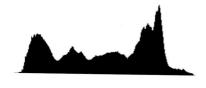

numbers for each red, green, and blue; R100, G58, B195 is a rich purple. A grayscale pixel only has one number representing the density of the pixel from black to white.

The histogram in Photoshop, of which I have more to say later, is simply a graph of the number of pixels at each byte value from 0 to 255.

Today, it is very common for pixels to have more than one byte of information for each color in each pixel. We still refer to these colors as having the range of 0 to 255, but the second byte allows for more precision in each of these numbers. A one-byte color represents color from 0 to 255 in whole increments, but a two-byte color represents color from 0 to 255 with fine intermediate increments allowing such values as 58.55. Color can be described much more precisely with two bytes or 16 bits.

Bit Depth

The number of bits used for each color channel (Red, Green, and Blue) in a pixel is referred to as its "bit depth". An image that uses one byte per chan-

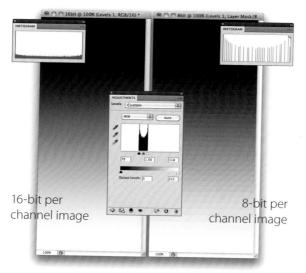

nel (or 8-bits per channel) is referred to as an 8-bit image or as having a bit depth of 8 bits per channel. The vast majority of digital images have 8 bits per channel. This allows for 255 different values of each red, green, and blue, or ideally 16 million possible colors. For the vast majority of printing or display options, this is more than sufficient for representing colors. But in the world of digital image editing, more bits are often desired.

Scanners and digital cameras often create files with more than 8 bits per channel—each of these options provide the same range of values (0 to 255), but the extra 8 bits provide intermediate values for finer precision (i.e., values like 100.254 rather than 100). When editing images, it's possible that significant edits will result in visually revealing the limited precision in 8-bit images.

At left, a moderate field of blue has been expanded to cover densities from bright blue to dark blue. A version with 8 bits per channel doesn't have sufficient precision to display across this entire range of colors, resulting in an

image with several discrete values of blue.

This is often referred to as posterization. The version with 16 bits per channel has sufficient precision to edit across the full range of colors and display a smooth gradation of colors.

When scanning images or capturing digital camera images, it's best to try to create images with more than 8 bits per channel. Most scanners allow for scanning at more than 8 bits. Digital cameras that support RAW files allow for more than 8 bits, as well. JPEG files typically support only 8 bits per channel. (This is the main limitation of using JPEG files for capture in

digital cameras.) JPEG files can still be used for digital capture, but cannot be edited as well as RAW image files.

When devices with 12-, 14-, or 16-bit capability save files, they always save the files with two full bytes per color channel per pixel. These are all represented as 16 bits per channel when the files are opened in Photoshop.

Bit depth is also often referred to in terms of bits per channel. If each pixel has three color channels, each with 8 bits, these images have 24 bits per pixel. Images with 16 bits per color channel have 48 bits per pixel. Remember that having only 8 bits per color/channel limits the amount of image editing you can do, while more than 8 bits (e.g., 16 bits per channel) provides for very extensive editing.

Note: When editing in Photoshop, start with images in 16 bits per channel mode.

HDR Images

In the last several years, many photographers have discovered something called High Dynamic Range Images. While 16-bit per channel images allow for fine gradation and precise specification of color, HDR images use 32 bits per channel. However, the arithmetic is different here. Instead of giving still greater precision from, say, the darkest and lightest values in an image, HDR uses its 32 bits to specify values exceeding what we're accustomed to seeing in images of any sort.

Estimates of the dynamic range (the range from dark to light, from black to white) of human vision vary from 12 to 20 f-stops! As our digital cameras are challenged to provide even half that tonal range, there have been almost no photographic processes that capture the full human range. Today, our software allows us to combine multiple images into only one with the entire tonal range of the scene. Although there are many examples of poorly executed HDR images on the internet, and many criticisms based on those examples, it is possible to achieve sublime images that are closer than ever to the range we actually see.

I will share some insights into both capturing images for HDR processing and some tips for that processing.

Channels/Color Models

The red, green, and blue (RGB) parts of the color image are separated into three distinct images referred to as "channels". Typically these are displayed in Photoshop as grayscale. You can see the channels for your image by selecting the channels panel in Photoshop.

Understanding RGB is understanding color photography itself. Imagine three slide projectors shining light onto a screen. One has a red light bulb, the second a green light bulb, and the third a blue one. The three lights overlap partially (*see illustration*). Where the red and green lights overlap, they combine to form yellow. This is not like pigment! Notice the colors

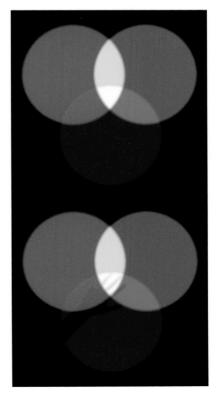

where any two lights overlap. You might think of these (cyan, magenta, and yellow) as the sum of two colors, or as the absence of the third.

If something were to block one of the lights, for example the blue one, the shadow would either be completely dark or filled in by one or both of the other lights. If the item casting the shadow was not completely opaque, then we'd be able to control the ratios of each light.

Imagine using black and white transparencies in each of these hypothetical projectors. Where each slide is dark, it blocks (or masks) the light. Now do the arithmetic: if the red-lit image is very light, and the other two dark, then the light that reaches the screen will be predominantly red. In Photoshop, each of these transparencies is represented by a channel.

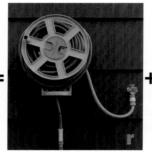

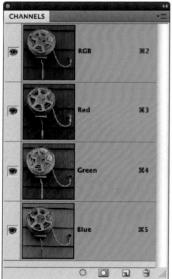

In this example, each of the three channels is shown. The red faucet handle is lightest on the red channel (letting through the red light), the hose is lightest on the green channel, and the wall behind them is lightest on the blue channel. Thus, each of these elements appear in those colors. Note the part of the hose that is yellow. It is light on both the red *and* green channels, so both those colors combine to make yellow.

The first color photograph was made by James Clerk Maxwell this way in 1861! Since this is the way color photographs have been made for nearly 150 years, it makes sense that Photoshop should use the same method. However, since we're dealing with software, we should keep in mind this is a metaphor, and there are other methods for making color.

Indeed, RGB is just one of several color models available in Photoshop. For photography, color digital images should (almost) always be in RGB mode. Digital cameras and scanners capture information in components of red, green, and blue: their sensors are sensitive to the amount of light, not color. So each sensor has a red, green, or blue filter in front of it, just as Maxwell's lenses did in 1861. And most desktop printers, as well as many large professional photo printers, also work in components of red, green, and blue.

But, don't commercial printers work in CMYK—Cyan, Magenta, Yellow, and blacK? Yes, generally most printers create colors by using CMYK inks. Cyan, magenta, and yellow are the complementary colors of red, green, and blue. And CMY inks need to be used to create colors when mixing ink onto

paper. But the conversion from RGB images to CMYK images is something best left to your print professional if sending images elsewhere for printing. In the case of most desktop printers, the printer driver only accepts RGB values and performs the conversion from RGB to CMYK within that printer driver.

Note: For digital photography, there are really only two important color modes: RGB and Grayscale. RGB has three color channels: Red, Green, and Blue, while the Grayscale only has one channel: Gray (or Black).

Color Management

To understand color management is to realize that your digital darkroom actually contains *at least* three different image versions—the virtual image inside the computer, the monitor image on the computer screen, and the printed image on paper.

The virtual image is how the computer (Photoshop) sees your image. This is the digital version of your image, the numbers that Photoshop uses, and for color management we'll assume it's the most accurate version.

When displayed on a monitor or printed, the image becomes subject to the limitations of those devices. Innate faults within monitors and printers render the image imperfectly. We can address this by preparing monitor and printer profiles. A device's profile is a document that lists the corrections necessary to render certain colors in the virtual image correctly (or as closely as possible) on the other device.

Summary: Your digital darkroom contains at least three different images—the virtual, Photoshop image, the monitor image, and the printer image. The goal of color management is to render the monitor image and the printer image as a match to the virtual image by using profiles.

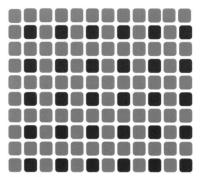

Digital camera sensors use red, green, and blue filters just as the first color photos had.

Monitor image (uncorrected)

Monitor image (via profile)

Let's take a closer look at the monitor version of an image. The monitor image is the computer's attempt to display the virtual image on the computer screen, but, unless given some help, it fails to do it exactly. For example, assume that the virtual image contains a specific shade of Green, represented in Photoshop as, let's say, "165 Green". Photoshop knows exactly what color 165 Green is supposed to be, but the monitor fails to display that exact color. It may make the image lighter and more red. A monitor profile makes these quirks of the monitor "known" to Photoshop, which then can use the profile to correct the image by darkening it and removing red *as it's displayed*. The actual color numbers (165 Green, in our example) remains unchanged: it still represents the correct color, but the adjustment happens only for our specific, quirky monitor. Very clever!

Summary: A profile is a list of target colors with value corrections to allow precise color rendition by a particular device. By using a profile, we can present a particular target color and correct it so it is accurately rendered. Monitors and printers must be profiled and color corrected independently.

An Honest Window to Your Image: Monitor Profiling

There are two basic elements of monitor profiling: calibration and profiling.

Calibration

You need to configure your monitor to the best settings for brightness and color. A well-calibrated monitor does a good job of displaying colors; if it's close to "right", the monitor profile will only need to note a few small adjustments. To calibrate your monitor, you will need to use the controls on the monitor itself to adjust brightness and color. Refer to the monitor's user manual if you don't already know how to do this.

- ▶ Set the Target Color and Contrast: these values are referred to as the White Point and the Gamma. All monitor profiling tools require that you set these. Although the monitor can mimic the color and contrast of a variety of light sources, you should set your monitor to mimic daylight.
- ► Set the White Point to: 6500K, D65, or Daylight, which are synonyms for the same value.
- ▶ Set the Gamma to: 2.2, Windows or TV Standard (even on a Mac).

Profiling

The most robust profiling requires a software utility to display colors on the monitor and provide a chance to measure and correct these colors. The best solutions also use a hardware sensor to measure the colors displayed by your monitor (to know how far off they are). The software utility creates a profile that corrects for those inaccuracies.

If you use one of these solutions, turn on your monitor and let it warm up for 20 minutes before profiling it. Be sure you've set it up to not go dark or the computer to sleep in that time.

Devices

It is possible to buy a hardware sensor (known by some as a puck or spider or, properly, a colorimeter) that can be attached to your monitor to measure colors displayed by companion software. The result is a very accurate monitor profile.

The software for the sensor is also fairly easy to use, requiring only one or two steps after the initial installation, so it can be easily run once a month.

Some monitor sensors:

 X-Rite Colormunki Photo (also does printers) or i1Display 2

(www.xrite.com)

 Datacolor Spyder series several products (www.datacolor.com)

All of these products work well. They all provide a software utility that uses a step-by-step wizard to guide you

through the process of profiling your monitor. These also have an easy or automatic mode; this mode will automatically set the White Point and Gamma values for you (to 6500K and 2.2 respectively) if the monitor supports it. The more advanced models also include steps for precisely calibrating your monitor using the sensor device.

Checking the Profile

Once you have profiled your monitor, it is best to check the profile using a good visual target. **Getty Images** provides an excellent test image for evaluating the color of your monitor. Google "site:gettyimages.com color resources" to find it. A good test image contains a variety of common objects in color and gray, a color test target, and most importantly, some examples of skin tones. Open the image on your computer screen and evaluate it.

Printer Profiles

Printer profiles are more complex. A good printer profile addresses a specific printer, ink set, paper type, *and* software settings. There is a variety of sources of good printer profiles, though. Your printer driver likely includes a good set of profiles to work with the inks and papers designed for it.

Summary: Monitors and printers are profiled and color corrected independently. If we set up both the monitor and the printer to match the virtual image inside the computer, then the printer and monitor should match each other as well.

Devices have another limitation. The real world has a vast array of colors: saturated, brilliant, subtle, muted, dull, and gray. No device can reproduce all of these colors.

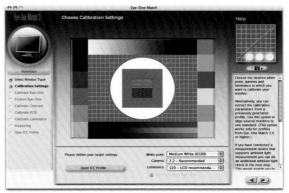

Our devices produce a subset of these colors. The **gamut** of a device is the range of colors it can render. Colors outside this gamut simply cannot be rendered by that device. Were you to try, the device would render the nearest color it can display.

Because of the differences between monitor gamuts and printer gamuts, you cannot assume the monitor image matches the printer image. Colors that appear on the monitor may simply be unprintable. To resolve the mismatch in printer and monitor gamuts, periodically use Photoshop's "soft-proofing" feature. This allows you to simulate any printer (or other device) for which you have a profile on your monitor! We'll talk more about soft-proofing in the chapter on output.

Working Color Spaces

Even the virtual image in our computer has a profile to describe its gamut. The gamut, or the **color space**, is usually set by the limitations of the physical device. But our software has no physical limitations, just what we choose in its settings. The Working Color Space defines the color gamut used by Photoshop when editing images. The boundary of a working color space indicates the brightest, darkest, and most saturated colors that are possible within that space.

There are two schools of thought on how broad a gamut one should embrace with a working space. Many recommend a space not much larger than the color space of our output devices. Then, our images won't experience such a drastic change when output. Also, some working spaces exceed many monitor spaces, and thus we won't really know what we're dealing with. The two choices here are called sRGB and AdobeRGB (1998).

Others suggest using a space that holds every nuance of color from our *capture* device. In this way, as output devices get better, we can take advantage of them to produce more of the colors our cameras actually recorded. This perspective requires one to have the expectation that current output will always reduce the saturation and/or dynamic range of our images. The primary choice for this philosophy is **ProPhotoRGB**.

sRGB

sRGB is the standard assumed color space for the Internet and many consumer imaging devices (e.g., low- to mid-range cameras and printers). Images created supporting sRGB should look similar on any monitor across the Internet, as this is the standard presumed by web browser applications and many monitor manufacturers.

Its main limitation is that it holds the smallest gamut of all three color spaces—a sort of lowest common denominator. For professional output, it is not recommended. However, for the web, it's ideal. So use sRGB to create web images—it's the Internet standard. Also, use sRGB if you wish to forever forget about color spaces. It is the easiest color space to use, because of its ubiquity especially as Photoshop's default, but will rarely produce the full range of image.

AdobeRGB

AdobeRGB is the most popular color space for digital photographers. AdobeRGB has a larger gamut than sRGB. It includes most of the colors of a typical photo printer and is made to encompass all the colors of printing presses. In fact, it was designed to do so.

Use AdobeRGB to ensure access to a large range of colors that your printer can print. Many high-end monitors tout themselves as displaying "nearly all" of AdobeRGB. For matching (and just somewhat exceeding) current printing technology, this is a great choice and many have made it.

You will still use sRGB for web images and those printers that don't support AdobeRGB or custom printer profiles.

ProPhotoRGB

ProPhotoRGB has recently become a popular color space for professional photographers for at least parts of their workflow. Larger than AdobeRGB's gamut, it includes all colors likely available to printers for many years to come. With such a large color space, it's very easy to edit colors that are unprintable, so expectations need to be adjusted. Also, ProPhotoRGB includes colors that cannot be rendered on any current monitor. However, it is useful on the input end of an advanced workflow: it will encompass all the colors from your camera, for instance.

I will recommend ProPhotoRGB for a working color space: it offers the smoothest handling of images that use 16 bits/channel. Although it offers access to many colors that *no* printer can currently print, it is the right choice for Adobe Camera Raw's Workflow Options (next chapter) and for Adobe Photoshop Lightroom, as these make great use of all of your camera's colors.

Summary: Whether you choose AdobeRGB or ProPhotoRGB, you will achieve all that your output devices can produce. As I feel duty-bound to help you protect your images and preserve their full integrity, I will recommend the slightly more difficult ProPhotoRGB as your working color space.

Camera Profiles

Using modestly priced software and a color target like those included with the X-Rite Passport (see page 107), you can make custom profiles that correct for even strange lighting conditions in which you may find yourself.

These profiles can be applied at the time of image import in Camera Raw or Lightroom to correct for those lighting conditions and/or your camera's quirks.

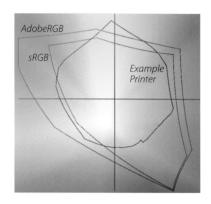

File Formats for Digital Imaging

Photoshop supports a wide variety of file formats, but almost all image editing work will be completed with the formats described below. Most of the other formats are either outdated or of little interest to photographers. With the exception of RAW formats, you can select the format for your image file by selecting File>Save As and selecting the file format from the Format list.

DNG & RAW Files

Many digital cameras can save their images as RAW files. These are unprocessed digital camera images. We can process them to a higher-quality than we can with JPEG files. One of the biggest advantages of RAW files is that they have more than 8 bits per channel of information and can therefore be edited more than JPEG files.

Every camera manufacturer has its own proprietary RAW file format—one that contains all the data recorded by the sensors. These include NEF (Nikon RAW), CRW (Canon), as well as many other formats. Adobe Photoshop CS5 supports most RAW file formats. Unfortunately, that support does not extend to adding metadata or saving into these manufacturer-proprietary formats. For that, there is the Adobe Digital Negative (DNG) format. Unless you use DNG, metadata, for example, will have to be saved into an accompanying "sidecar" file; a risky situation at best.

Therefore, I recommend converting manufacturer specific RAW files into Adobe's opensource DNG format. Adobe has pledged to be the "steward" of this format in much the same way they have for TIFF. Files you save in this format can be safely archived as they will be supported by Adobe applications far into the future.

DNGs will contain all the important data of your camera's RAW file and will not require any support files as they are processed or have metadata applied.

Lightroom and Adobe Camera Raw integrate RAW files with Photoshop easily and provide a simple powerful interface for making adjustments before—or perhaps instead of—opening them in Photoshop. These features make Adobe Camera Raw and Lightroom the best RAW utilities available. Adobe has done a good job of maintaining support as new cameras (and RAW formats) are released. Newer cameras may require that you occasionally check that your software is up-to-date.

Lightroom and Adobe Camera Raw (ACR) provide very rich options for editing that quickly generate very good-looking images. You may use these for many of your corrections and leave others to Photoshop. Photoshop allows for more precise fine-tuning using layers.

Photoshop (*.PSD)

Photoshop Document (PSD) is the standard file format for Photoshop. It stores all of the information for a Photoshop image, including Channels, Layers, and more. After completing edits in Photoshop, it's important to save a version of your image in a format that stores all the structure and information that you have added so you can retrieve it all when you open the file later. Traditionally, this has been the role of the PSD format. However, only Photoshop (or other Adobe software) can reliably read Photoshop files. PSDs also provide powerful integration features when used with other Adobe products like InDesign.

When saving Photoshop PSD files, Photoshop will provide you with a Maximize Compatibility option dialog. Note the text in the dialog. You can change the preferences so that you always generate the preview, and never see the dialog box again. Check the Maximize box and Don't show again. To change back, use Edit>Preferences>File Handling on Windows or Photoshop>Preferences>File Handling on the Mac OS.

Photoshop PSD files can only support files up to 2GB in size. For the majority of images, this is sufficient. But in the real world of digital imaging, it is possible to have larger files. Photoshop supports larger files by using the Large Document Format (PSB). This format supports all of the features of PSD files, but also supports files of any size.

TIFF (*.TIFF, *.TIF)

Tagged Image File Format (TIFF) is an industry standard image file format. TIFF format can also preserve much if not all that you can do in Photoshop and, depending on options chosen when saving, may be accessible to someone who may not have Photoshop. In many ways, a basic TIFF is just a big array of pixels stored in a large file. It may not contain all of the sophisticated information used in Photoshop (e.g., layer information usable to InDesign). TIFFs are a very safe way to save your image files since the image is typically saved in a lossless state, i.e., there's no data conversion caused by image file compression. Use TIFFs when a file is needed to have all its data intact outside of Photoshop. TIFF supports images of both 8 bits and 16 bits per channel.

Adobe has added a wrinkle to TIFF—saving layers. As far as I know, this extended version of TIFF is supported only by Adobe. As this may prevent non-Adobe programs from accessing the data, check with an image's recipient to see if this is an option you can choose.

One TIFF option allows compression of files. Check with your images' recipients before using these compression settings. Lempel-Ziv-Welch (LZW) compression can save much space on storage media, and is widely

supported. ZIP compression can make even smaller file sizes, but is not nearly as well supported. Don't use this option if you're worried about compatibility with other programs and systems. The other TIFF options aren't typically recommended or relevant.

JPEG (*.JPG, *.JPEG)

This is the format for *very* compressed files. Most images on the Internet are saved in Joint Photographic Experts Group (JPEG) format, since they can be compressed to such small file sizes—at least 20:1, that is, one-fifth the nominal file size—with little loss in *apparent* image quality. Compressions of 100:1 are possible, but result in significant loss of image quality.

All digital cameras have the option to save images as JPEG files which allows you to save many more images onto your camera's data card. But since this format only supports 8 bits per channel images, and achieves its amazingly small file sizes by actually deleting data, avoid using it for capture. However, if your camera only supports the JPEG format, it's still workable if you choose the highest quality JPEG and then arrest the deterioration of the image by saving it in a lossless format from then on.

JPEG files are essential for use on the Internet, where download time is a more crucial consideration than image quality. Use JPEG for images on a website or email.

The JPEG Options dialog appears after you save your image. Set Image Quality to 9—High for most files and to 6—Medium for especially large or relatively unimportant files.

JPEG Format Options should be set to Baseline for most images that are to be shared via email.

PDF Files

Photoshop has excellent support for Portable Document Format (PDF) files. These files can be viewed by anyone using the free Adobe® Reader. Since Adobe Reader is almost universally available, PDF files are an excellent way to send very high quality versions of your files to someone who may not have access to Photoshop or even a modest image viewing program. You may even add password protection for either opening the file or just for printing or editing.

The Lightroom Catalog

Whereas Photoshop is an image editing application, Lightroom should be thought of as a photographer-friendly database application. Instead of opening, editing, saving and then closing your image files as we do in Photoshop, Lightroom essentially uses one file: its catalog database. As you work in Lightroom, it is continously updating this file. Indeed, if you look under the File menu, you will not see a Save command!

When you import RAW files (including DNGs), JPEGs, TIFFs, or PSDs "into" Lightroom, you are asked to specify where those image files are or to where they should be moved. They do not reside *inside* Lightroom. Lightroom's catalog database is simply aware of where they are. Thus, and this is critical, if you move the images using any method other than those within the Lightroom application, the catalog will have *no* idea where the images are! So choose wisely when deciding where the images are to be when you import, or use Lightroom to relocate them later.

Although there is no Save command under Lightroom's file menu, the universal keyboard shortcut for Save (<code>%+S /(Ctrl+S))</code> still does *something*. It makes the Lightroom catalog write much of its data to the image files. Normally, all the work you do in Lightroom is stored in the catalog database *alone*. I like to think of this Saving as informing the image that it has new information to be aware of. For many users, this is a completely new way to work, and it takes time to get used to it. So I will be sure to spell out this new—and powerful—way of working as we go through the workflow section of this book.

System Configuration

2

This brief chapter is an overview of how you might configure some general settings in each of the applications we're discussing—Photoshop, Bridge, Lightroom, and Adobe Camera Raw. There are also some issues to consider when buying or outfitting your hardware. I strongly recommend revisiting the settings you initially choose. After a few weeks of frequent use, or a few months of more leisurely use, go through the settings I discuss to see if your way of working would benefit from other choices.

Whether we're talking about Preferences, Color Settings, Workflow Options, Workspaces, or other settings, the workflow they aid is your own, not mine. I will offer suggestions, but it's up to you to determine what's best in the end.

Computer Requirements

What is the best computer for running Photoshop? One can get by with modestly priced computers and enjoy Photoshop CS5's marvelous performance enhancements. However, if your computer has a 64-bit operating system, Photoshop may well benefit tremendously. I say "may" because the benefit this allows is Photoshop's active use of more than 2GB of RAM.

One of the goals of 64-bit architectures is the use of more RAM, "memory". In mainstream desktop computers where 32 bits is common, only 4GB of RAM can be accessed. [Did I just write "only 4GB"? Wow.] 64-bit computers can handle over 16 million times that. Not that any of us can afford that much RAM, but the ceiling has been raised so that we can dedicate as many resources as we can afford to improve the speed and stability of applications like Photoshop. And with high-end graphics processors designed to accelerate Photoshop CS5 (and Adobe's video applications), anyone can enjoy lightening fast performance. Of course, this comes with a price tag.

Nonetheless, I usually use modestly configured computers to run Photoshop. The greatest aid to smooth and responsive performance was adding additional RAM (again, the more, the merrier). In my Seattle training lab, I'm using 4GB of RAM in iMacs (running either Windows or the Mac OS) with great results!

Buy a good monitor. The monitor is the interface between you and the image inside the computer. Inferior monitors make it very difficult to edit images: you simply can't see the details. You don't need to buy the best monitor on the market (they can cost much more than the rest of the system!), but avoid the cheapest LCD monitors. I suggest buying the second tier of any product line. Lastly, if you want to do color correction, you need to calibrate and profile your monitor. This can be done with a hardware device made for that purpose. Calibrate your monitor as soon as practical.

Work Environment

Light

Work with subdued and consistent lighting. Overly bright lights make the monitor appear dim and reflect light off the monitor. Dim lights can make the monitor appear overly bright and lead to eye fatigue as you glance from the monitor to adjacent objects. Variations in room lighting will also change the appearance of images on your monitor. You can keep reflected light off your monitor by buying or making a monitor hood. You will need a good, bright light for viewing your prints near your monitor. It is worthwhile to consider "daylight balanced" lights for that purpose, as monitors often are aglow with that same color of light.

Colors

Use boring, gray colors for your computer desktop. You should set the colors of the computer screen to be mostly neutral (grays, black & white); vibrant colors on the monitor, surrounding your images, make it difficult for you to accurately perceive colors in your images.

On Windows, open the **Display Properties** from the Options Bar; set the Appearance to Windows XP style and the Silver color style.

On Mac OSX, open your **System Preferences** and select **Desktop and Screen Saver**, then choose a solid gray background, or a black and white photo.

Finally, keep overly vibrant and distracting colors away from your direct field of view. Your walls don't need to be flat gray, but avoid hot pink. (Many professionals do use medium to light gray walls.)

Application Preferences

In the software we use, we can specify the general behavior, performance, and appearance of the application. What follows is an overview of settings you may wish to consider choosing. If some of the choices are mysterious now, you may wish to trust the recommendations below, but then promise yourself that you'll return to these choices when their topics are more familiar to you.

Photoshop

One begins a journey through the "prefs" by choosing Photoshop> Prefences>General (on the Mac) or Edit>Preferences>General on Windows. More efficiently, one can use a keyboard shortcut <code>#+K/Ctrl+K</code>.

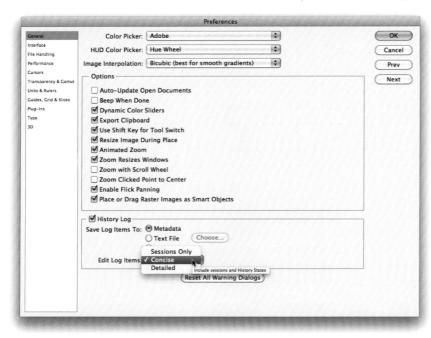

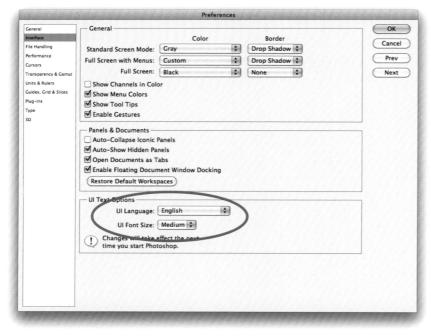

General

While learning Photoshop, some users find it useful to have the application take notes of what they do. If this seems handy, enable the **History Log**. It's up to you whether it records your actions into a standalone text file or into the document itself (accessible by using File>File Info... and choosing History). You may be tempted to choose a Detailed history, but be warned that it is deeply detailed.

It is also here where Warning Dialogs can be reset. When an annoying message keeps appearing, you may notice a checkbox in its dialog that says Don't Show Again. Later, if you need that dialog, or wish to see it to evaluate whether it's needed, use this preference to show all those messages again.

Interface

I have come to appreciate the preference to **Open Documents as Tabs** in a single window. This saves much needed screen real estate.

My aging eyes also enjoy the larger UI (User Interface) Font Size choices.

File Handling

Some Photoshop luminaries dismiss the Maximize PSD and PSB File Compatibility preference as a drive space waster. However, I know it allows other applications like InDesign, and my Bridge, operating system to show me what my image actually looks like. It does this by embedding a preview of the image in the document for the benefit of those applications that can't parse (read) a Photoshop Document.

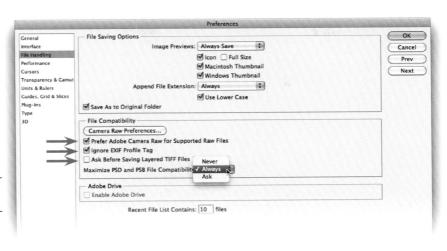

Some cameras have a tendency to put a "tag" into their images that claims the image is in sRGB, whether that's true or not. For that reason, I choose to **Ignore EXIF profile tag**.

TIFF files have become close to PSDs in the data they can record. Luckily, the recipients of my TIFF files all have Photoshop and can handle that data richness. So I don't need Photoshop to warn me whenever I save a layered TIFF file. Also, I have chosen not to install Adobe Drive on my system, so I have not enabled it in Photoshop.

Camera Raw Preferences

Accessible from either Bridge or Photoshop Preferences, since either may "host" Adobe Camera Raw, there are only a couple of things I change here. Since several adjustments I make in Camera Raw are corrections for either a quirk of a particular camera (e.g., the chromatic aberration of one lens) or the ISO setting (color noise), I can have the defaults for these corrections refer to the specific camera or setting. A better choice, however, is to use presets (more later).

I also like my DNG files to show an up-to-date preview. When I edit them, I have Camera Raw automatically update their previews.

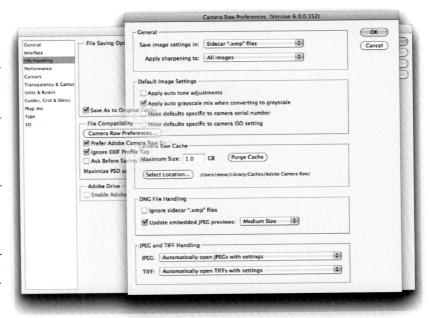

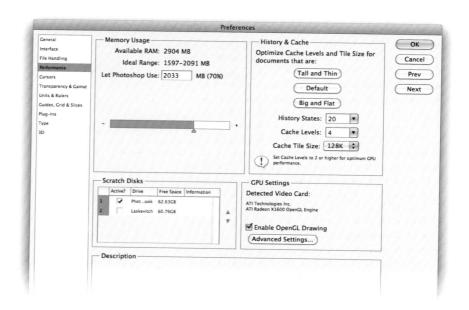

Performance

When tuning the performance of Photoshop, you will discover many variables. Here, you will be able to choose the parameters, like RAM, that affect performance most.

Among the issues to consider are what video card is installed in your computer, whether it supports (and how well) technologies like OpenGL, how large and how fast are the installed hard drives, and of course how much RAM is installed.

Cursors

Not much to change here other than I like having a crosshair in the center of my brushes to give me more precision when using tools that employ painting. Invesigate what Precise cursors look like. Even when the preferences

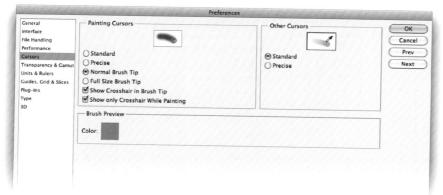

are *not* set to show them, they will display if your Caps Lock is on.

Transparency & Gamut

When Photoshop is trying to show you a hole in your image, or if you've hidden part of it, the application will show you a gray and white grid. However, you may choose whatever colors you like for this grid.

Units & Rulers

Centimeters or inches, picas or percent, you choose the ruler units you need. When you choose to see what the Print Size of an image is, View>Print Size, Photoshop will likely not know what resolution your monitor is. You may not know either! To find out, measure the width of the live part of your screen with a tape measure or similar (be careful not to scratch it). My laptop's screen is 14 ½16" (36.7cm) wide. Check your system's display settings (System Preferences,

Display on the Mac, or the Settings tab of your Display Properties on Windows). Find the pixel width of your display (the one I'm using is 1680 pixels wide). Divide the pixel width by physical width, and enter that value into the Screen Resolution field.

Pixel Width ÷ Physical Width = Screen Resolution 1680 ÷ 14 7/16 = 116.36 (for my laptop)

Plugins

You'll notice mention of Extension Panels here. Photoshop is packed with panels, and now you can make your own, if you choose, using Adobe Configurator. Your panels might access online resources (so you can use the greater Photoshop community to find answers to some questions, perhaps).

There are many possibilities with Configurator. See the forums on Adobe's site (especially the Photoshop section) for more on how to use Configurator.

Color Settings

As you process the image files from your camera, their color data has to be in sync with where they are in the workflow. That is, your camera captures a very wide range of color. This must be translated into Photoshop's range of color (its Working Space profile, most likely ProPhoto RGB if you follow my advice), then later, that range of color must get squeezed and finessed into your printer's range of color, as described by its color profile. To help ensure that this happens as expected, you should configure your Color Settings (Edit>Color Settings) like the following:

- 1. Start with North America Prepress 2.
- 2. For consistency with Lightroom and Camera Raw, choose *ProPhoto RGB* as your Working RGB space.
- 3. Save these settings with a named Settings file so you can share it with your other computers and friends (you can even supply an explanatory note). I chose *Photographer's Handbook* for the name of mine.

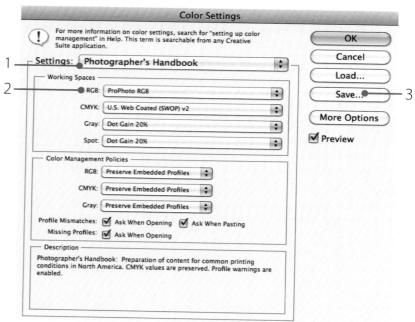

Bridge

One begins a journey through the "prefs" by choosing Bridge>Prefences... (on the Mac) or Edit>Preferences... on Windows. More efficiently, one can use a keyboard shortcut <code>%+K/Ctrl+K</code>.

General

In the Behavior section, you may wish to have Adobe Photo Downloader launch whenever Bridge detects that you've connected a card reader and memory card or your camera directly to your computer. I do this on computers that do not use Lightroom as the primary downloading application. I know many photographers who prefer the software from their camera's manufacturer, but I do not.

If you find that you use Adobe Camera Raw frequently and that you use Photoshop only once in a while, you might choose to change what a simple double-click does. By default, this will launch Photoshop so it will "host" Camera Raw with the expectation that the image will then be passed along to Photoshop for further editing. The preference here will cause Bridge to be Camera Raw's host without the need to wait for Photoshop.

Thumbnails

One of Bridge's primary functions is to view thumbnail previews of images in your computer. Often, it is useful to see a little extra information with each image. For example, I use color labels (see below) to indicate how far in my workflow an image has proceeded. I also like to know the image's file size and what application will launch when I open that image.

Playback

Bridge offers clever ways of grouping images for efficient viewing. One of these will "stack" the thumbnails so only one (presumably a definitive one for the group) is visible. But if you hover your cursor above that thumbnail a play button appears. When clicked, you're shown all the images in the stack as

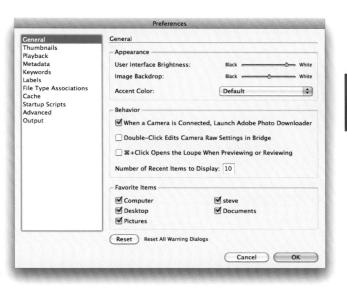

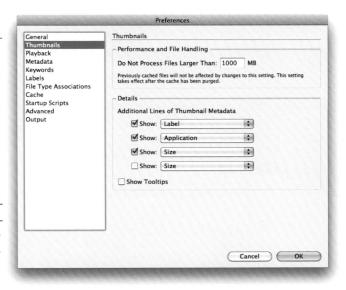

if each were a frame in a video. The rate at which they're shown is set in this preference page.

Br

There is much data about our images, some of which we rarely, if ever, need to see. When you learn what metadata (data about your data) *you* require, choose it here.

Keywords

I'll spend more time later describing how (and why) we keyword our images. Primarily, keywords give us another way to find images whose names we may have forgotten. Many photographers use geographic locations as keywords. For example, I might have keywords like United Kingdom, England, London, Blackfriars Pub. You'll note that these are hierachical; that is, they get more and more specific as they progress. I might have other London locations that I wish to use as keywords that should be associated with the

more general keywords (United Kingdom and England).

When inputting keywords, we can choose, via this preference panel, to use some delimiter (like a forward slash) when typing that will inform Bridge that those keywords are hierarchical.

Labels

My labeling system lets me know at a glance what each image in my view requires. If I see a blue label and the word "Master" I know that image is the result of some work.

If you customize your labels according to my scheme or one like it, be very sure that you do so on each computer you use. In fact, if you also use Lightroom, be certain that you set its labels *identically*, too. If you do not, the thumbnails will show a white label, though the text will be preserved.

Cache

To speed things up, Bridge uses a cache, a bit of memory to record the thumbnails and previews of your images. When you first look at the contents of a folder, it will take a few seconds (if there aren't too many images) or many (if there are) to generate thumbnail images. Be patient! If you don't let Bridge finish, you may corrupt the cache, necessitating its being purged. As you can see, purging can be done from this page in the Preferences.

Advanced

Choose whether or not you'd like Bridge to launch automatically at startup so it's handy when you need it.

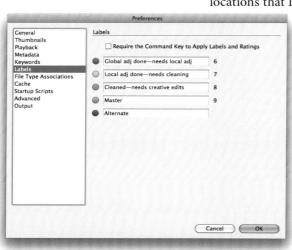

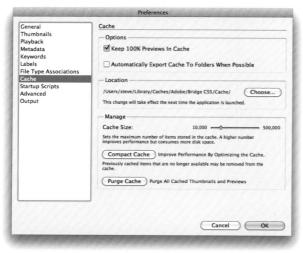

Output

Upon output, sometimes we need the color profile of an image file to change so it is correct for the recipient. Here, you'll find a checkbox to keep this from happening. In the last chapter, we'll examine whether this box should be checked more often than not.

Adobe Camera Raw (ACR) Workflow Options

We will examine the processing of RAW images carefully later. For now, we'll configure one of the few truly "sticky" settings in the Adobe Camera Raw dialog box: Workflow Options.

To get to this dialog, you may be using Bridge to look at any folder of images. Select one image by single clicking on it.

Then control+click / right+click on the image to see a context menu. Choose the option to Open in Camera Raw... At the bottom of the dialog box that appears, you'll see underlined text in blue. Those are Camera Raw's Workflow Options. Click on that text (it's supposed to look like a hyperlink) to get the dialog illustrated here.

As discussed in the previous chapter in the Working Color Spaces section, we should set the Space option to ProPhoto RGB. When you open this image in Photoshop, if it too is configured to use ProPhotoRGB, all the color information will be respected. If we should choose to use the robust and widely used AdobeRGB in Photoshop, I would still choose ProPhoto here in ACR to have as much data to work with as possible, and the colors will be converted to AdobeRGB when passed to Photoshop.

Set the Depth option to 16 bits/channel. 8 bits can be fine if you know you won't do any moderate to major adjustments later, but why take the chance? Many photographers leave this option set to 16 bits just to be safe. The only cost is increased file size and a slight restriction on features that can be used in Photoshop. Hard drive prices are low enough to ease angst about the former, and there are ways around the latter.

Resolution should be set to the default resolution for your typical output: 300 pixels/inch for most print devices, 240 or 360 pixels/inch for Epson inkjet printers, 72 pixels/inch for web images.

Camera Raw sets the Size option to match the default pixel count for the digital camera used. Other size options are available. An asterisk (*) option in the size menu identifies a high quality option for upsampling images for a few cameras.

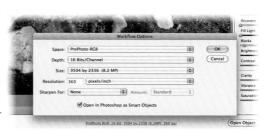

Lightroom

Lightroom is packed with many preferences and settings. As you work with the application you will no doubt need to refine these to your way of working. But the suggestions that follow are chosen with some care, so I suggest you start with them until you have reason to choose other settings.

One begins a journey through the preferences by choosing Lightroom> Preferences... (on the Mac) or Edit>Preferences... on Windows. More efficiently, one can use a keyboard shortcut <code>%+</code>, (comma) / Ctrl+, (comma).

	General Presets	External Editing File Handling Interface	
	Settings:	Show splash screen during startup	
		Automatically check for updates	
Default Catalog			
When exacting :	was this same	Load most recent catalog Prompt me when starting Lightroom	
when starting t	ip use this catalog	Prompt the when starting Lightroom	
Import Options		/Users/steve/Pictures/Lightroom/Lightroom 3 Catalog.lrcat Other	
Show import dia	log when a memory	y card is detected	
Ignore camera-c	enerated folder na	ames when naming folders	
☐ Treat JPEG files			
ompletion Sounds			
When finished importing photos pla When finished exporting photos pla		No Sound	
		No Sound	
rompts			
	(Reset all warning dialogs	
atalog Settings			
Some settings are c	atalog-specific and	d are changed in Catalog Settings. Go to Catalog Settings	

	General Presets External E	diting File Handling Interface
Default Develop Setting		
Apply auto ton	e adjustments	
Apply auto mix	when first converting to black an	d white
☐ Make defaults	specific to camera serial number	
☐ Make defaults	specific to camera ISO setting	
	Reset all default	Develop settings
Location		
✓ Store presets with catalog		Show Lightroom Presets Folder
Lightroom Defaults		
	Restore Export Presets	Restore Keyword Set Presets
	Restore Filename Templates	Restore Text Templates
Re	store Local Adjustment Presets	Restore Color Label Presets
CF SALES AND A STATE OF		ry Filter Presets

General

Most Lightroom users have one, all-encompassing catalog (Lightroom database) with which they manage their images. Some, however, may have several; for example, one for personal work, another for professional or portfolio work. If you suspect you will have two or more catalogs to choose from, then I suggest that you have Lightroom prompt you for which you're using each time you launch so it's easy to get started.

I really enjoy Lightroom's ability to automatically show the Import dialog when I insert a memory card into my reader. Just be sure that no other software (iPhoto comes to mind) thinks it's supposed to do the same.

If your camera always shoots RAW+JPEG, and you don't want the redundant JPEGs, you will not want to treat them as separate photos. However, if you mix RAW and JPEG yourself (serious shooting mixed with casual snapshots perhaps), then be sure to check this setting.

Presets

As so many issues we address when developing our images are the result of a particular setting (like increased noise when we use a high ISO) or specific camera, I like my customized defaults to be specific to these factors.

Also, as any one Lightroom catalog may find its way from one hard drive to another (from studio machine to laptop, for example), I like the presets I create to be stored with the catalog for easy access to them because they may sometimes need to be moved manually (by you).

External Editing

The preferences for External Editing, Edit in Adobe Photoshop CS5, should probably be set as illustrated here. This is especially true if you have configured your color settings as suggested in chapter 1 (this would also make Lightroom consistent with my suggestions for using Adobe Camera Raw). To open a Lightroom-edited image in Photoshop, select it in the Library Grid, then use either 第+E / Ctrl+E or control+click / Right-click on the thumbnail and choose Edit in Adobe Photoshop CS5. Before the document opens in Photoshop, you will see a dialog box. I recommend, unless you have reason to do otherwise, that you edit a copy of your original, but one that exhibits the edits you have already done in Lightroom (your global adjustments and light cleanup for example). You can even Stack this copy with the original so that they stay associated with one another.

File Handling

I like it to be easy to use hierarchical keywords, and the forward slash is so much easier to type than the "pipe" (|) character. Also, since I send images to people who use different operating systems, some with limited character support in file names, I decided to deem any questionable character (except spaces) as illegal.

Interface

Lightroom's interface is nicely customizable. Here, you can experiment freely and frequently to find what you like.

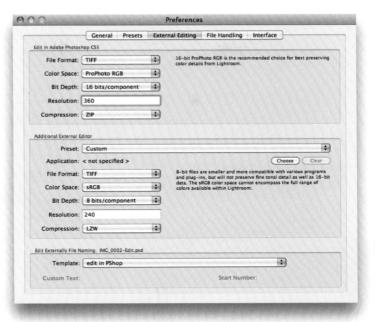

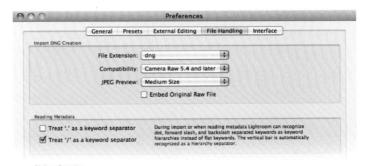

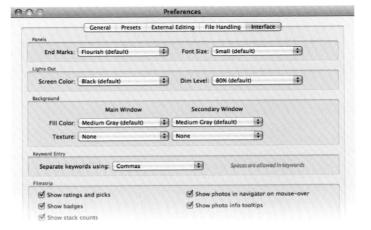

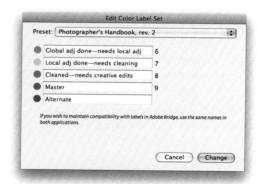

Lightroom also offers other dialog boxes in which to configure the look and feel of the application.

Under View>View Options and Metadata>Color Label Set>Edit you'll have the opportunity to establish what data gets displayed with your image thumbnails.

Note: Be sure to set your Label text **identically** to Bridge's so they can be viewed successfully in both. By "identically", I mean right down to capitalization and punctuation. Also, be sure to do this on each computer you use.

Catalog Settings

It's possible to get to your Catalog's settings by going to Lightroom>

Catalog Settings... (on the Mac) or Edit>Catalog Settings... on Windows—or the keyboard shortcut \(\mathbb{H} + \text{option} +, (\text{comma}) \) (\(\text{Ctrl+Alt} +, (\text{comma}) \).

General

I like to have a backup of my Catalog(s) made each day that I use them. Note that this is **not** a backup of your images, but only of Lightroom's Catalog file in case it should become corrupt.

If it's behaving poorly (slow to respond), you can also use the Relaunch and Optimize button to see if Lightroom can heal itself. I find this is good to do after any particularly long and complex work session, too.

File Handling

Having Lightroom discard its full size previews (1:1 Previews) after 30 days is a good policy so that your Previews file doesn't grow to unwieldy sizes.

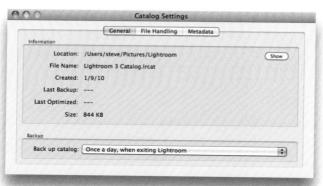

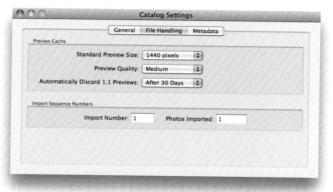

Metadata

Keep in mind that everything that Lightroom does is kept in metadata. And until that metadata is written to the file itself, it is in Lightroom's Catalog only. This is why I suggest that after working on a set of images, you should select those images, and press <code>#+S/Ctrl+S</code> (or choose Metadata>Save Metadata to Files).

Why should I recommend that you manually save your metadata to your image files rather than use the preference available here that allows you

to "Automatically write changes to XMP"? The answer is performace. As you work, making one subtle adjustment or another, that preference would try to write that adjustment to both the Catalog file and the image file, causing a performance loss that I and many users find unacceptable. So we rely instead on the same keyboard shortcut we use in any other application to save our work: #+5 /Ctrl+5.

Some applications outside of Adobe's family of products may not be able to handle reading the more complex development metadata in JPEGs or TIFFs. So if you use those file formats, or if you expect to send those file formats to recipients with limited software choices, then be sure to Export copies in those formats and not use the files you've edited in Lightroom. This way you can continue to write that metadata to those formats as illustrated here.

If you travel, you may forget to change the time in your camera to the time zone of your destination, causing your images to be marked with the wrong date or time. A new option in Lightroom 2.0 allows date or time data to be written directly into proprietary RAW files as well as DNGs!

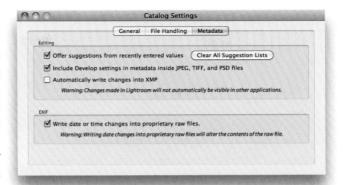

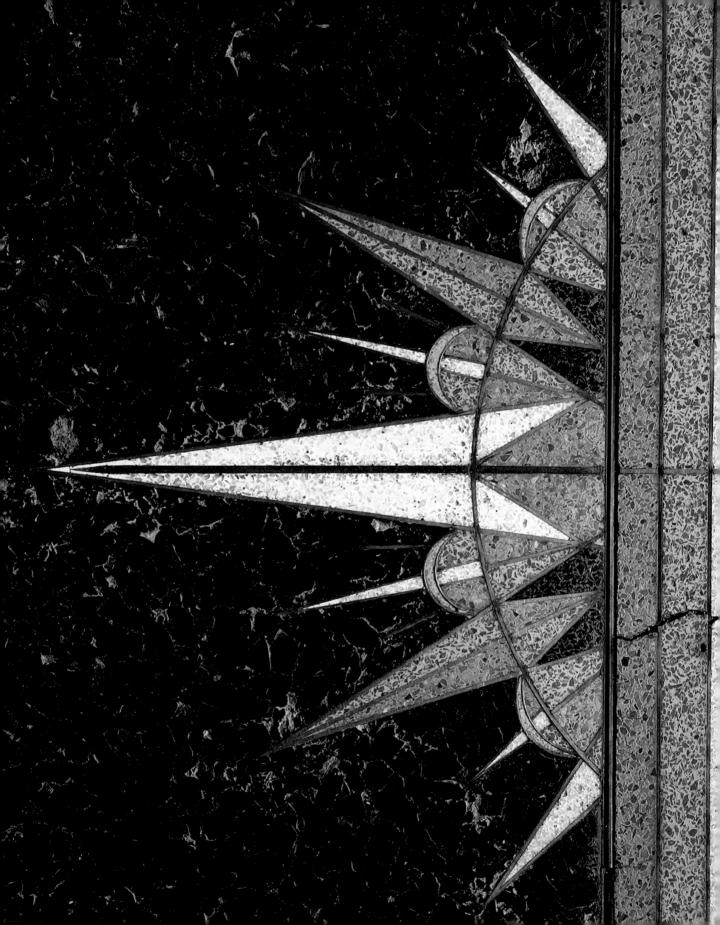

The Interface: A Tour

3

For any workflow to actually flow, one needs to develop comfort with the tools at hand. For example, it becomes tedious and slow to examine an image if one is unfamiliar with the fastest ways to zoom and pan.

Also, our software needs special care and feeding. Without enough disk space, Photoshop becomes unstable. What's enough? More than you might think. Lightroom gets testy if you move an image on disk without using its interface to do so. These and other "quirks" can cause frustration if not grief.

In this chapter, I'll give you the insight you need to really own your software. We'll learn how to rapidly zoom in and out and pan around even the largest images, how to leap from one image to another, and from one application to another. I'll also examine those features that shouldn't be used hastily!

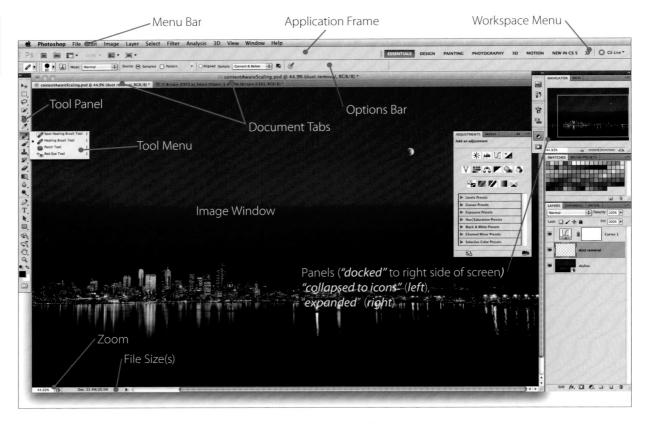

Finding Your Way in Photoshop

This chapter introduces the basic interface of Photoshop: its Tools, Panels, Options Bar, and Image window. If you're comfortable with these topics, skip ahead to the next section of this chapter or to the next section of this book. The main goal of this chapter is to identify the basic skills and vocabulary of Photoshop, Bridge, and Lightroom that are used throughout this book.

The image above shows the main elements of Photoshop. Be sure you have an image open if you want to experiment with the interface, as many Photoshop options are not available if no image is open.

Panels & Workspaces

Photoshop has many different panels for evaluating and editing your image. Panels are very useful for monitoring the various elements of your image, especially as your image becomes more complex.

Panels can be visible, grouped, docked, collapsed to their icons (and names if you like), or hidden.

By default, visible panels are docked to the right edge of your screen, with a few groups fully expanded in a column at the far right. Each panel

may be dragged by its icon or name. If you drag one away from its dock, you may let it float freely on screen, put it elsewhere in a dock, or even group it with other panels. Try it! It's actually quite easy to customize your workspace this way. Watch for the blue lines that tell you when your panel will dock to some other. Notice the blue highlighting that results when you drag a panel below, next to, or atop another. What happens when you drag a panel to the *left* side of the screen?

Docks and free floating panels in the workspace can be resized. You can resize column widths by dragging the line at the left edge of the column. The double arrows collapse or expand the column. Notice that the arrows change direction when open or closed.

Visible panels can have other panels grouped with them. These appear as named tabs behind the visible panel's name. To make these panels visible, just click on their tabs. If you look carefully, you'll see that even the icons are in groups.

Panels that are collapsed to icons allow oneclick access without cluttering up Photoshop. Collapse the panels you use but do not usually need to see.

Panels are hidden when you close the panel window. A panel can be made visible again by selecting it from the **Window menu**.

Note: When you need a panel that is not currently visible, find it listed under the Window menu, where all panels are listed.

Each panel has its own menu with options for customization. It can be accessed by clicking on the tiny menu icon in the upper right of the panel.

Managing Panels

When you first run Photoshop, there are three panels immediately available, and another seven that are one click away. For image editing, some of these are seldom used. So let's rearrange the panels:

- If you've got a panel mess (maybe from experiments rearranging panels), let's clean them up by selecting Reset Essentials (default) or Photography (what photographers need most) from the Workspace menu in the upper right.
- 2. Choose Window>Brush. Brush and Clone Source appear, with Brush expanded. Click on the Brush panel icon to collapse it. Also add the History panel, Window>History, and collapse it.
- 3. Return to the Workspace menu in the upper right of your screen. Choose Save Workspace... You may now have your own workspace with a name you choose. You'll notice that workspaces can also include modified keyboard shortcuts and menus! Try those alterations later.

HISTOGRAM

Ps

You can now access any of the visible and docked panels by clicking on the tab or icon for that panel. Take a look at the panels that are left. You will use the Adjustments, Masks, Info, Histogram, History, and Layers panels (and occasionally others) throughout this book. As you can see, Adobe software applications are panel heavy.

You can hide all of the panels (including the Tools Panel and Options Bar) by pressing the **tab** key; pressing **tab** again makes them reappear. If you hold the **shift** key when you hit **tab**, the tools and the Options Bar will remain while the other keys' visibility is toggled.

Some Important Panels

Histogram panel This should look familiar to any photographer who's enabled this feature in-camera. It displays the tones (levels or shades of gray) in our images. On the left are the dark pixels, light ones to the right. Tall spikes indicate a large number of pixels with a given tonal level.

Adjustments panel This panel has two basic states: one for choosing adjustments, the other for editing them. Choose the adjustment generically by clicking on the desired adjustment's icon in the top half, or with a starting adjustment by choosing one of the many presets in the lower half. Once you have chosen, the panel displays the controls you need to fine tune the adjustment.

Masks panel You will sometimes want to prevent an adjustment from affecting an entire image (e.g., lightening only a dark corner or whitening a model's teeth). We use masks to protect pixels from an effect. This panel lets us start with rough masks and refine them. Much more will be said on this later.

Info panel We use this to display color information for the pixels under the cursor as it is passed over the Image window. It can also give you hints for the tool that is currently in use, the position of the cursor, and the file size of the image. Some Photoshop users never remove this panel from the screen.

History panel This panel lists the past states of the image. Each time you edit the image in some way, that state is recorded. You can use the History panel to quickly jump to former states, much like multiple levels of undo, but better, as you can traverse many states at once. However, this is limited to one editing session: once the image file is closed, the histories are deleted. Also, there is a finite number (20 by

default) of states that can be accessed.

Layers panel Here is where you create and examine the structure of your

image file. We'll be looking at layers more later, but you should start to think of them as stacked transparencies or sheets of clear plastic with images on them. Some layers act as color adjustments for the layers below them, much like colored gels might (Adjustment Layers are what get created when you use the Adjustments panel). Other layer types can have effects

and filters put on them, such as sharpening and other corrections.

Brush panel Yes, photographers have to know how to paint, too. Well, just a little. We use tools that embrace a painting metaphor to mask, retouch, and sometimes to adjust areas of images. Being able to build the right brush tip is a very useful skill, and the means to do so are in this panel.

Clone Source panel This panel's purpose will be better understood when I describe retouching later. But briefly, this panel lets you configure those tools we use in retouching so they can automatically scale and rotate material from one part of an image as it's used to repair another.

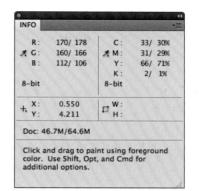

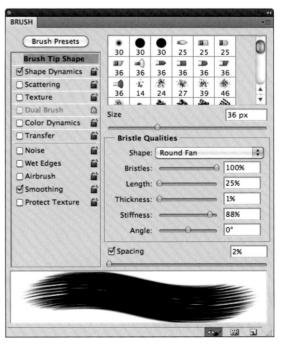

Channels panel Channels hold the net color data of our image. Harkening

back to the world's first color photograph, we think of these as the metaphorical transparencies we discussed in the first chapter, each of which controls how much red, green, or blue light pass through to our eyes. There can be additional channels to store data as gray-scale information (which pixels are masked, for example, or which pixels were selected and may need to be again). These extra channels

are called *alpha channels*. Also, print professionals work with CMYK channels to establish what percentage of each of those 4 color inks will be placed on paper. We will restrict our conversation to RGB channels.

Actions panel After you develop fluency in Photoshop, you may want to

"record" sets of actions you regularly perform. This is especially handy for those tedious tasks that need to be performed on many images. Plan to return to this topic after you have explored doing tasks yourself.

The Tools

The tools in this panel allow you to work directly on the image: selecting, painting, adding text, etc. Generally, you'll select a tool, move your mouse pointer over the image, and use the tool directly on the image by clicking or dragging on the image.

Tool Tips The Tool Panel shows **tool tips** for each tool. Point your cursor at a tool, wait a second and a tool tip will appear. The tool tip displays the tool name plus the keyboard accelerator used to select it. As seen in the illustration, the Clone Stamp tool can be selected by pressing the 'S' key.

Note: Most of the tools change the cursor when the mouse moves over the Image window to reflect the selected tool.

The Tool Panel includes a number of hidden tools. A tiny black triangle identifies the tools having hidden tools beneath. Access them by pressing the mouse on a single tool icon or you may control+click/right-click on a tool to see its companions.

Each tool has a set of options for customizing its function. When you select any tool, the Options Bar (just below the Application Frame near the top of the screen) changes to display the options for that tool.

You apply a tool with its current settings by clicking or dragging on the image. For example, clicking on the image with the paint tool makes Photoshop paint the Foreground Color onto the image. Other tools may require an initial step before they can be used.

Keyboard Shortcuts and Modifiers

Although I've already mentioned several keyboard shortcuts, I'm not going to provide a long list of keyboard and mouse-click accelerators. A list is just not a practical way to learn them. But, to learn *some* of them makes it much easier to focus on editing rather than navigating through menus each time you need to find a particular command.

Many shortcuts are easy to find right in the Photoshop interface. For example, if you repeatedly use a menu item, note the keyboard shortcut listed just to the right of the command's name, then use it instead. You'll quickly get the hang of it. (This may sound trivial, but few people use this easy technique for learning shortcuts). Soon, the commands that used to take a lot of time to apply will literally be close to hand.

There are many additional accelerators hidden within Photoshop. I use a number of them, and, as necessary, identify them throughout the book. Photoshop also has a number of context menus that accelerate access to various functions—accessed by a control+click / right-click. Some interface elements have a small circled triangle • that is used to access more options. And note the tiny menu icon in the corner of panels. Explore what these are hiding!

Note: Finally, you probably already know about Undo— <code>\(\frac{\pmathfta}{+Z} \) (Ctrl+Z). This is likely the most important shortcut in Photoshop. It makes editing safer: knowing you can always undo a change that doesn't work out. Note, however, that the Undo command toggles between Undo and Redo—if you select <code>(\pma+Z)/Ctrl+Z)</code> once it will undo, but a second time will Redo the previous command. This is great for evaluating the most recent edit, giving a quick "before and after" toggle.</code>

Menu Customization

Photoshop CS5 has the ability to customize the items that appear in the menus. This is a terrific feature since it allows you to clean up your menus by hiding many of the less frequently used features. I don't use any custom menus in this book, but you may wish to consider this feature as you grow

Ps

comfortable determining which features you can do without, or use it to highlight in color those items you can't afford to miss.

Navigation and Viewing

As you edit your image, you will need to change the view of the image—zoom in and out, pan around the image, and change the gray background Photoshop displays around the image. Two important views are Fit on Screen and Actual pixels. The keyboard shortcuts for changing the view of the image are very useful, since they allow you to change the view at any time, even if you are in the midst of an operation (e.g., defining a crop area with the Crop tool or correcting color with Levels). It can be important to change the view of the image as you are making edits.

Fit on Screen

Often, you will want to view the entire image as large as possible within the Photoshop window. This viewing mode is called Fit on Screen; access it by selecting View>Fit on Screen or by pressing \$\mathbb{\mathbb{E}}+0 /\mathbb{Ctrl+0}\$ (that's a zero there!).

In most cases, when the image is sized to Fit on Screen, there are many more pixels in the actual image than can be displayed on the screen. This used to cause some artifacts in the view of the image. However, Fit on Screen works great in Photoshop CS5 to see your whole image in one view.

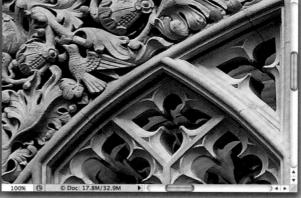

© bath abbey interior29.psd @ 100% (Photo Filter 1, Layer Mask/16

This image at 25% magnification has 16 of its pixels mapped to each monitor pixel. (Only 1 in 4 across as well as up and down.)

This image at 100% magnification, or Actual Pixels, has each of its pixels mapped to a monitor pixel. This is the best magnification at which to view an image, or at least the part that fits on the screen.

Actual Pixels

Sometimes you need or really want to see each individual pixel for editing. For this, use the **Actual Pixels** mode; select View>Actual Pixels. In this case, **each image pixel is mapped to exactly one screen pixel**. In most cases, you will only be able to see a portion of the image on the screen.

You can select View Actual Pixels by double clicking on the zoom tool, or fastest by hitting <code>#+option+0</code> / Ctrl+Alt+O (zero).

The Hand Tool

The Hand tool is always available. To fully switch to the Hand tool, you would tap the **H** key. But we rarely need to use the Hand tool for more than a short time while we're using other tools. So I just *hold down* (not just press) the **H** key to get the Hand tool, then I press and drag with it to move my view of the image around. Using this "toggle", you get a bird's eye view; that is, while you're pressing and dragging with the Hand tool, Photoshop temporarily zooms out but shows you a rectangle representing the area to which you are really zoomed.

When I'm done panning, I release the **H** key, the area within the rectangle fills the Image window, and I see that I'm using the tool I had been previously. The hand tool used in combination with the zoom in and zoom out key commands allows you to see all of the details of the image. In versions of Photoshop before CS5, one used (and still can use) the **Spacebar** as a toggle to the Hand tool without the bird's eye view.

Professional Zooming

Zooming In and Out: It's easy to zoom in and out of the image from only the keyboard. You can hit <code>#+[Plus sign]</code> / <code>Ctrl+[Plus sign]</code> to zoom in or <code>#+[Minus sign]</code> / <code>Ctrl+[Minus sign]</code> to zoom out, both in predetermined units.

To zoom to *exactly* the area you want, not too much or too little, try this: hold down the **Z** key then "draw" a box with the magnifier cursor that should appear. That area should now perfectly fit your Image window!

Instead of drawing a box, you can also hold the mouse button down with the cursor centered on the area to which you want to zoom. This will give you an animated zoom. Pressing the mouse button down while holding option+Z /Alt+Z animates zooming out.

Use Fit on Screen— #+0 /Ctrl+0—to see the whole image again.

You can also create a second window of the current image (one for each of two magnifications, perhaps): select Window>Arrange>New Window for [document name]. When any pair of windows need to be seen at once, use the Arrange Documents button in the Application bar (illustrated here). Two windows of the same image file work on the same image pixels, and all your edits will simultaneously show up in both/all. Some users like this so they can see "the big picture" in one window while doing delicate edits in a zoomed view.

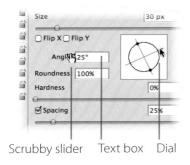

A Navigation Exercise

The **tab** and **F** keys can be used to quickly change the Photoshop workspace around your Image window. The **tab** key hides and displays all of the Photoshop panels. The **F** key switches Photoshop between **Standard Mode**, **Full Screen Mode with Menus** (your image will be placed center screen on the Photoshop workspace), and **Full Screen Mode** (your image will be placed center screen on a field of black). These allow you to quickly view your image without much clutter. Try pressing **tab** (to remove the panels), **F** *twice* (to go to Full Screen Mode), and **%**+0 / Ctrl+0 (zero) to Fit on Screen. Press **tab** and **F** to return to the standard viewing mode.

Note: Watch your cursor for time-saving user interface elements. Instead of fumbling with menu arrows (), use Scrubby sliders (drag left and right when they appear, and the value they control changes). Instead of entering numerical values, use dials.

Vital Features

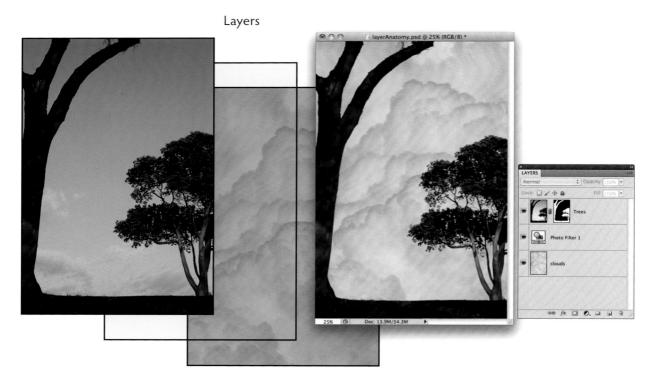

Many readers of this book may already be comfortable working with layers. But, there is always something new to be learned, even for very experienced users. So please review these features.

Understanding layers is the most essential step to understanding Photoshop. The classic way to visualize layers is as stacked sheets of transparent film with images on each one. This stack visually combines to create the final image, with each layer obscuring the layer below it (Note the names in both the illustration below and the Layers panel opposite).

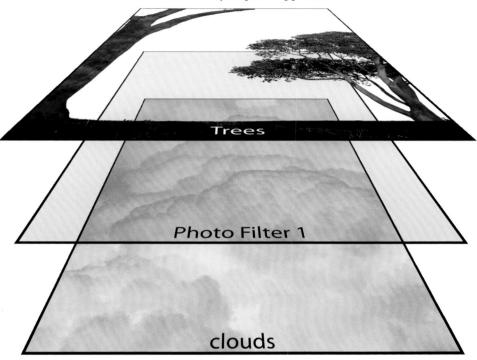

There are three main classes of layers:

- ► Image Layers
- ► Adjustment Layers
- ► Smart Objects

Image Layers

Image layers are independent images that can be stacked on top of one another to form the final image. (Photoshop refers to these simply as 'Layers', but in this book, we'll often use the term 'Image Layers' to distinguish them from other layers.) The **Background**, which is usually found at the bottom of the stack, is the Image Layer containing your original image. It can be renamed as in this example. Other layers are often used in conjunction with the **Background** to create a final image.

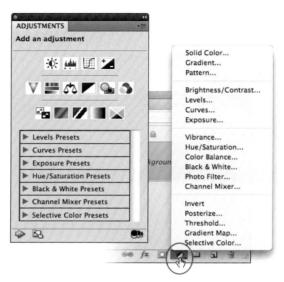

Adjustment Layers

You *may* apply adjustments to your background image directly by using the individual adjustment tools that are found under the Image>Adjustments submenu. These tools apply their adjustments to the image's pixels. However, once the adjustment is applied, the image is changed; these changes are irrevocable once the image is saved and closed.

That is why I prefer to make adjustments using Adjustment Layers. These act as filters over your image to apply the adjustments as the image is viewed (or printed), but do not actually alter the underlying image.

Adjustment Layers don't contain image pixels, but color and/or tonal adjustments to the layer(s) beneath them. You can apply many Adjustment Layers to your image to change its brightness, contrast, or color.

The whole image is a blend of the stacked Image Layers and Adjustment Layers from the bottom up—applied adjustments and added images form the final desired image.

You can create an Adjustment Layer in several ways. One is to use the Adjustments tab: click on the adjustment you want, and the layer appears, and the Adjustments tab shows the controls for that adjustment. You may also click on the Adjustment Layer button at the bottom of the Layers Panel. Finally, you may select the Layer>New Adjustment Layer command.

Note: Whenever possible, it is best to apply Adjustment Layers rather than applying the adjustments directly to the image.

When you create an Adjustment Layer, you should consider naming your layer based on the adjustment task that you will perform—something like "Brighten" or "add Contrast"—this makes it much easier to find the appropriate Adjustment Layer when you are editing the image at a later time. Use the Adjustments panel to make your adjustment—a panel you should explore.

The new Adjustment Layer will appear in the Layers panel. Each type of Adjustment Layer has an icon to identify it (if your thumbnails aren't large enough: make them larger by <code>control+clicking</code> / <code>right+clicking</code> a thumbnail and choosing Large Thumbnails). You can disable or enable the adjustment by clicking on its "eye-con", the eye icon to the left of every layer. Each Adjustment Layer also has an associated mask. These are completely white (the adjustment evident everywhere) by default, but can be painted black or white to localize where the adjustment should be applied.

One significant advantage of Adjustment Layers is the ability to return to the adjustment dialog and fine tune your adjustments. This is often referred to as "nondestructive" editing, since the underlying image is not actually changed by the Adjustment Layer, just the displayed or printed image. To change the adjustments in an Adjustment Layer, click on the Adjustment Layer that you wish to edit. The Adjustments Panel will show the previously applied adjustment. You can then fine-tune it. Using multiple Adjustment Layers makes it easy to develop the cumulative effect desired.

You will use Adjustment Layers significantly in the Global Adjustments and Local Adjustments sections of the Workflow chapter.

Smart Objects

Smart Objects are very special layers that can be made in several ways. For photographers, their primary use is as layers that "remember" their original condition no matter how much editing (color correction, resizing, filters such as sharpening, etc.) is done to them! The use of Smart Objects usually adds to file size, but diminishes worry and hard work when edits need to be reconsidered. I like to think of them as containers that protect the original data but allow me to alter their visual appearance repeatedly but nondestructively.

Naming Layers

It is wise to name your layers. Although Photoshop assigns default names to all layers like "Background copy", "Layer 47", or "Curves 1", these provide little useful information. Assigning your own useful names makes it easier to find and edit the appropriate layers later. If you create or duplicate a layer using the Layer menu (or the keyboard shortcuts listed in that menu), Photoshop provides you with a dialog to name the layer before creating it. Even if you end up with a default name for your layer, double-click that name and Photoshop will let you rename it.

Copying Layers

Drag and Drop! It is possible to copy a layer from one image file to another merely by dragging the layer from the source image's Layers panel and dropping it onto the destination Image window. You can also copy a layer from one image to another by selecting the layer in the source image and using the Layer>Duplicate Layer command. In the Duplicate Layer dialog, change Destination Document to the destination image.

Ps

Layers Panel Buttons

Along the bottom of the Layers panel are several button icons you can use to quickly edit your layers.

Click on the **Trash button** to delete the currently selected layer(s). Or you can drag a layer to the trash button to delete it.

Click on the **New Layer button** to create a new, empty Image Layer. Or you can drag any layer to the New Layer button to make a copy of it. Hold down the **option** / **Alt** key when using this button and Photoshop will give you a dialog to name the new copy.

Click on the Adjustment Layer button to get a pop-up menu for the Adjustment Layers available in Photoshop. Select one to create it. Hold down the option / Alt key when selecting an Adjustment Layer and Photoshop will give you a dialog to name the new Adjustment Layer.

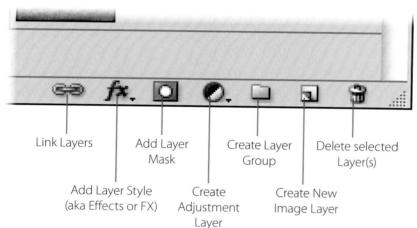

Click on the Mask button to create a new mask. Photoshop creates a mask that is either white everywhere or a mask that mimics a selection if you have a selection in the image. You need to create a mask only for Image Layers, since Adjustment Layers automatically have an associated mask. If your Image Layer already has a mask, it is possible to create another mask (a vector mask), but that flavor of mask is beyond the scope of this book.

Layer Styles (e.g., Drop

Shadows) are used by graphic designers and much more rarely by photographers. Linking layers requires you to highlight two or more layers, then to click on the Link Layers button. From then on, these layers will move and transform in unison.

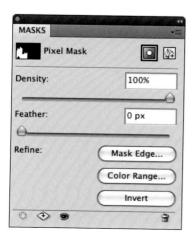

Layer Masks

Layers often have an associated black and white mask that defines where the layer is visible or hidden. You can use a mask to localize the effect of an Adjustment Layer, or limit where an Image Layer is visible. Where the mask is white, the layer (either image or adjustment) is visible; where it is black, it is hidden. By default, new masks are entirely white: that is, the layer is completely visible.

Masks are most often created from selections. Selections define a region of an image and these can be converted into masks. Masks can also be painted with black or white (to conceal or reveal a layer, respectively) or a shade of gray to give partial opacity, using the **Brush** tool.

Masks are a vital part of Photoshop. Though you'll often find yourself paint-

ing a mask actively in the Image window, you won't see the black or white paint: just the image appearing or disappearing! A glance at the Layers panel will reveal that the mask has indeed been changed.

© A3Layers.psd @ 82.3% (Abbey Tower, RGB/16) *

© A3Layers.psd @ 82.3% (Abbey Tower, RGB/16) *

© roman bath 14 as Smart Object-1 @ 33.3% (roman base)

ve editing that even ble. Using the Masks your masks. I'll have a Lagal Adjustments

Photoshop is so invested in nondestructive editing that even masks can be edited in ways that are reversible. Using the Masks panel, you can finesse the edges and extent of your masks. I'll have more to say about masks and their use in the Local Adjustments chapter.

A Typical Document's Layers

The Background layer is always labeled *Background*. It is a special type of Image Layer with key limitations. There can be only one, it must be at the bottom of the Layer Stack, and it can have no mask

or any transparency. Its presence is actually optional for the PSD and TIFF formats (so there may not even be one), but for other file formats (e.g., JPEG) it is the *only* layer that can be present. More on these formats and their limitations later.

Each Image Layer has its own thumbnail displayed to the left and its associated mask, if there is one, to the right of the layer thumbnail.

The active layer (the one currently targeted for editing) is high-lighted. Any edits you make apply only to the active layer. You can select more than one layer at a time, but only a few edits, like movement and scaling, can be applied to more than one layer simultaneously.

Each Adjustment Layer has a thumbnail icon representing the type of adjustment it is to the left, and its associated mask to the right—by default all Adjustment Layers have a mask filled with white (and therefore active everywhere).

The eye to the left of each layer is sometimes called the "eye-con". Click it to make its layer visible or invisible. option+click / Alt+ click on the eye-con for any layer and all *other* layers toggle their visibility.

Note the subtle border around the Layer thumbnail (above) and the Layer Mask thumbnail (below). Less subtle is the identifier in the title bar of the image.

© A3Layers.psd @ 82.3% (Abbey Tower, Layer Mask/16)

- 1. The picture of the tree bark was originally the **Background**. It was converted to a **Smart Object** and renamed "Tree Skin".
- 2. Two filters, Smart Sharpen and Lens Correction, were applied nondestructively to the Tree Skin Smart Object. To limit the extent of those filters, the **Smart Filter Mask** was painted with black in areas.
- 3. Two new Image Layers were added: one holds some retouching and is "clipped" to the Tree Skin layer, the other brought below the Tree Skin layer and filled with green and converted into a new Background.
- 4. A blurry, oval mask was added to the Tree Skin layer so that it fades at its edges, allowing the new background to be seen there.
- 5. Finally, two Adjustment Layers were added: one to increase contrast, but masked to affect only the greenish areas, and the other to "cool" the whole image a bit, as it was just a little too red overall.

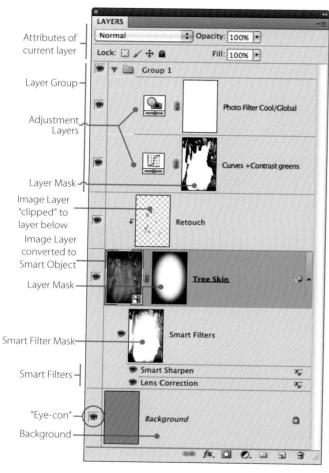

Filters

Filters are the means by which we can affect groups of pixels. A classic and easy to use filter is Gaussian Blur. When used, pixels appear to smear into one another. Its dialog box has a small preview window, a preview checkbox for displaying the filter's results in the Image window, and a slider for controlling the amount of blur.

Some of the remaining 109 filters can be very complex. In fact, some were formerly software applications in their own right! Typically, all filters have been applied to Image Layers with results that are difficult or

impossible to reverse. With the invention of Smart Objects, the destructive nature of most filters has been tamed.

Smart Filters

When applied to Smart Objects, filters are known as Smart Filters. The most complex and exotic filters (e.g., Liquify, Vanishing Point, Lens Blur) cannot be applied as Smart Filters, and thus are often applied to duplicate Image Layers if one wants access to the original pixels again.

A Final Appeal for Smart Objects

Adjustment Layers are great: they can be applied, revisited, and removed if you change your mind. The same can not be said of Filters and a few other features (such as the correction tool called Shadow/Highlight) unless you convert Image Layers into Smart Objects.

However, if you convert one or more layers to a Smart Object, then you can enjoy the same non-destructive editing with these traditionally pixel-destructive tools.

To see what I mean, try the following experiment:

- 1. Open an image in Photoshop. Duplicate the image by choosing Image> Duplicate (give the file a name with the word "smart" in it).
- 2. Return to the original image.
- 3. Go to the menu command Filter>Blur>Gaussian Blur. Choose a blur Radius of about 20 pixels then click OK.
- 4. Go to the duplicate file. The image will likely be on a Background.
- 5. Convert that **Background** to a Smart Object: **control+click** / **Right-click** on the Background layer's name in the Layers panel and choose Convert to Smart Object.
- 6. Now for this Smart Object, go to Filter>Blur>Gaussian Blur. Choose a blur Radius of 20 pixels then click OK.

What you should see is the Gaussian Blur listed below the Smart Object's name. That makes it a **Smart Filter!** If you change your mind about the strength of the blur, just **double click on the name of the filter**, and you can change it. Click on the "eye-con" to turn the filter on and off.

Remember, you can select several layers then convert them all to a single Smart Object. If you later wish to edit any one of those layers, you can

double-click on the Smart Object's thumbnail. After a startling dialog box, you will see a new, temporary document containing those original layers. When you've finished editing them, simply choose File>Save and File>Close. Your Smart Object will update, and any Smart Filters you applied will automatically update, too.

The Gaussian Blur filter dialog box. One of the simple ones.

After editing the contents, choose File > Save to commit the changes. Those changes will be reflected upon returning to TreeSkin.psd.

The file must be saved to the same location. If the Save As dialog appears, choose Cancel, and flatten the image before saving.

Finding Your Way in Bridge

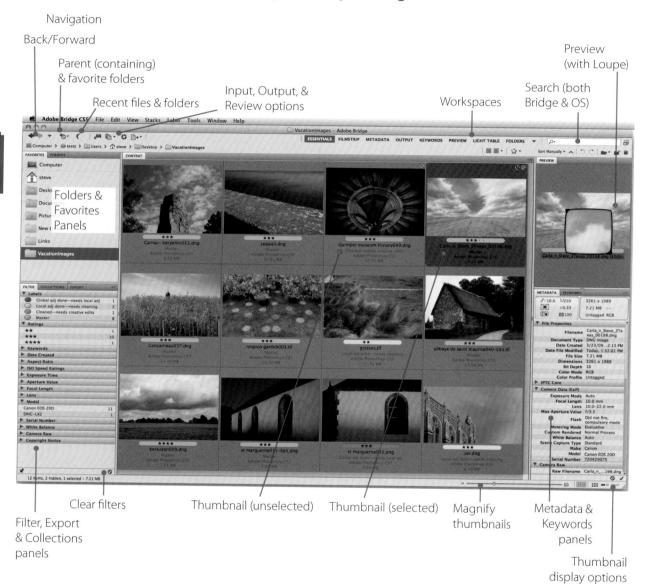

What is Bridge?

Remember that Bridge is primarily a way to look deeply into a folder of files on your system. It also lets you sort, rate, and organize those images in dozens of ways. But remember that Bridge is not a "normal" application in that it doesn't open documents, let you work on them, save them, etc. It's a *viewer*.

So it remains up to you where you store your files. Bridge may be able to help you find them, but mostly it's a way for you to enjoy the organizational system that you first design.

Exploring Bridge—A Guided Tour

The Bridge window has panels as Photoshop does. You can rearrange, resize, and close these panels. You can access Bridge Workspaces from their menu/names in the upper right (e.g., Light Table with only the Content panel, Metadata with a details view in the Content panel and more space given to the Keywords and Metadata panels, and the Essentials with a good balance of those panels and a Preview panel). Let's use the Essentials.

- Use the Favorites panel to navigate to images in frequently accessed folders on your computer. If you loaded images to your operating system's Pictures folder, click on it.
- 2. If the images are elsewhere, use the Folders panel to navigate as you would in Explorer (Windows) or the Macintosh list view.
- 3. When you find a folder with images, click (just one click!) on an image thumbnail. (Double-clicking opens the image—that comes later).
- 4. Notice that the Preview panel is now showing a larger version of the image.
- 5. Find another image not adjacent to the first. Hold down **#/(Ctr)** and click on it. Both are now selected. Or hold down **shift** and click on another. This selects a range of images.
- 6. Click on one of the images in the Preview panel. You've discovered the Loupe! Drag it around to get a closeup view of the image's pixels. You can use your mouse's scrollwheel or the + or keys to zoom the Loupe.

 #+Shift+A / Ctrl+Shift+A deselects all images.
- 7. Select just one image in the Content panel. Look at the Metadata panel for technical data about that image. Turn down the disclosure triangles to see more data. (IPTC Core holds the data you can apply from a Metadata template when downloading images, like copyright and contact data.)
- 8. Select several related images. Choose Stacks>Group as Stack or use the shortcut <code>#+G/Ctrl+G</code>. This is a great space-saver! The number tells you how many are in the stack: click on the number to expand or collapse the stack. Clicking the second (shadow) border selects just the front image or all images in the stack.

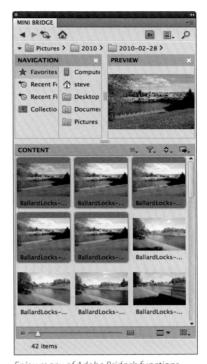

Enjoy many of Adobe Bridge's functions without ever leaving Photoshop CS₅! Try the new Mini Bridge panel.

If there are ten or more images in a Stack, you'll see a "Scrubber" button at the top of the thumbnail when you hover over it. Slide it back and forth to see previews of the images in the Stack.

Br

Sorting & Filtering

If the location of the folder you are examining is not shown, choose Window>Path Bar. Now at a glance (at left) you can see where in your system the folder is that you are examining. Toward the right you'll see a menu Sort by Filename for choosing by what criteria those images are sorted and, with the arrow to its right, what order.

The Filter panel lets you choose which images are visible. For example, if you see multiple items under the filter category File Type, you may click on one to limit the images shown to that file format. In the illustration, there are both TIFFs and DNGs. If I wish to see only my RAW (DNG) files, I'd click on that type and the TIFFs would disappear. Click on the same filter or the \bigcirc icon at the panel's base to disable it.

If there are subfolders within the folder you are viewing, and you wish to see their content, choose View>Show Items from Subfolders. Return to the same command to disable it.

Metadata

Your digital camera collects more than pixels. It also records data about that image data. It notes the date and time each photo was taken (have you set the *correct* date and time on your camera?), exposure data, some camera settings, what camera it is—right down to the serial number, usually, and much more. We call all this data about your image metadata.

Bridge offers ways of sorting through your images and reducing the visual clutter by filtering based on almost any imaginable combination of metadata.

This system is so powerful, that I know photographers who put all their images in one mighty folder without a single subfolder! I'm not so brave, but I don't use a very complicated folder structure.

I'll share more about metadata later. But keep in mind that there are many ways to take advantage of it—and we shall.

Searches & Collections

How would you find a few images in a single folder with thousands of them? If you choose Edit>Find... or use the shortcut <code>%+F/Ctrl+F</code>, you'll get a dialog box that lets you build exacting search criteria. You can add criteria by using the + sign at the right of any of the criteria present. Then you can decide if you want to match any or all of those criteria.

Once the search is complete, the images that meet those criteria are in the Content Panel. You'll notice the search criteria at the top of the Content panel along with a few buttons. The images displayed are the images that match those criteria *right now.* If you want to maintain

right now. If you want to maintain an ongoing watch for those and newer images, click the Save As Smart Collection button () near the New Search button.

The new Smart Collection appears in the Collections panel. From then on, just click on that item, and your search will be performed for you again.

Integration with Other Applications

Finally, for now, I'd like you to look under the **Tools** menu. Later, I'll help you develop a Metadata Template so your most important metadata is automatically attached to all your images directly upon downloading them to your computer.

But lower in that menu are menus for each Adobe application you also have installed. In the case of Photoshop, you may select a number of images in Bridge, then choose Tools>Photoshop>... then one of the choices present for automated production of those images.

For example, if you've correctly shot a series of exposures to be combined as a single High Dynamic Range image (HDR), you would select those files, then choose Tools>Photoshop>Merge to HDR... Then you would be presented with the dialog box that lets you customize that process.

Finding Your Way in Adobe Camera Raw

It is either in Adobe Camera Raw (ACR) or Lightroom that many of us perform our global image adjustments. So we will be spending a lot time examining this dialog box in that chapter. For now, navigate to any image using Bridge, then control+click/Right-click on it choosing Edit in Camera Raw...

Tools

The Tools in ACR allow editing on our RAW image captures. There are tools for cropping, straightening, retouching, and applying local adjustments in either a painterly fashion or as gradients. Unlike Photoshop, these tools operate nondestructively by default. Like everything else in ACR, the tools make changes not to the image pixels directly, but to metadata only.

They are risk-free!

Image Adjustment Tabs

To perform global image adjustment tasks, we work our way down and across these tabs. From simple Brightness and Contrast tweaks to sophisticated corrections for our lens' defects, we can use these controls to make these changes (again, nondestructively).

Shortcuts & Navigation

Many of the shortcuts that we use in Photoshop apply here in ACR, too.

%+Space / Ctrl+Space gets us the Zoom tool, with which we can draw a box around the pixels we want to see closer.

- ► The **Spacebar** allows us to pan with the Hand Tool.
- ► If we're editing more than one image and have the filmstrip on the left, we can use ૠ+A / Ctrl+A to select all the images so they're all getting the same treatment as we apply adjustments.

When we're done, we either create copies to send to our clients (the Save Images... button), Open our documents in Photoshop, or click Done to write the metadata "notes" of our work to the documents themselves.

Of course, we can click **Cancel** if we wish to move on without saving our work.

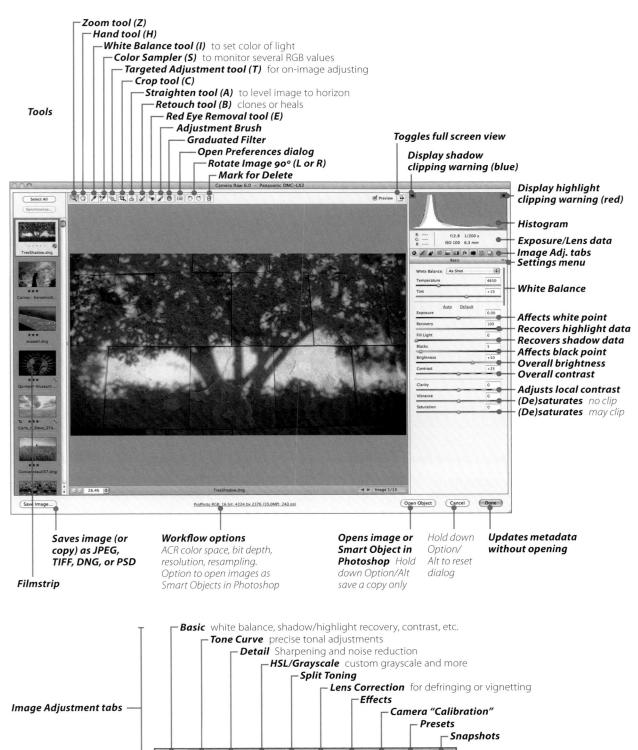

Finding Your Way In Lightroom

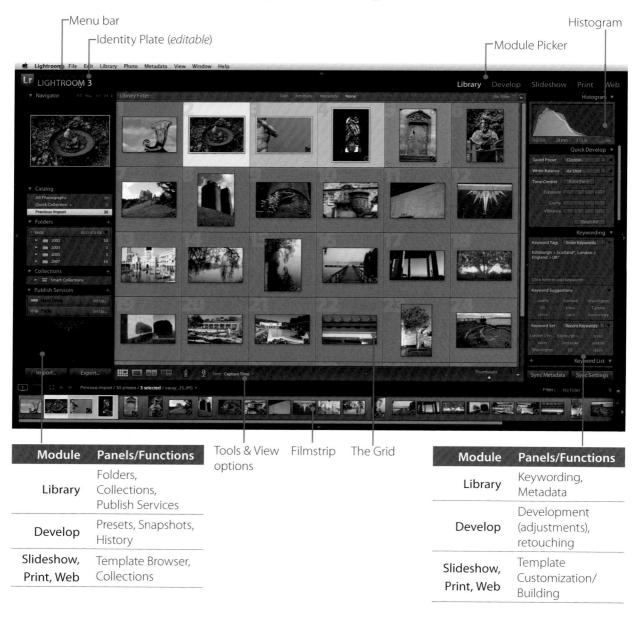

Lightroom is an all-in-one tool to do what Bridge and Adobe Camera Raw do, plus some of what Photoshop does. These products coexist because no one does all of what we may need. For example, we cannot create composite images in Lightroom, nor can we manage files made by other Adobe applications (like Illustrator, for example). But since this is a book about *photographic* workflows, Lightroom must be included.

Panels & Modules

When you open Lightroom for the first time, it offers a tour of sorts. Take it! If you have already skipped it, you can find it with the command Help>The Five Rules. This highlights the major parts of the interface:

- the Module Picker, where you take images through the workflow;
- 2. the **Panels**, similar to Photoshop's panels, where you achieve your editing tasks;
- the Filmstrip, where you can always access your images along the bottom of the screen;
- 4. six important keyboard shortcuts; and
- 5. a valuable tip which I leave to the resourceful reader to investigate.

The first thing most Photoshop users notice about Lightroom is that it consists of one huge window, where the panels of Photoshop have been replaced by panels that can slide in and out of the sides of the screen. And although there are menus, we use them very little, and thus spend much of our time in one of the full screen modes, even the one that removes the menu bar!

While looking at the interface, try the shortcuts on the next page. When the panels are hidden (by using the **tab** key), you'll see the triangles on the edges are pointing inward. If you hover your cursor over the left or right edge, the panel will automatically move in so you can use it. Once the cursor is away again, the panel retracts. Use **tab** again to bring all the panels back.

Click on the name of the Module you want to examine:

- Library is for organizing, applying and checking metadata, and perhaps a little bit of image adjustment or "Development", although I prefer to save that for the next module. Set up "publishing" to hard drives or to your Flickr account. You may add more such services over time, too.
- ▶ Develop is for your global adjustments, light retouching, and some painterly enhancements. You can save Develop Presets and apply them to other images later, or work with the History states in your images' editing lifetime (yes, a history panel that doesn't clear upon closing the document).
- ▶ Slideshow is the module where you can design and present a slideshow with music or without, and with or without your Identity Plate as a sort of watermark. You can export your slideshow as a PDF or play it directly in Lightroom.
- ▶ Print is the module for outputting to your printer. You may print many images on a contact sheet, several copies of one image per sheet, adjust margins, and apply last minute "printer" sharpening. What's really great is that you can queue up many images to print and go out to lunch!

▶ Web is the module where you can set up and use site templates for creating online portfolios. These may be fairly straightforward HTML or they may use Flash for more interesting effects. Everything from text to color may be customized, and you get to preview the result in a real web browser before uploading. Lightroom can even upload to your web server once you've configured its settings.

Grid vs. Loupe vs. Compare

While in the Library module, we find several ways to look at our images.

- ► Using the Grid view, accessed by the letter **G**, we see our images laid out as slides on a light table.
- ► If you double click on an image, we don't leave the comfort of Lightroom for Photoshop; we find ourselves in Loupe view, with that image occupying the entire main window. You can also use the L key to get to Loupe view.
- ► C lets you Compare a couple images, perhaps two frames of the same subject, while you try to decide which one is best.

Vital Keyboard Shortcuts

Shortcut	Function
tab	Hides & shows side panels
shift+tab	Hides & shows all panels
F	Cycles Full Screen Mode (to maximize space)
L	Dims the interface except for selected image (partially, black-out, and normal)
~	Toggle between Loupe view and normal view
第+[forward slash] / Ctrl+[forward slash]	Brings you Module-specific help

I'll have a lot more to say about Lightroom (and Bridge and Photoshop) in the next section, **The Workflow**.

Section 2 The Workflow

A Brief Overview

Any complete workflow has dozens of different tasks. To simplify, I've broken an overall workflow into a series of stages. Each major workflow stage has about three to six tasks within it, but most can be performed easily in a few minutes. Each major stage has its own chapter in this section.

Stages—Major Task(s) Application Choices Capture & Import Bridge Lightroom
1 Capture & Import Lightroom
0.1
2 Organize & Archive Bridge Lightroom
Adobe Camera Raw Global Adjustments (Development) Photoshop Lightroom
4 Local Adjustments Adobe Camera Raw Photoshop Lightroom
5 Cleanup & Retouching Adobe Camera Raw Photoshop Lightroom
6 Creative Edits & Alternates Adobe Camera Raw Photoshop Lightroom
7 Output
Print Photoshop Lightroom
Slideshow Bridge Lightroom
Web Bridge Lightroom

Capture & Image Import

This is a book predominantly about post-capture workflow, so I won't cover the specifics of capture with particular cameras. But there are a few important points to make about image capture. Ensure good exposure in your images. There's a myth that Photoshop can fix any type of problem in digital images. There are definitely many options for fixing problem images in Photoshop, but it's always best to start with the best possible image. Second, capture a sharp, unfiltered image: use sharp lenses and limit the use of camera filters or other light modifying tricks. Most filter effects, with the very notable exception of polarization, are easily mimicked by our software and with much greater precision.

When it's time to actually move your images from your camera or memory card to your computer, both Adobe Bridge and Adobe Photoshop Lightroom have many options. When your camera or card is attached to your computer, Lightroom can automatically present its Import dialog and Bridge can be set to automatically open Adobe Photo Downloader. I'll carefully discuss the options presented there including file naming, destination folders and their naming, automatic backup, conversion to the DNG format, and the use of metadata. Metadata is the magic hook to find and organize even the biggest image libraries.

Organize & Archive

Create a strategy for keeping your images organized. Lightroom or Bridge (with the Adobe Photo Downloader) can send freshly downloaded images to any specified folder, and can automatically create subfolders based on various dating schemes or an arbitrary custom name of your choosing. I outline a labeling strategy for keeping track of unedited images, images in progress, and finished images, as well as variants. We'll keep closely related images together with Stacks, and broader groupings with Collections. Moving your images through this process will make it easier to find them later and see your progress at a glance.

I'll also discuss a few options for backing up your images. To paraphrase a man from Chicago, "Back up early, back up often".

Global Adjustments

If you're new to digital photography and image editing, your camera is probably set to capture JPEG files. If setting your camera to capture RAW files sounds like a new and complex idea, don't worry about doing that now. But as soon as you're more comfortable working with your camera, you should set it to capture RAW files. Using RAW files, either camera proprietary versions or Adobe's DNG, is a major part of any robust photographic workflow.

Global adjustments are those made to tone, brightness, contrast, color, crop, or others that affect the entire image (or close). If performed well, you can do 90% of your image editing work with a few adjustments. Many of these adjustments are found not only in Photoshop, but in Adobe Camera Raw (which, despite its name, can now be used with RAW, JPEG, or TIFF), and Lightroom.

Local Adjustments

Sometimes you'll need to perform adjustments on only a portion of your image: the sky or a person's face. In order to localize these adjustments to part of an image, you may need to select those pixels you want to affect and then perform your adjustments. There are several ways to "paint" adjustments as well.

Cleanup and Retouching

Basic clean-up may occur at almost any time in the editing process. I've chosen to do so at this stage so that any subtle flaws may have been revealed by your adjustments. The fundamental task in cleaning or retouching an image is "spotting" (removing dust spots and other blemishes). Like the Global Adjustments, clean-up can be done in Photoshop, Lightroom, or Camera Raw. Each has its particular quirks and strengths.

Creative Edits and Alternates

This is a catchall step for all the various types of image effects you might want to employ, such as adding soft focus, burning in, defocusing the image corners, blurring a background, adding film grain or border effects. Most of these techniques are best left until after other image adjustments are done. Some example techniques are described in this chapter.

Output-Print, Web, and Presentation

Some tasks are specific to the particular output size and the medium to which we're outputting. They include final image cropping, final print resizing/resampling, and sharpening.

Most inkjet printers today can make very good photographic prints right out of the box. Photoshop and Lightroom also allow many desktop printers to print using profiles. Profiles improve printer color accuracy.

Whether you need to output a few images for your blog, or an entire website of images for your family or clients to peruse, Photoshop CS5 and Lightroom 3 have tools that make this stage far less painful than even a few years ago.

Capture & Import

4

Although this chapter will not discuss every possible setting and button on the camera(s) you may use, I will ensure that you will know the important things to find and configure.

The bulk of this short chapter will be the myriad import settings found in Bridge (or rather, its companion, Photo Downloader) and Lightroom. Especially if Lightroom is your main image organizing application, be sure to read the File Management section of the next chapter as well.

Capture

This book predominantly focuses on post-capture workflow. However, I'd like to give a few suggestions on ways to capture images to make that workflow work.

Shoot RAW

By choosing RAW, you give yourself every bit of data that your sensor captured. With any other choice, some assumptions are made as to how the image will be "developed". See your user guide to set your camera to RAW.

Photojournalists sometimes have a need to capture in a mode that some cameras offer called RAW+JPEG. This way, they can upload the smaller JPEGs to their publisher(s), but still have the valuable RAW data to process more carefully later. Most users don't need the added JPEG.

Lens Profile Creator

Adobe provides a free companion application via adobe.com that uses photos of charts (checkerboard patterns) to determine the quirks of particular lens configurations—and correct many of them automatically in Photoshop, Camera Raw, or Lightroom! Many profiles are supplied in those applications, but this utility lets you use your own or other photographers'.

Be careful to read the instructions! Here's an overview of the basics:

Print a chart—There are several to choose from. The sizes, and the sizes of the checks within, vary so that you can shoot with a lens from as wide as a fish-eye to a long telephoto. The goal is to make each check no less than about 20 pixels on a side when photographed with the combination you're profiling. This can take some experimentation! Be sure the

print is crisp, sharp, and with no color fringing on the squares.

- Photograph the printed chart—with the camera set to manual. You want to ensure that each capture is exactly the same exposure, and you'll be making about nine of them with the chart in different positions in each: one in each corner, the middle of each side, and in the center of the frame.
- ► Use the Lens Profile Creator—Add your images to the profiling project, then let the software know which chart, camera, and lens you've used. With luck, the application will make a profile for Photoshop's Lens Correction filter, ACR and Lightroom!

Standard Practices

Exposure

If, like me, you remember shooting with film, then you may wonder if digital sensors behave more like slide film or negative film. Many assume slide film, but I disagree.

0 photons just noise	1 bazillion photons	2 bazillior photons			pazillion hotons	16 bazillio photons		azillion hotons
black	+1 stop	+2 stops	+3 sta	ops +	4 stops	+5 stops	+	6 stops
					1			1
64 shad	des 128	shades	256 shades	512 shades	1,024	shades	2,048 shades	otal
								4,096 total
								4,0

Let's consider a fairly standard digital camera with a six f-stop range. We'll assume that it yields an image that uses 12 bits (short for *binary digits*) for each pixel's red, green, or blue data: it will have a total of 4,096 levels (shades) of each. Regrettably, those levels aren't divided equally amongst those f-stops.

Recall that as you want to increase your exposure by one f-stop, a small increment *visually*, you have let twice as much light into the camera. Film, like our eyes, responds to that doubling of light with that small, incremental change—¹/6 of the way from black to white in our example. Twice as many photons means only a small change in visual tonal value.

But in a camera's sensor, twice as many photons need twice as much data to record their impact. So in our example, fully half the data that's delivered to us is for the brightest f-stop only! Half of what's left is for the next brightest stop, and so on, leaving very little data for the darkest stop.

The bottom line? If your scene requires only 5 f-stops to record it, then make sure the brightest part of the scene is *nearly* blown-out white in camera. Later, when developing the image, we can drag the dark areas back down to black, but still have twice as many levels to use in those shadows.

This is like shooting negative film.

Sensitivity

Avoid high ISO settings. The newest SLRs have the marvelous ability to minimize noise when shooting at high sensitivity. But most cameras, maybe yours, will have more trouble at 1600 than at 100. Why? Turn up the volume on your favorite music player with no music playing. Be careful to lower the volume again later. What you hear is the effect of heat and electronic

interactions. The analogous phenomenon in digital imaging will be colorful speckles in the dark part of the image. That is, the area where noise doesn't have a lot of "signal" (music or light) to overwhelm it. This is another incentive to *tend* towards overexposure with an adjustment downward later.

For Panoramas

If you want to "stitch" images together as a panorama, consider these tips:

- ► Use a tripod. If the tripod head has a bubble level (a.k.a. a spirit level), that can be helpful in keeping each exposure on the horizon.
- ► Ensure there is 20%–30% overlap (for longer lenses and wide-angle lenses respectively) in the images.
- ► If you make many panoramic images, consider a "Pano" head for your tripod. These make it easier to find a lens' **nodal point**. This is a point, usually near the tip of a wide-angle lens, around which it is best to rotate. You can tell when this is where your axis of rotation is when foreground and background objects no longer move relative to one another in the viewfinder as you rotate.

Despite all these "best practices", I have good, knowledgeable friends who know Photoshop will forgive even almost haphazard shooting and makes decent panoramas anyway! So try it and see if you need extra gear.

For High Dynamic Range Images

Do you recall the hypothetical 6-stop range on the previous pages? What if the scene requires a range closer to human vision (which is more like 20 stops)? You can make a series of exposures that can be combined later in one image file. When creating these High Dynamic Range (HDR) images, make several frames one to two stops apart by varying *shutter speed only*. Since some of those exposures may be lengthy, a tripod is useful.

If you want to make a few images to be ready for merging to HDR, make sure the darkest one holds all the important highlight detail, and the lightest shows important shadow detail without too much noise.

Passerby Removal

To remove random content from images, it's considerably easier if you have made several images of the same scene. Photoshop has a way to note what content is common in all of several images, and to disregard the fluctuating content (like sensor noise, passing cars or people, rain drops, etc.). So if you wish to engage in "passerby removal" or noise reduction, make several captures of the scene.

Import

Digital Negative

Much has been written and said about the DNG format from Adobe. Camera manufacturers are starting to use it as the RAW format in their cameras. Adobe has said it will be the "steward" of this open source format, but if they should cease to be, the instructions to read a DNG will be publicly available.

DNGs hold all of the sensor data recorded by the camera. They do not require additional files to be created to hold their metadata, as is the case for camera proprietary RAW formats. These extra files ("sidecar" files), can be separated easily from the image files with which they belong: a demoralizing accident. DNGs avoid that problem.

Therefore, when importing images I recommend that photographers convert their proprietary RAW files into Digital Negatives.

Br

Deferred Import

Prolific photographers complain about how long it takes to download photos if they are also converting them to DNG at the same time. For them, I recommend downloading the image files from the camera or cards to a waiting folder on their computer. Once all the cards' content has been transferred (using either Lightroom's Import dialog or the Adobe Photo Downloader launched from Bridge), they can then convert all the images at once as they are brought into their proper archive (your Pictures folder, for example).

This is only a minor step if you are using Lightroom, as you use its Import dialog whether importing from camera or folder, and the option to convert to DNG is there.

With Bridge, the creation of DNGs from *downloaded* proprietary RAW files requires the free application DNG Converter.

However, if time allows, and whether you use Bridge or Lightroom, the conversion to DNG should happen when downloading. So let's discuss the major steps involved in that process.

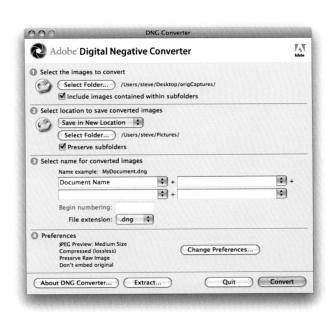

Bridge

You can use Adobe Bridge to import your images from your camera or memory card. There are options for renaming the images, sorting them by folder based on date shot or imported, and even for automatically backing up the original files to another disk or folder in your system or over a network.

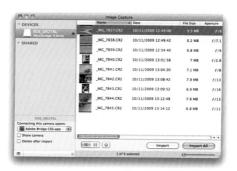

The preferences of Apple's Image Capture program let you determine what happens when a card is detected.

If your operating system lets you launch applications automatically when a memory card is connected, you should have that application be Bridge, so its preference to download automatically when a card is detected can be engaged without conflicts.

Configure Bridge

To be confident that Bridge does what you want, you should change a few of the preferences: Go to the Edit menu (Windows) or the Bridge menu (Mac OS) to Preferences.

See Section A, Chapter 2, *System Configuration*, for suggested settings. Also, so you always have your images "stamped with your seal", create a Metadata Template.

To create a metadata template in Bridge CS5, choose Tools>Create Metadata Template.... Fill in fields that you feel are general enough to be applied to any image you make. If you need several variations, make more than one template.

Now let's get some images!

Adobe Photo Downloader

When you connect a camera or its memory card to your computer, Bridge should now launch its downloader program. The standard dialog is often good enough, but we'll use the Advanced dialog so we can pick and choose which images we want to download by their thumbnails. There are two other advantages to the Advanced dialog: we get to apply a Metadata Template (once we make one) and we can apply our copyright text to the metadata as we download the images—now we can't forget!

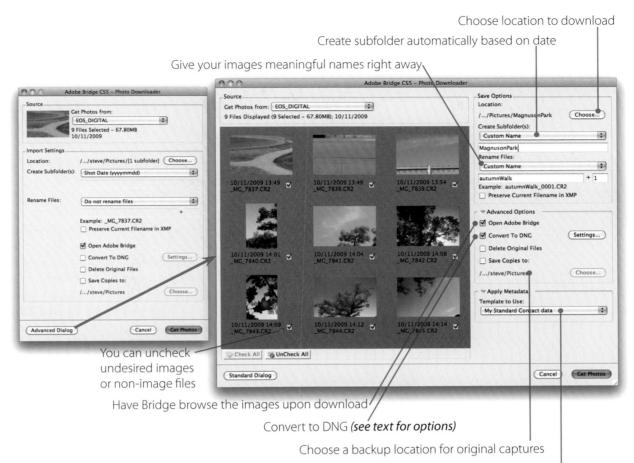

Specify Metadata Template or just add your name and copyright

Both the Standard and Advanced dialogs have an option to convert cameraproprietary RAW files into DNGs (recommended), and you can specify a destination for copies made of the camera's original image files. If you click the Choose button, you can specify an awaiting DVD, backup hard drive, or network backup drive, so the files are backed up instantly. Some photographers prefer to backup images that have been globally corrected first, but others don't want their workflow interrupted to do backup.

There is a wonderful option to create subfolders in your download location, preferably named after the date shot. This means that there are already two places where that date is stored: the folder in which the image is located and in the image file's metadata. When choosing a file naming scheme, give each image a name that is meaningful to the shoot. Adobe Photo Downloader has a field for specifying a custom name, and it can add serial numbers to the end automatically. The last option to mention is to Open Adobe Bridge with the downloads in the new window (very convenient).

Lightroom

Automatic Import

The preferences of Apple's Image Capture program let you determine what happens when a card is detected.

If your operating system lets you launch applications automatically when a memory card is connected, you may have that application be Lightroom. You can set Lightroom's preferences to open the Import dialog automatically when a card is detected. In this way, Lightroom will automatically launch and offer to download images when you connect a camera or card to your computer.

Configure the dialog box to download images to your main image library (or another if you wish). RAW files can automatically be converted to DNG format and named in a usable way. Note also that you can choose to back up your files straight from the camera to a network backup drive, for example. Some prefer to apply some initial global corrections before using Lightroom's Export feature to create backup files. Lightroom ships with export defaults for burning full sized JPEGs to disc, exporting DNGs, and even sending files by email.

Some photographers dislike the time it takes to convert to DNG when that conversion happens during import. So you may consider simply copying your images from your card or camera to a folder set aside to receive them. Depending on the card and the number of images, this can be a rapid process, even if you have a lot of camera media to import. Once your images have been copied to a hard drive, you can then use Lightroom's import (File>Import Photos from Disk...) as described above, but all at once and more quickly converted to DNG.

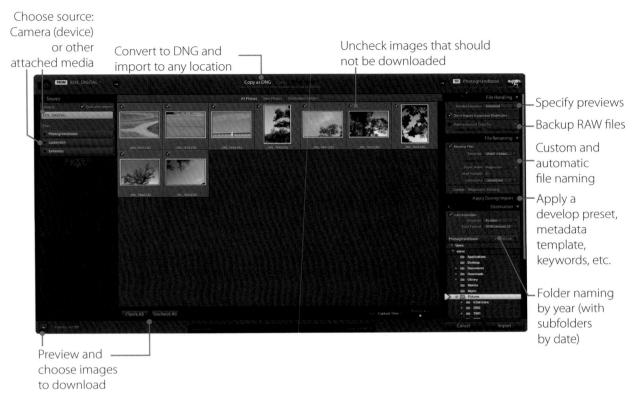

If you trigger your camera from your computer, then download the images to a special folder, you can specify that Lightroom "watch" that folder, then automatically import any images that appear in it. Choose the settings that get applied, and the Watched Folder itself, with File>Auto Import>Auto Import Settings.

Organizing and Archiving Images

5

Digital photography has made it easier for photographers of any level to quickly build massive libraries of images. *Large capacity hard drives are so affordable that we may* easily store several terabytes of image data. The difficulty, then, is not in capturing enough images or having room for them, but how to efficiently rate their quality, process the best images, and find them again swiftly when we need them. And because hard drives fail eventually, we need to arrange a backup procedure that is dependable and easy. But organization is a personal thing: what makes sense to one user may be a bad fit for another. In this chapter, I'll discuss several approaches to rating images from which you should develop your own. Likewise, the storage and arrangement of your image files should make it easy for you, not me, to access them. So the approaches I discuss will need to be tailored to your personality. That said, be sure to read the entire chapter before committing to a system. Both Bridge and Lightroom offer many ways to categorize your images, and it's not all about nested folders anymore!

Br

Rating Systems & Methods

Everyone has a different way of specifying the quality of images. Bridge and Lightroom use stars to indicate relative goodness. But deciding how you read those stars is required before applying star ratings to any images.

We have up to five stars to use. Bridge offers an additional catagory: Reject. In Lightroom, there are stars and two flags: one to indicate a Rejected image, the other Flagged. Using some combination of indicator, we'll try to whittle away at the dozens of images we have just downloaded to reveal just that one image (or five or twenty) that we think is definitive. Below I've outlined a few of my favorite rating systems, and I follow that with the specifics to use those systems.

These depend on the ability of the application to "filter" images based on their rating. That is, you choose to show images only with the rating(s) you want to see, hiding the others. Usually, you apply ratings while looking through the recently downloaded images, then filter away the lower rated, repeating until we have our representative set showing and not others. There's no need to delete, unless you want to, because we can hide images instead.

Method	Procedure
"Build-up"	Review 1: rate with ★ or ★★
	Filter: $\star\star$ & above, then, if there are too many remaining
	Review 2: ★★ or ★★★
	Filter: $\star\star\star$ & above, then, if there are still too many remaining
	Review 3: ★★★ or ★★★★
	Filter for the highest rating you gave.
"Brutally Binary"	Review 1: ★ or ★★
	Filter: $\star\star$ & above, then, if there are too many remaining
	Review 2: demote to ★ until only the best remain
	Filter: ★★ & above
	Alternative: use Flags (Lightroom) or Reject label (Bridge)
"Yes, No, Maybe"	Review 1: \star or $\star\star$ or $\star\star\star$
	Filter: $\star\star$ only, then, if there are any remaining
	Review 2: change to ★ or ★★★ until none show
	Finally, filter ★★★ & above
"The Decider"	Review once
	A A . A A . A
The Decider	★ or ★★ or ★★★

I reserve 5 stars for only those images I think should win a Pulitzer Prize!

I've mostly used the methods I call "Build-up" and "Yes, No, Maybe". "Build-up" gives a range of quality from which to choose, and could be

revisited later. Both give an opportunity for cycling through the images and deferring a final decision.

I like star rating as soon after download as possible so I know if images have been evaluated or not. If an image has at least \star then you know it's been reviewed and that you're ready for development.

Bridge

After the images have been imported, Bridge should now be showing the images. It's now time to pick the keepers, choosing the images that deserve further attention. For this, we'll use Bridge's star rating system.

To apply star ratings, select an image (or many or all in a shoot), then:

- 1. Choose Label>[the star rating you want, 1 through 5]. This is far too tedious, so consider...
- 2. Use the commands \(\mathbb{H}+[1-5]\) / \(Ctrl+[1-5]\). If using the modifier key gets tedious, you can just type the number if you change the preference under Labels in Edit>Preferences (Windows) or Bridge>Preferences (Mac OS): uncheck the box that says you need to use that modifier to apply Labels and Ratings.
 - If you're using a full keyboard, then you can place your fingers over the number pad (the numbers on the right-hand side), and your thumb over the arrow keys. Tapping the **Right-Arrow** moves focus to the next image, then a tap on a number gives that many stars.
- 3. Choose View>Review Mode. This gives a larger view of each image and lets you see the next and previous image as well as the one being reviewed. Your arrow keys let you progress through the images, the number keys apply stars, and if you click in an image, you get a loupe to check for sharpness and detail. Although the loupe remains as you change images, it takes a few seconds to resolve the magnified area.

To filter the view in Bridge, click on one or more criteria in the Filter panel (lower left by default). To show only those images that have been rated, for example $\star\star$, you merely have to click on the $\star\star$ row in the Filter Panel in Bridge.

If you decide to be *very* specific, and activate many criteria by which to filter, it's easier to use the Clear Filter button or use the shortcut **#+option+A**/**Ctrl+Alt+A** when done.

Click on a criterion to filter by it or to deactivate a filter. Shift+Click a rating to filter by that rating and higher.

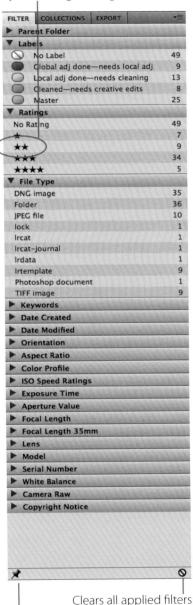

Lightroom

If you wish to star-rate the images you have just imported into Lightroom, you can use one of several views in the Library Module: Grid View (your

lightbox, as it were), Loupe View (where you can zoom in to gauge sharpness, etc.), Compare View (to judge between two images: the

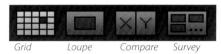

Select and the Candidate), and Survey View (for deciding from among several candidate images). I usually use Loupe view, navigating with the Filmstrip below, while rating. That is, I'll use my arrow keys to move to the next or previous images, evaluating the large image in the image window, but noting what images are coming or past in the Filmstrip.

The tip I offered in the section on rating using Bridge (proceeding through the images using your thumb on the right arrow key, and using your fingers to press a number 1–5 to set a rating) is useful here. After going through and rating the images, you may wish to filter for, say, 3 stars or higher.

Lightroom offers two places to set a filter: to the right, just above the Filmstrip; and along the top of the grid in Grid View only.

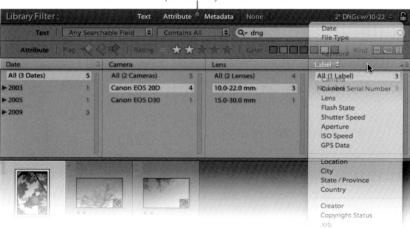

Choose the qualities by which to filter

Above the Filmstrip, you can click on a star and then to the immediate left of the stars, a symbol (\geq , \leq , or =). The symbol is actually a menu that lets you choose Rating is greater than or equal to, Rating is less than or equal to, or Rating is equal to. Finally, there is a small switch icon with which you can disable or enable your chosen filters.

At the top of the Grid, a very similar interface lets you build a filter based on a Rating **Attribute**, or a Label, Flag, or Copy Status attribute. But it has the additional ability to let you build a complex filter using any **Text** Lightroom finds in an image file's data, or indeed any **Metadata** that concerns you.

Keywords and Metadata

Of course you know your images and will recognize them when you see them. But first you have to find them in a sea of thousands. Also, you may not remember just where you were, who your subject was, or some other fact that should be associated with a particular image. These facts can be entwined with your images' other data as **Keywords** either when you download or later.

These and more general data about your images are collectively called *metadata*. An important set of metadata that you should have associated with your images would include your copyright and contact data. This core data, or any metadata, can be saved as a template (Bridge) or preset (Lightroom) that can be applied easily when importing your images.

Be sure your template/preset is appropriate for *every* image you shoot: name, address, title, and other contact data; copyright notice including at least a copyright symbol (option+g /Alt+0169), year of publication, and your name. I also recommend, unless you are using a code-based system (from <u>useplus.org</u> or <u>creativecommons.org</u> for example), using "All Rights Reserved" for the Rights Usage Terms.

Keywords

The keywording of images is both a laborious task, while you're doing it, and one that will save you tons of time later when you search for images. That's my way of saying, "take your medicine and do your keywording".

To have a robust list of keywords, you may use keywords made for you by a stock photo agency or other service (like Controlled Vocabulary) or your own. If you'd like to build (or buy) a set of keywords, it's best if they're in some kind of heirarchy. For example, North America|United States| Washington|Seattle.

You can use the tools available in Bridge or Lightroom to do this (see

next pages) or you may create a file to import many of your keywords at once. If you are proficient in Microsoft Excel, you may choose to use that tool to lay out a grid of keywords, then export them as a tab-delimited, plain text file which can be imported into either Bridge or Lightroom. Or bypass the middleman and compose the text file (UTF-8 or ASCII) yourself following simple rules:

Each keyword is on its own line:

Any keyword with one or more tabs before it (that is, having had the **tab** key pressed before it was typed) is the "child" of the nearest keyword above it with fewer (or no) tabs before it.

Europe

<tab> France

<tab> <tab> Paris

North America

<tab> United States

<tab> <tab> Washington

<tab> <tab> Seattle

Bridge

Copyright and Contact Data: Bridge Metadata Templates

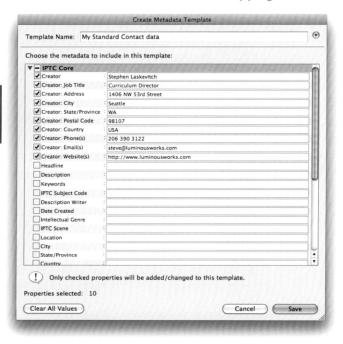

To construct your primary Metadata Template in Bridge, choose Tools>Create Metadata Template...

First, give your template a name (at the top). Then, fill in the important fields discussed on the previous page: your contact data, copyright, etc. Then click Save.

Now you may use that template when using the Adobe Photo Downloader (in its Advanced mode) by choosing the template from the Template to Use menu as above.

Keywords in Bridge

If you chose to build a keyword list as a tabdelimited text file, you should use the Metadata panel menu to load it. If it's your first set of keywords and you wish to be rid of the defaults, choose Clear and Import... Now your keywords

will own the list. Notice the Export choice for sharing keywords with Bridge on other computers or with Lightroom.

To use Bridge to build a set of keywords, use the buttons at the bottom of the Keywords panel 💆 🕆 💼 to add sub-keywords, keywords, or

to delete keywords. To make the task of keyword generation less overwhelming, many prefer to add keywords as they're needed, applying them to images shortly after they are downloaded.

To apply a keyword to one or more images, you should select the image(s): click on a thumbnail to select one image, then **shift+click** on another image to select it and all the images in between, or use the **%**/(ctr) key to select noncontiguously. Then simply click on a keyword's checkbox or **shift+click** to apply that keyword and its parent(s).

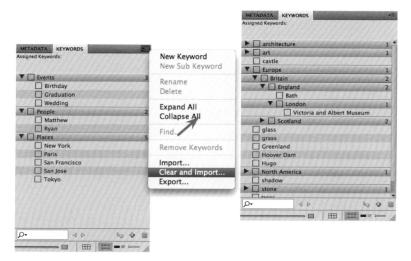

Lightroom

Copyright and Contact Data: Lightroom Metadata Presets

As early as upon import, you can apply keywords and your metadata preset-if you've built one. To do so, choose Metadata>Edit Metadata Presets... The areas to deal with first are IPTC Copyright and Creator. Fill in those key fields that are appropriate for every image you shoot: contact data, copyright notice, etc.

Important: When you have filled in the important fields, use the Preset menu at the top of the dialog box, and choose Save Current Settings as New Preset... which presents another dialog box: give your preset a name like "My Standard Metadata" or similar.

When you're done, click **Done**. You can create more presets later for special circumstances, and apply metadata to one image at a time when it meets those.

Keywords in Lightroom

To import a tab-delimited text file, choose Metadata>Import Keywords (use Export Keywords to create a text file from your current keywords). Just above the Metadata panel are the Keywording and Keyword List panels. Here is where you can quickly add keywords as they come to mind for selected images. As you add Keywords, they will appear in the Keyword List panel.

In the Keyword List panel, you'll see your growing list of keywords. As this list grows, organize it: for example, Neidpath

Castle is near the town of Peebles in Scotland, so we put the Neidpath Castle

keyword tag under Peebles, and Peebles under Scotland.

Sometimes we need to send images to others who may not have Lightroom. If we want those "Parent" or containing keyword tags to be exported with the images, we should control+click / Right-click on the keyword and choose Edit Keyword Tag. In the dialog that appears, we can specify synonyms (in case we forget the real keyword) and ensure that the "Containing" keywords accompany this "child" keyword.

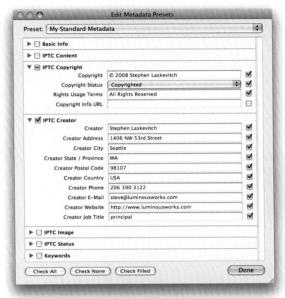

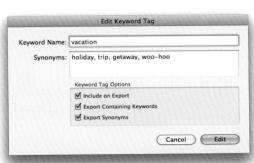

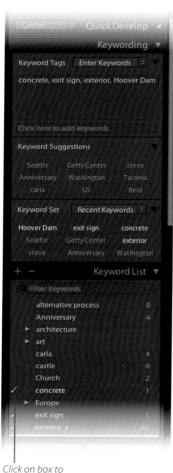

Click on box to apply keyword

Applying Keywords

Keywords applied to selected image

Suggestions
based on
capture time and
other criteria
Sets of 9 that can
be applied with
your keyboard's
number keys

List of all -keywords applied to images in Catalog

1) In The Import Dialog

The easiest time to apply keywords is when you import images. A rule I try to obey when shooting is to keep each distinct shoot (scene, subject, etc.) on separate media. In this way, when I download images, I can enter keywords that are appropriate to all the images on that card.

2) One At A Time Or In Batches While Browsing

If you have many images to keyword, and they are already imported, you may select them in the Grid view of the Library module, then select one or more keywords. These will then be applied to all the selected images.

You select a keyword in one of several ways. You may notice that the one you want is being suggested by Lightroom in the Keyword Suggestions section of the Keywording panel. These are 9 keywords that Lightroom suspects are likely appropriate based on similarities to other images with those keywords applied.

You can find the keyword listed alphabetically in the Keyword List panel. Be warned that you may have to click on a disclosure triangle to find a "child" keyword.

You may also use your keyboard's number keys. Hold down the option / Alt key: note the numbers that appear next to the keywords in the Keyword Set section of the Keywording panel. These can be the nine most recent keywords, or any set of nine you would care to create. You can also apply these to a selected image by clicking on the keyword. To apply the keyword from the keyboard: hold option / Alt and press one of the numbers 1–9 on your keyboard. Notice how the numbers correspond nicely to

the layout of the number pad on an extended keyboard.

3) Paint Them On

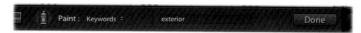

Use the Painter can. Once you select it from the bottom of the Grid, you may type what keyword(s) you want it to "paint" onto the images you'll click on. You can apply many kinds of metadata this way. Note that Keywords is actually a menu choice. When you're done, click the **Done** button, place the Painter can onto the circle, or press the **esc** key.

Labels: Workflow Landmarks

As you progress through the workflow, you will need to know how far along a particular image has proceeded, or what else it needs. You may just want to label an image as "Ready to go". In the past, we depended on elaborate hierarchies of folders to govern our original files, copies we made for different purposes, other copies in various file formats for different clients, and possibly more for images prepared for specific output. The folder location of those files was the indicator of "where" they were in the workflow.

Now, Photoshop and Bridge (through Adobe Camera Raw or ACR for short) give us ways of nondestructively correcting and adjusting our images without maintaining all these copies. That is, we can make many changes to color, tone, sharpness, and even the removal of dust or other artifacts, all without really altering the original data. So if we make a mistake, or wish to make a different creative decision, we simply make the new corrections. Much of this can be done in ACR and Lightroom, even more of course in Photoshop. In ACR and Lightroom, we can apply Camera Raw corrections to JPEGs and TIFFs, as well as proprietary RAW files and DNGs (Digital Negative format).

One image file can therefore be moved through the workflow, and even moved backward in it, without risking the original data captured by the camera. The trick is remembering where in the workflow a particular file is. So it is important to establish a labeling system that clearly identifies a file's status. The default labels attempt to do this, but somewhat generically. I propose some label names to match my workflow, but you should use phrasing that is meaningful to you.

In Bridge's Preferences, you can change the label text, but not the label color or order. In Lightroom, you may have several Label Sets, which are defined in the dialog box accessed via Metadata> Color Label Set> Edit...

In Bridge, you can also simplify the key strokes (modifier key plus a number) you use to apply a particular label by unchecking the box at the top of that Preference page.

Bridge Label Preferences (disable requiring modifier to apply label)

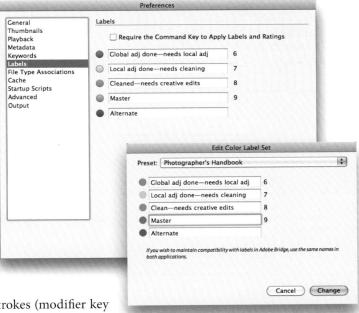

Lightroom:
Metadata>Color Label Set>Edit...

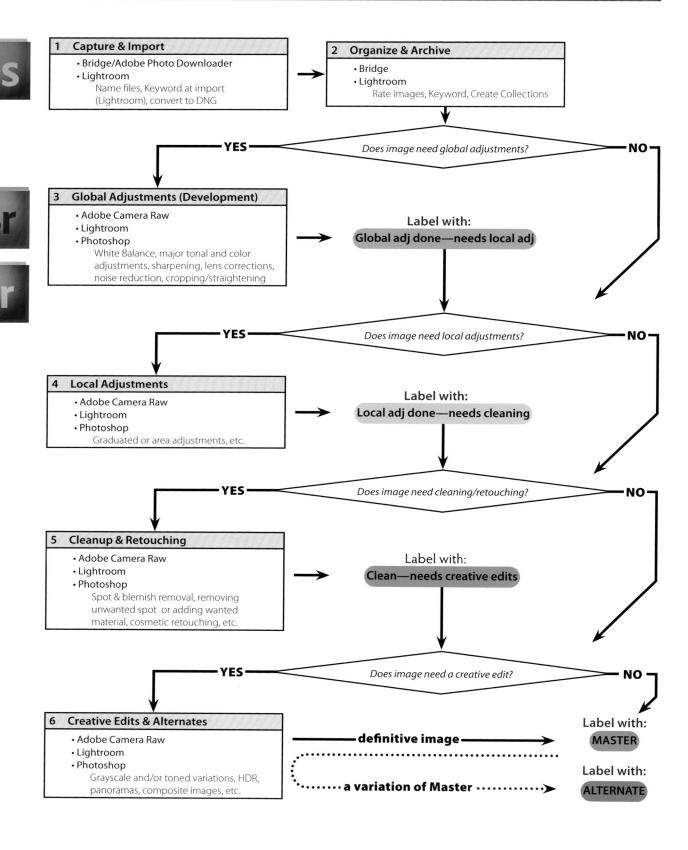

File Management

Folders vs. Collections

I just wrote that "in the past" we needed many folders to contain our images. But what about now? Both the Adobe Photo Downloader and Lightroom's Import dialog give you a chance to download your image to one all-encompassing folder (your Pictures folder, perhaps, or an external hard drive), and these dialogs can automatically create subfolders based on date.

However, you may also want more arbitrary arrangements: a Collection of images based on an ongoing series or all pictures of family and friends. Fortunately, both applications (Bridge and Lightroom) have a feature called Collections. A Collection contains a reference to any image you want it to without the need to make copies that dwell in different folders. In fact, if you wanted, you could download all your images to one mighty folder, then use metadata filtering and your Collections to find the images you need. I'm not quite so brave, so I use the automatic date-based folders, too.

A Collection can contain images from many different folders, and one image can belong to many Collections. I like to think of Collections as clubs to which an image belongs: just as one individual can belong to several organizations, an image can belong to several Collections.

For example, you may have a Collection for photos of trees and another for photos of friends. An image of a friend standing beneath a tree could belong to both without your having to make any copies!

Bridge

Look in: Pictures

Match: If all criteria are met

Include Non-indexed Files (may be slow)

✓ Include All Subfolders

- Criteria

Results

Date Created

•

⊕ ⊕

4/9/2009

Save Cancel

is greater than

Sharing space with the Filter panel is the Collections panel. Along its bottom are buttons to create and edit your Collections. A feature that builds a Collection's content automatically is the Smart Collection. When editing a Smart Collection, you define criteria very much like search criteria. Later, if new images match these criteria, they

are added to the collection.

Regular Collections can have images dragged to them. Or, when creating a Collection, a dialog asks if you want to include images that are selected in the Content area.

▼ Collections ▼ Smart Collections ▼ Smart Collections Create Collection... Create Collection... Create Smart Collection... Create Smart Collection... Create Collection... Create Collection Set... Sort by Name Sort by Name Architecture For the Collection of Set... Sort by Name For the Collection of Set... Sort by Name For the Collection of Set... Sort by Name For the Collection... Create Collection... Create Collection... Create Smart Collection... Create Collection... Create Smart Collection... Create Collection... Create Smart Collection... Create Collection... Create

Lightroom

Lightroom also has standard Collections and smart ones. You may also have Sets of Collections so that you can establish a heirarchy.

To create a Collection or Collection Set, click on the + in the upper right of the Collections panel. If you choose a standard Collection, you'll have the option to include photos that are selected and whether to make virutal copies (an option I rarely choose here).

Remember to give your Collection a good name.

To edit an existing Smart Collection, double-click on its name.

Lightroom also has a **Quick Collection**. When you press the **B** key, any image that's selected joins this temporary Collection. It's a fast way to, say, prepare a slideshow

of quickly selected images. Any collection can be targeted as the destination when pressing the **B** key: control+click / Right-click on a Collection (not Smart ones) and choose Set as Target Collection.

Metadata Challenges

All the processing we do in Adobe Camera Raw and Lightroom, all the rating and labeling we do in Bridge or Lightroom, and much more is recorded as metadata: data about our images' data. But where?

Depending on the application and the files under discussion, the answer may not be obvious.

XMP Sidecar Files

For camera proprietary RAW files, to which very little data can be written from our Adobe applications, a small, separate file, referred to as a "side-car" file, contains our metadata in format standard known as eXtensible Metadata Platform or XMP. The danger with this is that we'll have two files to manage, the image and its metadata. Also, I get uneasy without my copyright data residing in the image document itself. These are really good reasons to use DNG format for our RAW images, as the metadata will reside within the file.

The Document

For DNG, JPEG, and TIFF files, the document itself *may* contain the metadata. If imported into Lightroom or browsed by Bridge, a document with metadata will show that metadata (star ratings, develop settings, etc.)

However, in Lightroom, the "file" we edit as we work is a database (the Lightroom Catalog) and not necessarily the image file.

Lightroom

Catalog = Database

When you work in Lightroom, the document you've opened and are editing is not an image file, but a database with a name like Lightroom 2 Catalog.lrcat. This file is the first place your images' metadata resides.

When you're done with an editing session, I recommend choosing the command Metadata>Save Metadata to File. Note that there is no Save command in Lightroom's File menu. That's because the Catalog is saving itself continuously. But the image files won't "know" they've been edited until and unless the metadata within them (or their XMP sidecar files) have been updated.

Resist the temptation to enable automatic saving of metadata to your files, as that constant disk activity will slow the application's performance dramatically. Just remind yourself to save your metadata when you are done with an editing session. Recall the shortcut for the Save command in every program you use: <code>%+S/Ctrl+S</code>. It is no coincidence that this is the shortcut for saving your metadata in Lightroom! My fingers now instinctively Select All <code>%+A/Ctrl+A</code> then immediately Save (Metadata to Files) <code>%+S/Ctrl+S</code>.

Moving & Archiving Files

You may choose to have your main backup system back up your image files. Some photographers use a mirrored RAID (Redundant Array of Independent Disks) as their main repository of image files, and thus have two (or more) physical disks each holding all the images. If one drive fails, the other(s) will still have the data. Many solutions like this exist from drive makers like G-Technology (g-technology.com) or independents like the Drobo from Data Robotics (drobo.com).

Although having redundant storage on site is good for protecting your data from device failure, it won't help in case of fire, flood, or theft. So I use another external hard drive that I either carry with me when leaving my main devices at home, or that I store at another site. Yet another alternative is backup via the internet to a server.

Bridge

After you've done all the work of sorting, organizing, and "developing", you'll likely want to back up your images, too. Select the images to be backed up, then <code>control+click</code>/<code>Right-click</code> on one of them. In the menu that appears, choose Copy to > [choose your backup volume & folder]. This could be a waiting DVD or external hard drive that you store in a bank vault. It really should be a medium **not** inside your computer. Insurance may cover a stolen or flooded computer, but it won't cover lost files!

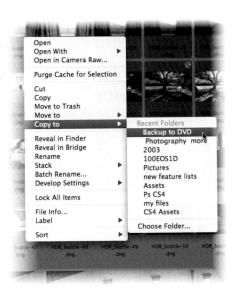

Take care to select only archival CDs or DVDs and to store them in a protected environment, e.g., away from light. Also, be advised that archiving with CDs or DVDs consumes lots of time and disks. The other mode of archiving, onto removable hard drives, is not archival: if left unused for many years, the data can be corrupted. Someday, perhaps, there will be a perfect solution. For now, store redundant files—just in case.

Lightroom

Catalog Backup

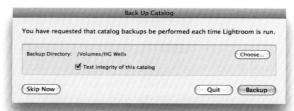

Depending on the choice you've made in your Catalog Settings, Lightroom will prompt you to back up the Catalog file when it launches (from every time to once a month to never—a bad idea). When it does offer the opportunity, you also can choose to where this important file will be saved. I choose the same volume I'm using for my main backup.

Those of us who use an automatic backup solution, like Apple's Time Machine, should be aware of a risk. If this regularly scheduled backup occurs while we're working in Lightroom, there's a chance that the database file could become corrupted! So set your system backup to exclude your Lightroom catalogs and preview data files. Instead, let Lightroom's own backup take care of that. You should still back up your preset files, however.

Export as Catalog

To back up your work from Lightroom to an external drive or distant location, you'll want the relevant database information, all the metadata,

and, of course, the image files. To do all that in one go, I use Lightroom's File>Export as Catalog... command. You may choose to create a backup

Catalog for only some selected images or all the images in the current Catalog. I include all the "negative files" (our image files, whether they're JPEGs, TIFFs, or RAW files) and the previews Lightroom has made. Sadly, we must manually move our presets and plugins.

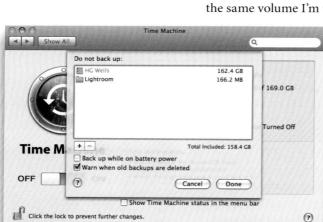

Have your automatic backup system *exclude* your Lightroom Catalog files.

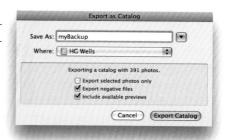

Multi-Computer Image Management: Two Examples

Bridge

If you use a laptop in the field then need to move the files to your desktop computer, you may use the Copy To command discussed above. Or, if you want to delete the images on the laptop as they are transferred to the new location, you can control+click / Right-click on your selected images then choose Move to> [choose the destination volume or folder]. Copy or move the files either to your desktop via a network or an intermediate hard drive.

Lightroom

Many of us have more than one computer and need to safely move images and our metadata from one to the other. It is not complicated to do so, but it's still easy to get Lightroom confused. So try these several steps:

From a laptop, I choose File>Export as Catalog... and choose an external drive (see previous page) as the place to export. I export everything: the "negative files" and the previews. A liberating fact is that the name of this exported catalog is completely unimportant, as it's only an intermediary. Note that Presets aren't included in this export.

I then "eject" the external drive before I attach that drive to my home/studio machine (or wherever the ultimate destination is).

2. On the destination computer, I launch Lightroom, using my usual Catalog file there, and I choose File>Import from Catalog... I navigate to the external hard drive and the temporary catalog I exported from my laptop.

I Choose to **copy** the photos from their current location (the external drive) to the regular folder or directory on the destination computer. Upon clicking Import, all the images and their

data will now be where they were needed.

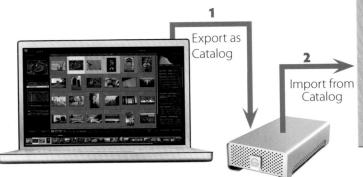

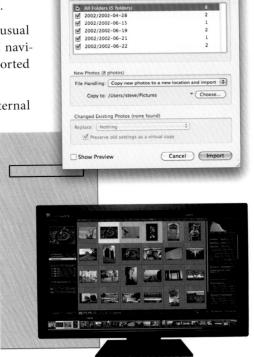

○ ○ Import from Catalog "Move to other machine"

Catalog Contents (8 photos)

Global Adjustments

6

The big picture: does the image need a crop? Is it too blue overall? Or is it too flat? In this chapter I'll focus on making the biggest difference to your images quickly so you can judge what else, if anything, needs to be done. For each major task, I'll start with defining the problem. I'll go over the things you should look for and consider correcting. Then I'll get into the details of fixing them.

Fortunately, many of these adjustments can be made in any of your applications: Adobe Camera Raw and Lightroom let you deal beautifully with the freshly captured image, and Photoshop also has much to contribute at any point in the workflow.

I've broken up this chapter mostly by the problems to be solved. Find the issue, then engage your application of choice. I suggest that you read the solutions for all the applications, so that you can decide for yourself which is best for you.

Number of Recent Items to Display: 10

General Approach

Your image files will likely be in one of three common formats: TIFF, JPEG, or RAW. Any of these can be edited by ACR or Lightroom, and all likely formats can be directly edited by Photoshop except RAW.

Nondestructive Editing

Photoshop

Nearly all the color and tone adjustments described for Photoshop use Adjustment Layers because adjustments made directly to the image are difficult or impossible to reverse. Lens corrections will be applied to Smart Objects via a filter. Use the Adjustments panel or Layer>New Adjustment Layer, **not** Image> Adjustments. All adjustments in ACR and Lightroom are nondestructive.

Adobe Camera Raw

Opening an image file by double-clicking on it in Bridge opens the file in Photoshop. If it's a RAW file, Adobe Camera Raw (ACR) will open, "hosted" by Photoshop, so you'll still have to wait for Photoshop to launch if it's not open already. However, there's a sure way to have ACR open, hosted by Bridge (no waiting for Photoshop), for JPEGs, TIFFs, and RAW files. Select one or more image files, control+click / Right-click on them, then choose Open in Camera Raw. Now you'll be able to make the majority of your global adjustments using tools that are nondestructive: they exist only in the file's metadata, and thus can be revisited many times, removed, copied, pasted to other images, saved as Develop Settings, and more.

You may work on more than one image at a time in ACR, too.

Of course, you may also choose to apply your adjustments with Adjustment Layers in Photoshop. Again, just double-clicking most image file formats will open them in Photoshop. RAW images opened this way must pass through ACR and benefit from the settings there. Often, images

will need the attention of both applications.

As well as the control+click / Right-click method of opening RAW files through Bridge, you can set Bridge's General preferences to have Bridge host ACR.

Lightroom

To make your adjustments, select an image, folder, or collection in the Library module, then choose the Develop Module. Although you may have more than one image selected, your adjustments will be applied only to the image that is "most" selected. After it has received its adjustments, you may synchronize those adjustments with other images later or automatically.

Cropping and Straightening

The cropping and straightening functions are tightly intertwined. In each application, a crop may be freely rotated by dragging outside the "box". You may set an arbitrary aspect ratio or use the original's. Also, if you use lens corrections (see page 149), the image may become non-rectangular. So each of the applications can keep the crop constrained to the image.

Ps

Adobe Camera Raw

If there is a notable horizon in the image (or a line that *should* be vertical but isn't), choose the Straighten Tool from the tool bar at the top of the window. Press and drag along the line you noted. When you release the mouse, that line will be perfectly horizontal (or vertical).

Immediately, ACR will change the tool to the Crop Tool so you can refine the crop that was made to straighten the image. If you would like to specify an aspect ratio (shape of the final image), you may do so by a click and hold while over the Crop Tool. When you're finished, simply choose another tool or function.

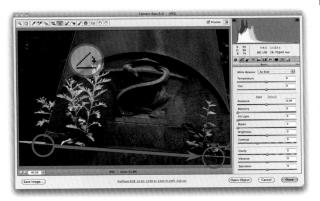

Crop Overlay

Lightroom

Cropping and straightening in Lightroom are even more intuitive than in ACR. When you choose the Crop Overlay, Lightroom snaps a crop to the edges of the image's boundaries. When you resize the crop, a 3 x 3 grid forms so you can use the "rule of thirds" if you like while cropping. When your cursor is outside the crop box, you can drag it to rotate the image

within the crop. While doing so, you're shown a much finer grid so that it's easier to straighten the image at the same time. But if that isn't enough, you can use the Straighten tool (it looks like a traditional spirit level). With it, you drag across a line that you would like to make either vertical or horizontal—Lightroom knows the difference. The crop adjusts to make it so.

Tip: Tap the "O" key for visual composition aids.

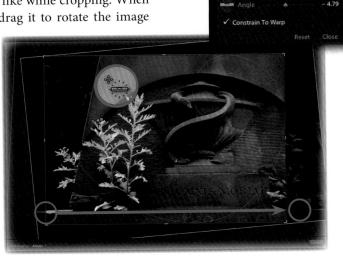

Ps

pixels/inch : Front Image Clear

Photoshop

₩idth: 12 cm

Height: 18 cm Resolution:

it. This gives you the option to hide cropped pixels rather than deleting them. You should zoom in for careful adjustments.

If you know the exact size of the final image, enter a specific Width and Height in the appropriate fields in the Options Bar. When you are finished with your crop, remember to clear the

Select the Crop tool for very precise cropping. Rename the Background layer by double clicking

of any size or shape.

Use the Crop tool to select a portion of your image, but you don't need to be too precise yet,

options by clicking the Clear button. Leaving the Width and Height clear allows for an image

just get a crop box onto the image. Once drawn, adjust the crop by dragging a corner or edge of the box. The dark area outside the crop (the "Shield") dims the pixels that will be eliminated.

After you've drawn a starting Crop, the Options Bar changes. Before accepting the final crop, you can change the opacity of the Shield, or choose to hide cropped pixels rather than delete them! Hiding is available only if there is no Background in the Layers panel (Smart Objects and real layers only please).

Zoom in to ensure that the crop is exact. Drag outside the box to rotate the crop. Note that although it appears you're rotating the

box, the image is what's rotated when you're done. If you extend the crop beyond the image's original edge, you will have to add image to those undefined regions, perhaps using the new (in CS5) Content Aware Fill.

You may experience the "Snap to Document Bounds" feature. This feature is handy except when it isn't. To temporarily disable it, hold down the control / Ctr.

Press the **Enter/Return** key to commit the crop.

To straighten quickly (*and* crop), use the Ruler Tool. Drag along what should be straight, then click the **Straighten** button in the Options Bar.

If you've dragged a crop beyond the original image boundaries, you may get undefined areas. If you select those areas (see Selection Tools and Methods in the next chapter), you can choose Edit>Fill. Then choose Content-Aware from the top menu of that dialog box, press OK, and Photoshop will take pixels from various parts of the image to fill in those blank regions!

Adjusting Color & Tone—Things to Know

Color and tone form the heart of image adjustment, so I thought we should spend a few pages going over some key concepts and interfaces before we start working. If these ideas are familiar, skip ahead a few pages to the actual adjustments.

White Balance

An odd but essential shorthand for quantifying the color of light is white balance. The number used (e.g., 2850 or 6500) is actually a temperature in the Kelvin scale (for more common units, just subtract 273 to get to a temperature in Celsius). Why would anyone use a temperature to describe color? If one heats what is known as a "black body" (something which absorbs all light), it will eventually glow visibly. A temperature of about 3000K is equivalent to a standard tungsten light. In our software, 6500K is considered the same as daylight. That's why 6500K is a target for the white glow of a computer monitor.

When adjusting our images in Camera Raw or Lightroom, one of the first things we do is set the White Balance, specifying the color of the light in the scene so the software can adjust all else. So if the light was very yellow indoor lighting, the 2850K tungsten preset may add the right amount of blue to compensate.

In mixed lighting, both software tools offer a White Balance tool to sample a light gray in the image. Since the software assumes that it's a light *gray*, it will choose the right color temperature (and accompanying tint) to make it gray if it isn't.

The perfect gray for reading the White Balance. This chart is the Color Checker from X-Rite: xrite.com/colorchecker

If there are no light grays in your subject, add one! Carry a Color Checker or similar products (right) or, as one former student does, use a light gray camera bag for a convenient gray patch.

the SpyderCube from spyder.datacolor.com

Passport from X-Rite

Ps

Histograms

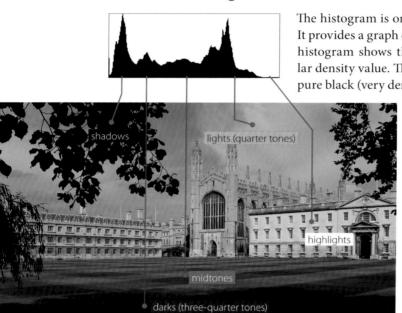

The histogram is one of the key tools in digital imaging. It provides a graph of the density values of an image. The histogram shows the number of pixels at each particular density value. The left-most point of the histogram is pure black (very dense), the midpoint gray, and the right-

most point pure white (no density). A big peak in any of these regions means the image has lots of pixels at this density; an open gap in the histogram means there are no pixels at this density.

Use the distribution of the histogram to determine the overall exposure of an image. The rule of thumb is that most images look best if they contain values at both the dark and light ends. Without some dark and light values, the image may lack contrast and appear flat. If you have a strong

peak at the bright or dark end of the histogram, it's possible your image is over or underexposed. Much depends on the individual image and personal aesthetic.

The histogram is also used to depict the smoothness of tones in an image. Consider a few examples:

1 Possibly underexposed image, or a darker subject

3 Possibly overexposed image, or a lighter subject

2 Properly exposed

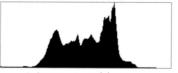

4 Image possibly too "flat" (lacking contrast), or just a foggy day

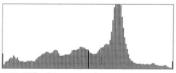

5 "Flat" image that was overcorrected; now posterized

- 1. A histogram representing an image that is likely underexposed, and therefore dark.
- 2. A smooth histogram representing an image with a full range of tones. You can edit this image extensively without concern.
- 3. A histogram for an overexposed image, and therefore light.
- 4. A histogram representing an image that is likely too "flat", and therefore possessing neither highlights nor shadows.
- 5. A histogram with a comb-like appearance representing an image with sparse tones. This image may appear blotchy or posterized, especially when printed.

Photoshop's histogram panel provides a real-time histogram of the active image as it is being edited. In the Photography workspace, it's the top panel that shares a window with both the Navigator and Info panel.

Keep these things in mind when using Photoshop's Histogram panel:

- First, make the histogram display as large as possible. Do this by opening the histogram panel menu and selecting Expanded View or All Channels View.
- Second, the histogram panel uses cached data to update the histogram in real-time, but this cache quickly becomes out-of-date and inaccurate. When this happens, Photoshop displays a warning icon (A). Click on this icon to update the panel and get an accurate histogram.

Of course Lightroom and ACR show a very similar panel. Lightroom's is even interactive: if you drag left or right on different parts of the histogram, tones in the image change.

Tone Curves

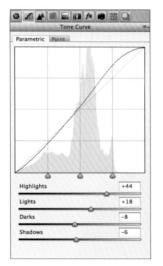

Camera Raw (parametric)

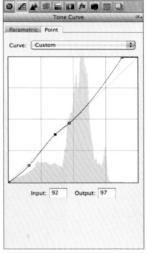

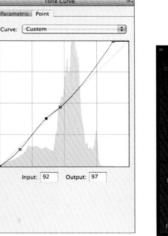

Camera Raw (point)

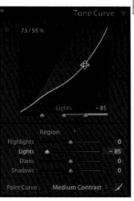

Lightroom (parametric)

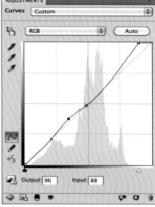

Photoshop

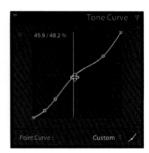

Lightroom (point)

All three of our applications have a curve-based way of adjusting tone (and in Photoshop's case, color). The idea is that we're looking at, and affecting, a graph. Along the horizontal axis are our tones from black (at left) to white. The vertical axis has black at the bottom. A straight line going from the lower left to the upper right, the default, indicates that the tones coming into the adjustment leave unaffected. But if you were to cause, say, the center of the curve to bow upwards, then the midtones will be lightened while black and white remain unadjusted.

Curves are probably the most sensitive way to adjust tone in an image, and we'll spend much time with them later in this chapter.

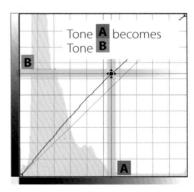

Hue, Saturation, and Luminance

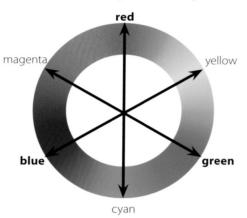

Most of our images may be composed of red, green, and blue data, but we may interact with them in other ways, too. Consider the phrase, "dark, intense red". Those three words describe Luminance, Saturation, and Hue.

Of course, Luminance is brightness. Hue is often expressed as an angle on the color wheel. A 180° change in Hue means changing a color to its opposite. Saturation is a measure of the purity of the Hue: if many hues are mixed, the color becomes grayer, whereas a purer hue is very intense.

Split Toning

Split toning has traditionally been a chemical process done to photographic prints to give tints to different parts of the tonal range. In our adjustments, we can give the darker areas a bluish tint, for example, while giving a yellower tint to the highlights to simulate a warm-toned paper.

Applying Adjustments to Color & Tone

Basic Adjustments

White Balance

Adobe Camera Raw

Basic, the first Adjustment Tab, has the most important controls for global adjustments. The White Balance control sets the overall color balance of the image. The default As Shot setting uses the control values set in the camera when the image was shot. As Shot values often work well, but if the image color seems off, try adjusting the Temperature. The Temperature control makes the image appear warmer (more yellow) or cooler (more blue). The Tint control makes the image appear more green or more magenta.

If there is a light gray in the image, or rather an area that should be light gray, you may try clicking on it with the **White Balance tool**. This one click will set both the Temperature and Tint sliders to make the area on which you clicked a neutral gray. As this is based on the light in the scene, we

choose a light area (not too light, however; there needs to be some tone where you click).

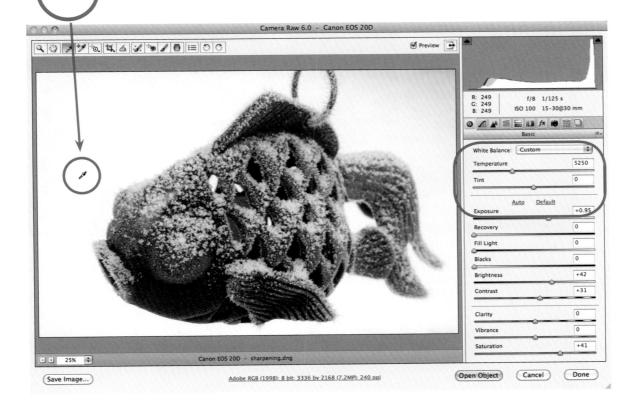

Lightroom

The White Balance eyedropper, located in the Basic Panel, acts like a docked cursor. When you click on it, it "becomes" your cursor and is joined by a very magnified pixel grid (a Loupe) so you know exactly which pixels you're using to set the image's White Point.

While that tool is active, you can zoom the Loupe by mouse scrolling or by using the Scale slider at the bottom of the image (that slider isn't there unless the White Balance tool is active). Once you set your White Balance by clicking, the tool will automatically "dismiss" itself, returning to its home in the Basic Panel.

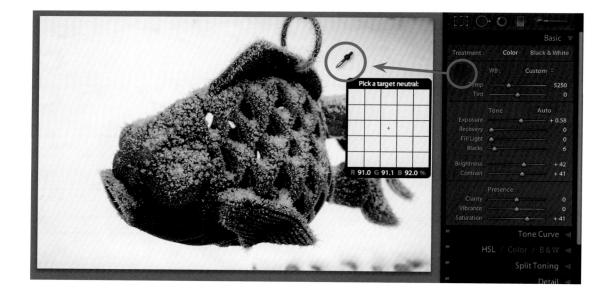

Adobe Camera Raw Lightroom

Exposure and Blacks

After the White Balance has been struck, take a look at the Histogram to see if there is clipping in the image. A helpful aid will be the triangles at the top corners. If one or the other is no longer a dark gray, then you know that some pixels are lost in the highlights or shadows. Other signs of clipping are spikes at each end of the Histogram. Click on a triangle to highlight the pixels that are being clipped. It's not always bad to clip: you may want mysterious shadows or bright reflections without detail.

If you need to see those bright and/or dark details, pull the Exposure or Blacks sliders left. Now, you may have brought back detail, but if the bright areas look muddied or the shadows still need more light, move the sliders to points where the image looks good overall, even if there's clipping in the highlights. You'll need Recovery and maybe Fill Light!

Fill Light and Recovery

If Exposure and Blacks can give only a compromise between good overall brightness and clipping, then you can pull down the brightest pixels with Recovery and illuminate the dark areas (but not the very darkest blacks) with Fill Light.

Brightness and Contrast

You may note that Brightness and Exposure *seem* to do the same thing. But Exposure uses the capture data far more efficiently. So use Exposure and not Brightness for brightness adjustments!

Contrast tends to push the midtones outward towards the ends of the Histogram when increased, so watch for clipping here, too.

Vibrance and Clarity

Clarity is what Adobe calls the local contrast. Its effects are similar to sharpening, so a modest increase in Clarity can improve the apparent sharpness in an image. This slider can be used for a soft-focus effect by dragging it to the left. Portrait photographers may find the effect pleasing.

Vibrance and Saturation are very similar to one another. Either can be used to enhance or subdue the color intensity in an image. The difference is that Saturation can cause a loss of detail in one or more of the color channels (red, green, or blue); i.e., it causes color clipping if the Saturation level is too high.

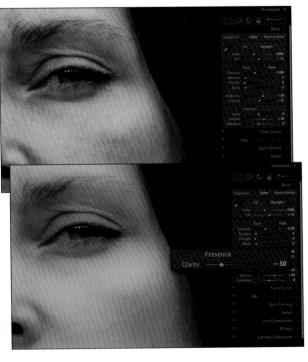

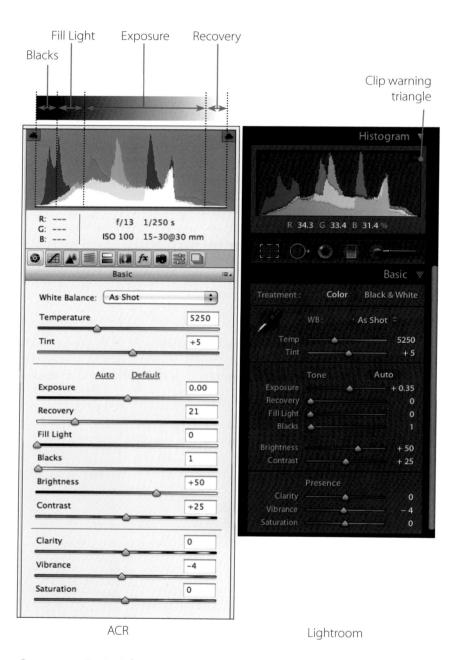

Summary: Basic Adjustments are the most important RAW Adjustments. Use the White Balance tool on a light gray, then adjust the sliders Exposure through Contrast to achieve a mostly balanced image. Watch the Histogram to make sure you're not losing data (unless you want to do so). You can "pump up" colors or make them pastel with the Vibrance slider, and control local (near-edge) contrast with Clarity.

Photoshop

Adjustments in Photoshop are best accessed via the Adjustments panel. Here, I'm choosing a Levels adjustment to make a basic adjustment to highlights, shadows, and midtones.

ADJUSTMENTS Levels

Ps

Levels

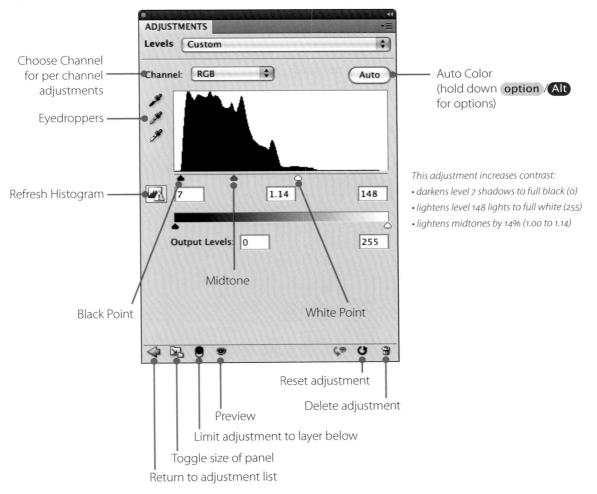

To make basic adjustments to brightness and contrast in Photoshop, use the Levels Adjustment panel. It's the best tool for defining black and white points, making the overall image lighter or darker, and doing quick color corrections. To access the Levels panel, select the appropriate button in the Adjustments panel.

The Levels dialog contains a histogram with slider controls:

- ► The black point slider, to darken shadows
- ► The midpoint slider, to lighten or darken overall
- ► The white point slider, to lighten highlights

The black point slider can be moved to set dark pixels to pure black. All the pixels represented in the histogram directly above the black point slider (and those to its left) will be changed to total black, clipping them, and all the other pixels in the image will be shifted towards the black point, making

the image darker.

increase in image contrast.

The white point slider similarly sets the full-white pixels and makes the image brighter.

Note: watch the Histogram panel while making adjustments. Adjusting both the black and white point sliders stretches the image towards both the black and white ends, resulting in an

The midpoint slider sets the middle-gray pixels. At the same time, it sets all the pixels to its left darker than middle gray, and those to the right brighter than middle gray. This may seem counter-intuitive since you slide the midpoint slider towards the

0 0.41 255

white slider to make the image darker, but the image preview displays the change to the image as you adjust it.

The preview button (the eye at the bottom of the panel) is key to adjustments in Photoshop. Leave it on to see the effect of the current adjustment in the Image window, and off to see the image before this effect. This is great for checking out subtle changes to your image.

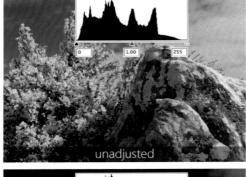

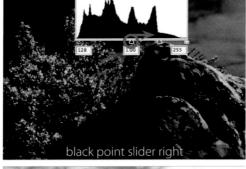

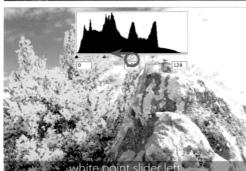

Levels is commonly used with two basic adjustment types: setting black and white points and changing image brightness.

A black and white point adjustment is very simple: drag the black and white point sliders in far enough so the image has some black pixels and some white pixels. This is often the single best adjustment you can make to an image since it ensures good overall contrast.

A brightness adjustment using Levels is also very simple: drag the midpoint slider to the left or right to alter overall image brightness. One of the advantages of the Levels adjustment is it allows changes to the brightness of midpoint pixels without major changes to shadow (black) or highlight (white) pixels. All the Levels adjustments discussed so far have been monochromatic: that is, they don't have much effect on color.

But our images are made of three grayscale images (the channels) that govern red, green, and blue. These can be adjusted individually just like any grayscale image. But these channels are adjusted individually to affect color. This is called a *per channel contrast* adjustment.

Precise Black & White Point Adjustment

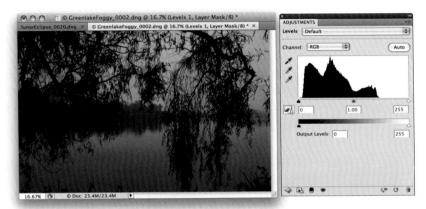

Starting point: flat and drab, with highlights too dark

Most images should have full contrast, from a rich, maximum black to bright white. However, just as there should be good highlight detail, the density of maximum black should be set precisely so the shadows still retain some density variation. A balance is difficult to achieve just by eye. Levels is excellent for precisely adjusting the image pixels to these values.

- 1. Create a new Levels Adjustment: click the Levels button in the Adjustments panel.
- 2. Examine the histogram for your image; ideally, the histogram will cover the full range of tones from black to white. Note which end falls short.

3. Holding the option (Alt key, slide the black input slider towards the right: as you drag, the view of the image will go white, with a few points of black and/or color. The pixels shown as black will be turned pure black ("clipped" to black) by this adjustment. Don't go too far! When you release, the dark pixels in the image will be darker.

4. Next, slide the white input slider towards the left to set the white pixels; pressing the option / Alt key while moving the white slider will show those pixels that will be clipped to white. Typically, the white point should be set so that just a few pixels will display as pure white; you may even wish to pull back the white point from making any pixels pure white (as in portraiture). Solid white parts of the image often appear artificial and may lack smooth details that you might expect in your highlights.

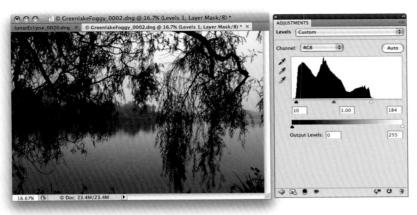

Finished! A full tonal range with pleasing contrast.

Your image should now have maximum contrast from black to white.

For images with smooth highlights (such as portraits), you may wish to maintain a separation between the highlights and pure white. Pushing the whites of a portrait to pure white, even on just one channel, may appear ghastly.

Tone Curves

Adobe Camera Raw

Tone curves are often challenging to new users. But ACR's **Tone** Curve offers a powerful and more intuitive way to make curve adjustments: the "Parametric" interface. It has sliders for each of the four parts of the tonal range, from lightest to darkest. As you drag each slider, the curve updates, as does the image. Tap the "P" key to get a "before and after" view. Again, I encourage you to watch the Histogram to be sure you're not losing important detail.

The three sliders along the bottom of the curve grid are for changing each range's tonal width, e.g., where **Highlights** give way to **Lights**, or **Darks** to **Shadows**.

You may also choose a Point Curve. Click along the line (that is, curve), to create a point at which to control tone. Dragging the point up or down lightens or darkens that tone. With either method, note that contrast is enhanced when the curve is steeper through peaks in the integrated Histogram.

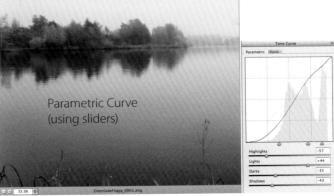

Lightroom

Lightroom's Parametric Tone Curve, where you drag sliders to affect different parts of the tonal range, is a little different from ACR's. In Lightroom, as you hover over a slider, the affected part of that range is highlighted on the curve. It works the other way around, too: as you move your cursor over the curve, the appropriate slider highlights. But it gets better: note the small target–like icon just to the left of the tone curve.

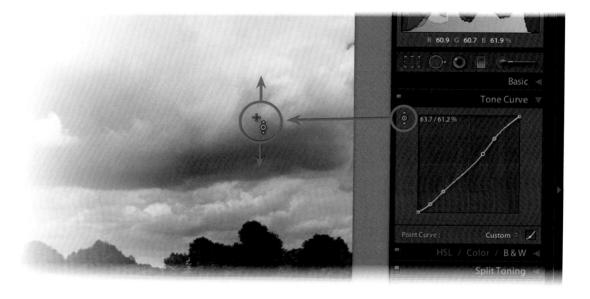

Like the White Balance tool, this is a cursor waiting for you to click on it. Apparently, it's called the Targeted Adjustment Tool (or TAT), but I prefer to call it the "Do-dad". Once you have it, move the cursor over the image. The crosshair is the actual cursor; the target with arrows above and below it is there as a hint. As you move over the image, the curve shows you the tones under the cursor; if you press and drag up and down on the image, you most affect tones like those just under the cursor. So if you press and drag vertically on a very light pixel, your image's highlights will be adjusted, and so on. This will spoil you—there *is* a similar "on-image" editing ability in Photoshop but not in ACR.

Note: Be sure to click the Done button below the image window to dismiss the Do-dad (TAT).

Lightroom also offers a point-based curve like ACR and Photoshop.

Photoshop

Color Balance

To refine the image's overall color balance and eliminate any color cast, use Color Balance. With this tool you can add or remove Red, Green, and Blue from the image. Whereas Curves and Levels are for correcting both tone and color, this tool restricts itself almost entirely to color.

To access the Color Balance dialog, click on its icon in the Adjustments panel (see image at right).

Color Balance actually makes a lot of sense once you understand the basic color wheel theory used in photography and digital imaging (see page 110). In photography and in computers, color is created by mixing Red, Green, and Blue values from the RGB color wheel. (You may have heard of other color wheels used in painting.) Colors complementary to Red, Green, and Blue are Cyan, Magenta, and Yellow-so changes in R, G, & B also force changes in the values of C, M, & Y. It follows then that adding one color automatically implies removing its complement. Adding Red is the same as removing Cyan.

Color Balance is therefore very simple to use. If your image has too

much Green overall, then (and add Magenta remove Green) by moving the slider between Magenta and Green left towards Magenta. careful when using Color Balance to identify the various color casts in your image. Often what appears as a Blue cast (especially blue in shadows) is actually a Blue/ cast, which Cyan requires adding Yellow and Red.

Color Balance also allows you to adjust the colors based on the overall image tone. By default, the tone balance is set to Midtones, so that color changes appear strongest at Midtones and weaker in Shadows and Highlights. This setting works best for applying overall changes to the image color balance. It is also possible to make color changes that are localized to the shadows or highlights in your image by switching to Shadows or Highlights.

Color Balance is useful in order to learn the basics of editing color in digital images because it makes the color "arithmetic" directly accessible.

Midtones Highlights

Curves

To refine your image tones with more precision than Levels, use the Curves Adjustment. Curves is commonly used to adjust contrast in the image and to make precise adjustments to individual tones in the image, often on each channel. It does everything Levels does and much more!

To access the Curves dialog, click the Curves button in the Adjustments panel.

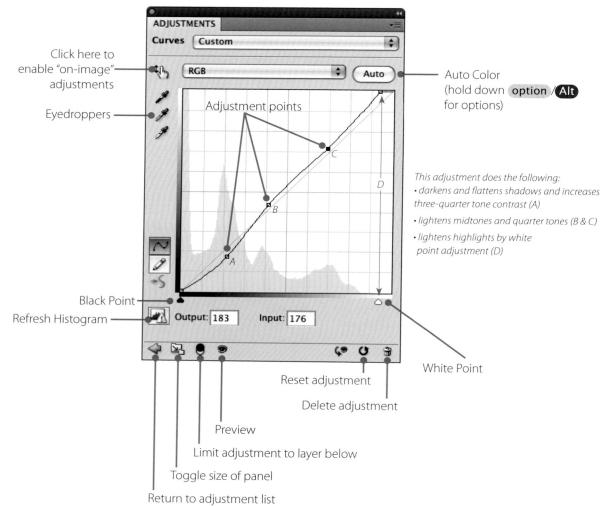

The default curve is a straight line. The straight line maps the input values to the output values, leaving the image unchanged. The horizontal axis represents the input values for the tones; the vertical axis represents the output values. The tones are displayed on the bottom and left of the curve as a black to white gradient. Use this gradient to visualize the various tones as you adjust your image.

To make a simple curve, click on the curve (line) to create an adjustment point, and drag the point upward. (Note: You can also use the keyboard arrow keys to move adjustment points.) This is a classic brightening curve.

Click on another part of the curve to add a second point and drag it around to see the effect on the curve. Points can be removed simply by dragging them outside of the curve box.

In grayscale images, Photoshop reverses the direction of the input and output gradients (from light to dark rather than dark to light), so the metaphor for pushing the curve upward is that you're adding ink or pigment rather than light. View the Curve Display Options by using the panel menu and choosing Curves Display Options, and choose to show 10% increments so you can enjoy finer control of your adjustments.

Some Sample Curves

There are many different types of edits you can perform with Curves. In fact, some Photoshop gurus claim they can do almost everything using Curves. Here are a couple of basic examples for changing image brightness and adding contrast.

To change image brightness, create a Curves adjustment, click near the center of the curve to create a point, and drag the point up, just like in the illustration below. This makes the pixels in the image brighter (except the very brightest and darkest ones).

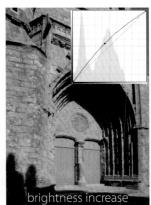

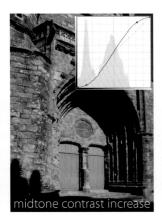

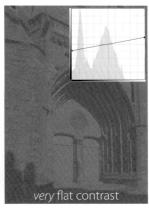

To add contrast to an image, create the Curves adjustment, click on the curve to create a point at the quarter tone of the image (about ¼ of the way from the white point) and another at the three-quarter tone of the image (about ¼ of the way from the black point). Move the quarter tone point upward (brightening the brighter pixels of the image). Move the three-quarter point downward (darkening the darker pixels of the image). Now we have a classic "S-curve". Contrast is added by darkening the dark pixels and lightening the bright pixels. The result is a curve that is **steeper** through the midtones.

Ps

Ps

✓ Point Sample
3 by 3 Average
5 by 5 Average
11 by 11 Average
31 by 31 Average
51 by 51 Average
101 by 101 Average

Copy Color as HTML Copy Color's Hex Code The S-curve preserves the values of the black and white points in the image—it doesn't push any pixels to pure black or pure white.

Very small adjustments made in Curves can make very significant changes to the appearance of your image. Curves is all about subtlety—often, less is more. The preview button (the tiny eye at the bottom of the panel) is extremely useful. Toggle it on and off to check out the effect of these subtle changes.

Finally, remove the other points and try moving the white point straight down almost halfway, and the black point up almost halfway. The "curve" is now almost a flat line. The image has almost no contrast. Could this be why a low contrast image is referred to as "flat"?

Note: Where the curve is steepest, the contrast is greatest. When you add contrast to one part of the tonal range, you've borrowed it from the adjacent part(s).

Curves Adjustment Using Locking Points

We often want to make small adjustments to an isolated range of tones in an image (usually to increase the contrast between these tones) but without changing the adjacent tones. This can be done easily by "locking" the adjacent tones before making the Curves adjustment. Here's how:

Create a new Curves Adjustment.

Click on the pointing finger icon to enable the Targeted Adjustment Tool, then click on a tone that you want to *protect* from change. This tool is for changing tones, too. If you had pressed *and* dragged instead of only clicking, you would be modifying those tones in the image.

Try this: after enabling targeted adjustments, click (without dragging) on an area of dark pixels. Then move your cursor over a midtone area. Press and drag upward on that midtone to raise all the midtones and quarter tones. The shadows should not change much. "Lock points" are sometimes just as important as the points you move.

You want to be sure that as you sample, you are not misled by some stray dark pixel in a predominantly light area or light pixel in a mostly dark area. So control+click / Right-click somewhere in the image, and you'll be presented with a list of dimensions that Photoshop will sample and average, ranging from a single pixel (Point Sample) to an area of over 10,000 pixels (101 x 101 Average). Choose a size that is consistent with the pixel dimensions of your image (larger for a 12-megapixel camera than for a 6-megapixel camera) and the details in your image (e.g., larger for fabric to average over the weave, smaller for smooth surfaces).

✓ Expanded View
Auto-Select Parameter
Auto-Select Targeted Adjustment Tool

If you use targeted adjustments frequently, choose their automatic selection from the panel menu.

ave Black & White Prese

HSL & Grayscale

Adobe Camera Raw Lightroom

HSL

These adjustments control eight different hues from red through magenta. You can shift one hue toward another (e.g., make oranges more red or more yellow), make it more or less saturated (take some red out of someone's face), or make it lighter or darker (make the sky's blue darker and more rich). This is a marvelous way to emphasize some colors and deemphasize others, unlike the saturation controls under the Basic tab.

Lightroom offers two interfaces:

HSL (Hue, Saturation, and Luminance), like ACR's shown here. You're given a list of Hues, and you use sliders to shift them, their saturation, or luminance.

Color Each hue has sliders grouped with it for adjusting hue, saturation, or luminance.

Lightroom's HSL gives you the ability, like the Tone Curve, to use your cursor to change the targeted attribute (H, S, or L) of the hue(s) under the cursor. If the color you drag over is mostly red, but a little orange, the adjustment is proportional to that mix!

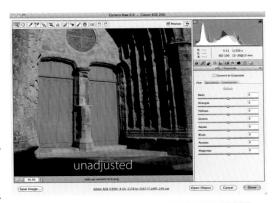

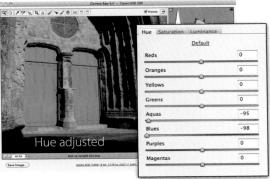

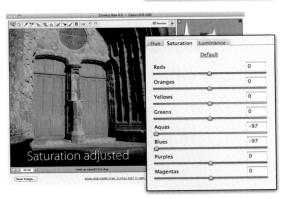

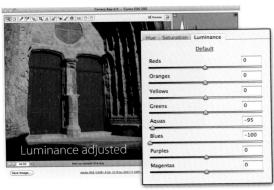

Grayscale

If you check the Convert to Grayscale box (ACR) or on the word Grayscale (Lightroom), eight sliders, one per hue, control the tones of those hues in the underlying color image. Remember, no data is lost in ACR or Lightroom—all that color is really still there but merely hidden.

This mixing is similar to, but infinitely more flexible than, what photographers shooting black and white film would do with colored filters on their lenses. For example, in this image we can decide to emphasize or hide the numbers by lightening or darkening the oranges and yellows in the grayscale conversion.

Above, the yellow/orange numbers in the image are lightened.

Here, they're darkened to almost match the surrounding rust.

Photoshop

Vibrance

Just like in Lightroom or ACR, Vibrance and Saturation can be used to enhance or subdue the color intensity in an image. The difference is that Saturation can cause a loss of detail in one or more of the color channels; that is, it can cause color clipping if the Saturation level is too high. So I recommend using the Vibrance slider if you want to make a global saturation enhancement.

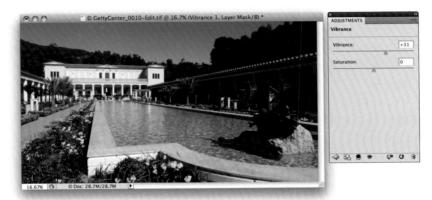

Hue/Saturation

To make changes to individual colors in the image, use the Hue/Saturation adjustment. With it, you can make changes to individual ranges of colors in the image; e.g., you can change the cyan pixels to make them bluer, or you can change the red pixels to make them more saturated. This is a powerful tool for making subtle but effective, or overt and bold changes to colors.

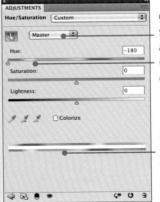

To make a global change, select **Master** and drag slider (Hue in this example)

Note how the lower "rainbow" shifts as you adjust

To access the Hue/Saturation adjustment, click its button in the Adjustments panel.

Ps

When the Hue/Saturation panel is viewed, it defaults to editing all of the colors in the image. Adjusting the Saturation slider increases or decreases the saturation for every color. Adjusting the Hue slider shifts every color in the image; usually, this is not the desired result. Adjusting Hue shifts the adjusted colors around the color wheel—in the example on the previous page, blues are shifted to yellow, reds to cyan, yellows to blue, and so on. The color bars at the bottom of the panel display these color shifts.

Hue/Saturation becomes much more powerful when it is localized to affect only a narrow range of colors. Change the Edit option from Master to one of the listed colors. Now a range is displayed between the color bars.

To more precisely select a specific color, use the on-image adjustment tool (the pointing hand/scrubby cursor). When held over the image, it will look like an eyedropper. Press and drag over the hue you wish to change. The Color range will be adjusted for just this color.

To adjust by hue, use the on-image editing tool (scrubby). **Drag** in the image to adjust the saturation of the hue under the cursor (**#+drag**)

(Ctrl+drag to adjust hue) or choose the hue from the menu and adjust its slider.

The Hue/Saturation tool is very powerful for making subtle (or not so subtle) changes to individual colors by changing the hue, saturation, or luminance of the color. For example, you can make a cyan sky bluer, or make blue water more saturated, and so on.

Black & White

Despite the fact that many designers and art directors choose black and white images only to control costs, black and white photography continues to evolve and create its own artistic path. Since black and white images are inherently abstract, they provide great creative opportunities. Many equate fine art photography with monochromatic images. Most enjoyably, we can edit and manipulate them in so many ways.

In the digital realm, images are rarely shot in black and white, but rather they are shot in

color and converted to black and white. This gives you more flexibility in how individual colors are translated into various black and white tones. If you use a digital camera, shoot all your images in color. If you are comfortable shooting black and white film, definitely continue to do so! "If it ain't broke, don't fix it", is the old saying. But, many opportunities are available in Photoshop to customize a conversion from color to black and white.

Start with a color image that has good density by performing the basic white and black point, brightness, and contrast adjustments on the color image (it is easier to convert a color image to black and white if it starts with good density).

Ps

If you query 100 Photoshop experts as to what is the "best" way to convert from color to black and white, you'll receive about 50 answers. Here, I'll provide a few that have served me well. I will assume you've tried the direct Image>Mode>Grayscale method and found it lacking.

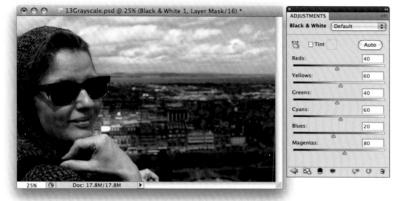

1. Create a Black & White Adjustment Layer by clicking on its button in the Adjustments panel.

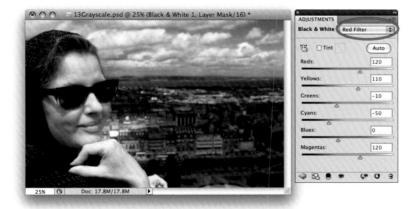

2. There are many presets that can be chosen at the top of the panel. If you choose none, you'll get a generic conversion. If you press the Auto button, Photoshop tries to give a good balance of tones based on the colors in the image. For this image, that isn't such a great choice, though it serves well much of the time. For pictures of people with a wide variety of skin tones, the Red Filter preset is a great starting point.

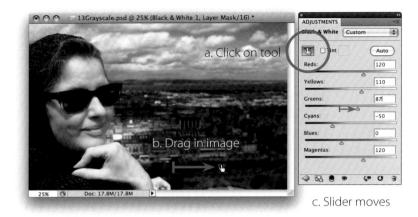

3. Do you remember what color each part of the image was? You don't have to: click with your cursor over the image, and the correct slider's number field highlights! But it gets better: don't simply click, but drag in the image, and the color under the point where you started to drag will get lighter or darker. You can even see the slider moving as you drag in the image.

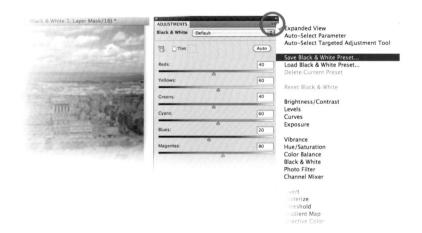

To make a true Grayscale image (one channel), choose Image>Duplicate. In the dialog, give a name that indicates that this is (or will be) Grayscale, and check the Duplicate Merged Layers Only box. Then convert this copy to Grayscale, with your original's color data intact.

4. If you like what you've done and want to apply the results to other images, save your settings as a Preset. At this point, you could click OK to commit the adjustment. If the image truly needs to be in Grayscale mode, I usually recommend making a duplicate.

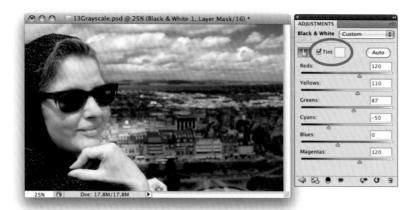

5. To apply a color tone to the image, click the Tint checkbox. Then choose a color with which to tone the image.

Split Toning

Especially useful for grayscale images, but not exclusively so, split toning is the process of colorizing the darker areas of an image with one hue and the highlights with another. This can simulate the look of toned silver (or platinum, etc.) on a differently toned paper.

- Move both Saturation sliders up about halfway (this will be too much, but we'll fix it later).
- 2. Adjust Hues for highlights and shadows (here, I have a warm yellow hue for highlights, and a blue for shadows).
- Readjust the Saturation sliders so they're more tastefully set.
- Optional: Adjust Balance to favor one hue over the other.

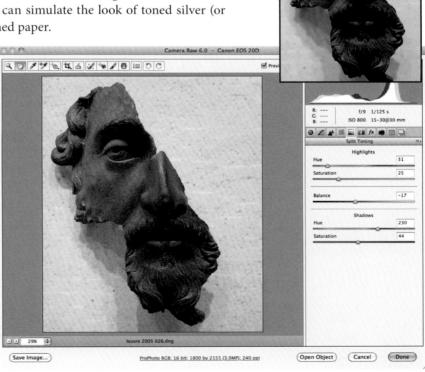

Ps

act

Ps

Photoshop

As long as your image is in RGB mode (if it's in Grayscale, use Image>Mode>RGB), you can tone it to your liking. Split toning is an effect that uses more than one color to tone the image.

We'll do this by applying colors that "map" to the image's shadows and highlights, and transition between these extremes. To do this, we'll use a Gradient Map Adjustment.

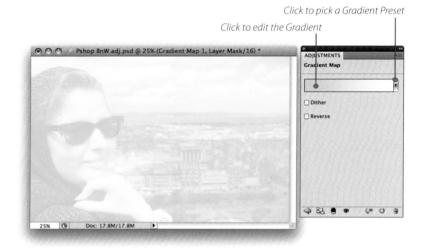

Create a Gradient Map Adjustment Layer by clicking on its icon in the Adjustments panel.

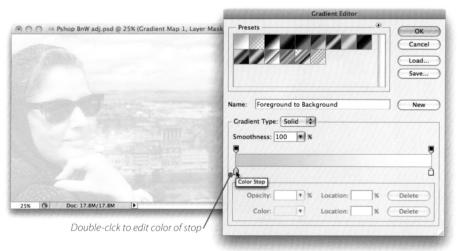

- 2. Don't be alarmed! It's very likely that the colors applied are *not* the ones you want. If there's a Gradient Preset that does have colors you like, choose it from the small menu to the right of the gradient preview. Otherwise, click on the preview itself to edit the gradient.
- When you click on the gradient preview, you get the Gradient Editor

dialog. This dialog would get a chapter of its own if the world were just. But here's the heart of the matter: the Color Stops along the bottom of the gradient can be double-clicked to change the color they give to the

Ps

gradient. For the Gradient Map Adjustment, the color at left "maps" or replaces black in the image, and the color at right replaces white. So, if you want an "old-fashioned" image, you can make a cool toned shadow area transitioning to a cream-colored highlight (mimicking old paper).

- When you double-click on the Color Stops, you get the Color Picker. Here, I chose a dark blue to map to black, and a cream to map to white.
- 5. You can even add more colors to map to intermediate tones. Here, I chose a 50% brightness brown to map to the original's midtones. Note the Location field for the position of the

selected Color Stop. You can think of a Color Stop like its near namesake, the organ stop. Whereas an organ stop lets air through certain chosen pipes, the Color Stop lets color through to certain parts of the gradient. In both cases, we try to be harmonious!

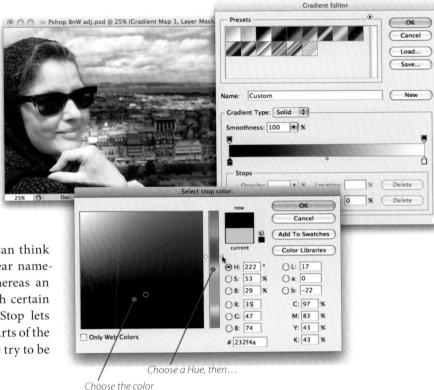

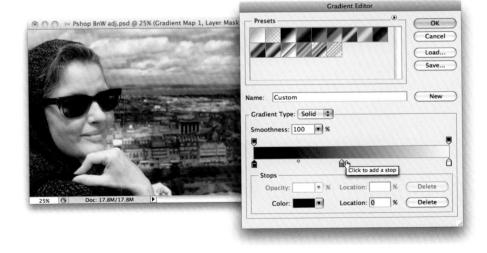

Organ Stops

More Photoshop Adjustments: Simple and Complex

Photo Filters

Often, accurate or neutral color is not enough—or not what pleases. Photoshop provides a nice, simple tool for mimicking color filters attached to a lens. A Photo Filter will add some depth to images that have merely adequate color.

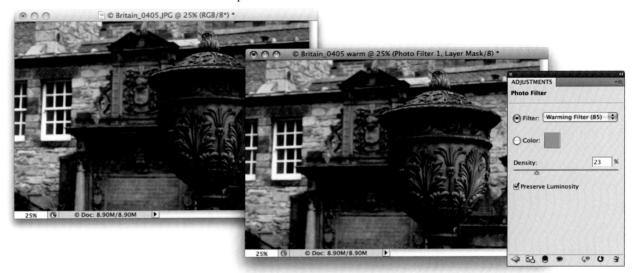

- 1. Create a new Photo Filter Adjustment Layer via the Adjustments panel.
- 2. In the Photo Filter panel, choose a Filter from the menu or, if none of those achieve the desired result, you can click on the color chip and use the Color Picker to specify precisely what color your filter should be. The Warming Filter 85 is often a pleasing filter; it creates a nice warming effect without being obvious. Adjust the Density (intensity) to increase or decrease the effect.
- 3. Note the Preserve Luminosity checkbox. This is equivalent to a photographer adjusting exposure after putting a filter in front of the lens.

Done! The warming filter adds just a touch of extra color to your image.

Shadows/Highlights Adjustment

After making the tonal adjustments so far discussed, the result should have good overall tone. However, the shadows and/or highlights may have become compressed, resulting in flat shadows or highlights with little detail.

The Shadows/Highlights adjustment is an effective and fairly easy-touse tool that allows you to restore some of the detail within the shadows or highlights without making significant changes to the overall tone that you have carefully adjusted. Shadows/Highlights is able to determine the areas of the image that contain shadows or highlights and edit the local contrast within these areas.

The biggest limitation of Shadows/Highlights is that it is not available as an Adjustment Layer, nor through the Adjustments panel; so you will need to make a Smart Object (see chapter 3).

To create a new Smart Object on which to perform the adjustment, select all the layers that make up the image that needs to be adjusted.

control+click / Right-click on one of them and choose Convert to Smart Object from the context menu. The Smart Object will get the name of the former top layer; you may wish to rename it. To get to your original layers again, you just have to double click on the Smart Object's thumbnail and follow the directions that appear.

Open the Shadows/Highlights tool by selecting Image>Adjustments> Shadows/Highlights...

This "adjustment" is really a Photoshop filter (it just hides in the Adjustments menu). So later, since it's been applied to our Smart Object, we'll be able to revisit it and mask its effects!

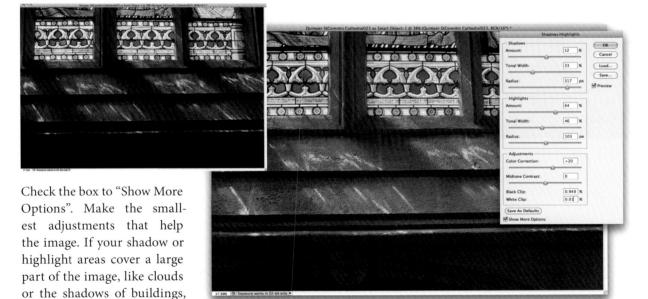

Radius value. Otherwise, adjust it with an eye on important details in the image. Tonal width, a measure of how far from white or black the adjustment should extend, should have a starting point of about 20%. Experiment from there (I often find that it works well at about 33%).

then you will use a large

After you've made the adjustment and clicked OK, you'll see that the Smart Object has an entry for Smart Filters—this adjustment is really a filter and thus can be treated like one. As a smart filter, it can be masked, readjusted (double-click on it), and have its Blending Options adjusted.

Ps

HDR Toning

Not really a way to create High Dynamic Range images, but rather a way to get the look that has become rather popular, HDR Toning is a new (in CS5) adjustment that cannot be applied to Smart Objects, layers other than the Background, or as an Adjustment Layer. You'll have to duplicate the entire image to apply this one. Choose Image>Duplicate..., then give the new document a name. Then choose Image>Adjustments>HDR Toning...

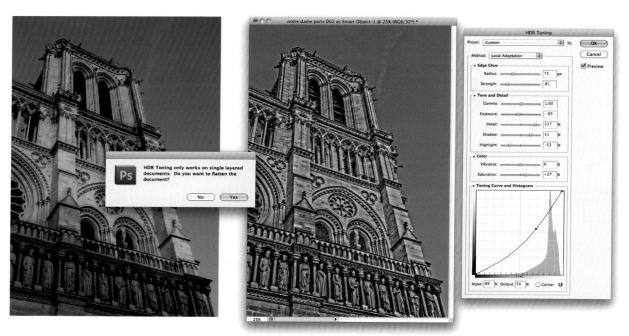

The settings here may give you a starting point from which to begin your own exploration.

Per Channel Contrast Adjustment

Contrast is a complex idea in photography. Contrast is the juxtaposition of differences within an image. Photographers often limit contrast to differences in tone, but it is essential to understand the broader definition of contrast to place it as a foundation of image design. Contrast can involve tone, form, texture, color, saturation, focus, sharpness, or even subject matter—all of which can help define the parts of an image. You should keep in mind the various forms of contrast (tone, color, etc.) in your images.

The image displayed here has a serious lack of contrast (it's "flat") and it also has a strong blue cast. One way to understand the latter is that the blue channel is too light and is letting through too much blue.

Create a Levels Adjustment. You can use shortcuts to examine your channels visually, and similar shortcuts to target them in Levels.

Channel	To view in Image window	To target for Adjustment
Composite (RGB)	% +2 / Ctrl+2	option+2/Alt+2
Red	% +3 /Ctrl +3	option+3 /Alt+3
Green	% +4 / Ctrl+4	option+4 /Alt+4
Blue	% +5 /Ctrl+5	option+5 /Alt+5

Note: These are different shortcuts than the ones Photoshop has had for many years.

Using the shortcuts above to view each channel, you should see in the image window a grayscale image (that's what each channel is). If you don't, you may have to go to the composite channel first ($\Re+2/Ctrl+2$), then to the individual channel.

To correct an image fully manually, target each channel and increase its contrast by dragging the white point and black point sliders inward to the first pixels in the histogram. Only upon the last slider do you know if it will work!

The Eyedroppers let you click on the pixels that should be made neutral white and/or black. Click on the white dropper, then click in the image on a pixel that should be white. Repeat for the black dropper.

See the next page to learn what Auto does and how to control it. So many options—and this is just one adjustment!

Ps

Controlling Photoshop's Auto Color

Photoshop provides a tool for automatic color correction. The Auto Color option is available in the Image>Adjustments menu, but here is a more powerful way to use this tool.

- Create a new Curves or Levels Adjustment Layer via the Adjustments panel. Both Curves and Levels contain a button for Auto Color correction. Hold down option / Alt as you click on that Auto button.
 - 2. The default Auto Correction options are not always the most effective options, but these options can be adjusted. Try both "Find Dark & Light Colors" and "Per Channel Contrast" to see which does a more pleasing *overall* job of color balance.
 - Next, set the Target Clipping values to 0.00% for both the Shadows and Highlights. Place the cursor in each of those fields, then increase the values with your keyboard's arrow keys to find an acceptable contrast.
 - 4. Try "Snap Neutral Midtones". Often, this auto color correction improves the midtones' color, but still may not perfectly color balance the image. One step to improve this is to set the Target Color for the midtones. By default, Photoshop tries to lock the middle tones to an exact gray value, but sometimes these middle tones should actually be close to, but not exactly, gray.

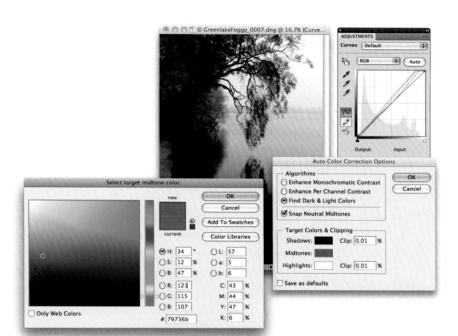

Click on the gray box for the Midtones Target Color; this brings up the Photoshop Color Picker. Change the target midtone color to a color that provides for a better overall color balance. Try selecting some colors that you feel the image needs. Once you have picked a color that makes your image look good to your eye, press OK to accept your color from the Color Picker, *and* click OK to accept the Auto Correction options. It's not likely you will want to make your color choice a new default, so click "No" in the dialog that asks.

5. Make whatever standard adjustments may still be needed.

The image should now have a fairly good color balance. This process works well for a majority of images, but there are still many images that will require manual color correction.

Reference Color

There are lots of techniques for correcting color precisely within your images, yet often the final judge for the quality of the image is simply your own eye. So make sure you have your monitor calibrated and profiled.

A good, if quirky, image to use to gauge both your eye and your monitor is the Getty Images test image. As of this writing, you can download this image via this web address:

http://legacycreative.gettyimages.com/en-us/marketing/services/ Getty_Images_Test_Image.tif Ps

Color Correction by the Numbers

Even with a well calibrated monitor, it is more precise to color correct using numerical values rather than our eyes. This is especially useful when you have something in the image that should be gray or neutral; a color is neutral if the R, G, and B values are all equal. If you have an image that contains something that should be neutral, use this knowledge. Ideally, you might have something bright that should be neutral (like a cloud or a white dress) and something mid-toned that should be neutral (like concrete or stone). If there's a shadow area that should be neutral as well, you can use it also.

- Use the Color Sampler Tool to continuously measure the precise values
 of individual colors in the image. With it, you mark up to four areas to
 be monitored from the Info panel, where the color values will be
 displayed.
 - 2. With the Color Sampler Tool active, change the sample size in the Options Bar to "5 by 5 Average", or larger if the area where you will place the sampler is noisy or grainy.
 - Display the Info panel using Window>Info or the F8 key.
 - As you move the Color Sampler Tool over the pixels of your image, the numerical RGB values of the pix-

els are displayed at the top of the info panel.

5. Examine the image for good highlight, midtone, and shadow areas. These should be areas that you want to be neutral. If your image does not have one of these, then you need another way of knowing the target RGB values. Neutrals are easy: R=G=B.

Tip: The numbers won't be equal yet (that's why we're correcting the image!), but for the midtone, for example, you should look for RGB values that average to about 128.

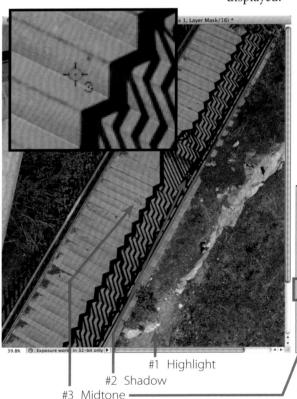

- 7. Choose a Curves Adjustment in the Adjustments panel. You'll now see not just the values are current, but also the adjusted values as you make changes in Curves. They read as Before/After.
- 8. In the Curves panel, choose the on-image editing tool in the image creates a point on your RGB channel curve, but here's a much more useful method, though it's easy to miss: <code>#+Shift+click/Ctrl+Shift+click/C</code>

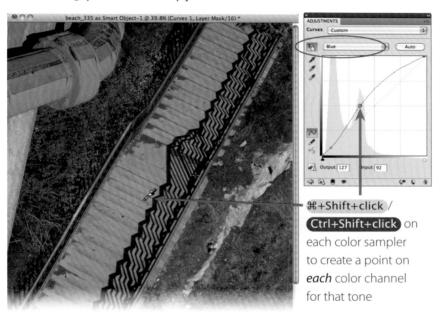

9. To quickly navigate from channel to channel, use the shortcuts listed in the Curves' Channel menu and below:

Channel	To view in Image window	To target for Adjustment
Composite (RGB)	\#+2 / Ctrl+2	option+2 / Alt+2
Red	% +3 /Ctrl+3	option+3 / Alt+3
Green	% +4 / Ctrl+4	option+4 / Alt+4
Blue	第+5/ Ctrl+5	option+5 / Alt+5

Ps

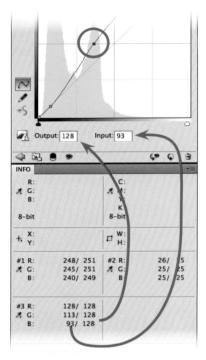

Move the white point left or down (black point right or up) until the desired value is achieved in the Info panel. Here, the target highlight value is 239 and the target shadow value is 18. By moving the black point (normally 0) to the right, Color Sampler #2 for the Green channel is lowered gently.

Summary

With Curves active, you create curve points on each channel, then adjust their midtone values directly and numerically. Then, adjust the black and white endpoints while watching your color sampler values in the Info panel and getting the RGB values close to equal, and therefore neutral. In this image, the greenish cast is now removed.

- 10. With the midtone curve point in the Red channel selected in the Curves dialog, click in the **Input** field (in the lower part of the panel). Type in the "before" value for the Red channel as it appears in your Info panel (the number may already be correct if you clicked in *exactly* the right spot).
- 11. For Output, type in "128" and hit **tab** to get from one field to the other. In this example, 112 units of red will now output as 128.
- 12. Repeat this for each channel. If you have the midtone point selected on the Red channel, the midtone point will be automatically selected on the other channels as you go from one to the next.
- 13. Finally, the white and black points. Navigate back to the Red channel's curve and select the white point (the uppermost right). Unfortunately, if you try to enter values for the light and dark Color Sampler areas, your colors may be hard to control. It's usually difficult to move points that are close to the ends. But it is OK to move the endpoints themselves.

So, if the Curve gets wildly bent when you adjust the highlight or shadow points on any channel, delete the point causing this and move the endpoints instead: left or down for the white point, right or up for the black point. With the point selected, you may use your arrow keys.

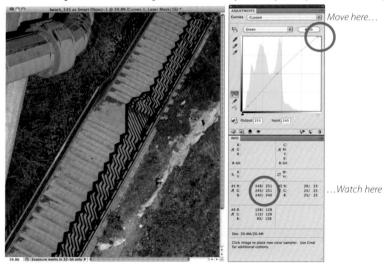

Note: When moving endpoints, keep your eye on the values in the info panel. The Input and Output fields won't correspond to your sampled points.

14. To neutralize the highlight reading is to adjust all three channels' highlight points to be equal to the middle or highest reading. For the shadow point, use the middle or lowest value. In this example, the uncorrected highlight values are 221R, 228G, and 239B, so 239 would be a good target for each channel's highlight point. I moved the Red and Green highlight points to the left and their shadow points to the right.

Noise Reduction and Sharpening

Sharpening should be done here—but only a touch. If you want to start an argument among Photoshop users, the most debated topic may well be sharpening. But I will agree that when it's time to print, you may find yourself doing a tiny bit of sharpening then, too.

Example of noise

Noise Reduction

Digital cameras are electronic devices. The sensors work by maintaining an electrical charge which changes when light hits them. The trouble is that the charge fluctuates constantly. Imagine a music system with the volume way up. The hiss you hear is the result of random electrical fluctuations. (Be sure to lower the volume again!)

In our images, that "noise" is exhibited by colorful speckles in the dark areas that incoming light hasn't been able to overwhelm. Sophisticated blurring is what we'll use to fix that. If your camera's ISO (speed) setting is high, there is more charge on the sensors and more risk of unacceptable noise.

Adobe Camera Raw Lightroom

When you inspect your image's shadow areas and notice colorful speckling, you've found sensor noise. As you increase the Color Noise Reduction, you *may* notice that small, delicate color details vanish with the noise. However, with ACR 6.x and Lightroom 3, a new noise reduction and sharpening

system is in place. Upon opening images that have been developed in earlier versions, you may see an exclamation point in the lower right corner of the image window. Clicking this applies the new algorithm to the image.

Even more risky is Luminance Noise Reduction, as it blurs tonal details away. Both sliders are wonderful when required, but use them carefully. With the software algorithms included in Camera Raw 6 (which ships with Photoshop CS5), you have more control. If you notice an exclamation point in the lower right corner of the image window, you may click on it to update noise reduction and other functions. This may change the appearance of images processed with previous versions of Camera Raw or Lightroom, so watch for those changes. However, so much is improved that I'm willing to live with those subtle shifts.

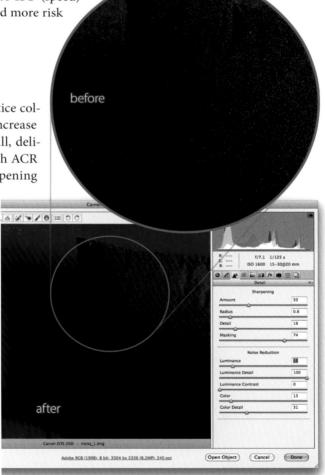

Ps

Reduce Noise OK Cancel Preview Basic Advanced Settings: Default Strength: 6 Preserve Details: 19 % Reduce Color Noise: 52 % Sharpen Details: 25 % Remove JPEG Artifact

Photoshop

Many digital camera images contain some amount of digital noise. The noise is just random density variations. Although digital cameras have reduced noise dramatically, it's sometimes necessary to use the noise reduction filter anyway.

Select Filter>Noise>Reduce Noise to access the Reduce Noise dialog.

Turn off the Preview option in this dialog and look for digital noise. Noise is most noticeable in dark, smooth-toned areas.

Turn the Preview on. For most images the Photoshop default settings for the Reduce Noise dialog are good. Increasing the strength may further reduce noise, but often it begins to soften the image. Don't increase the Sharpen Details option beyond 25%—you can sharpen the image later in the workflow.

If you choose Advanced mode, adjust the noise reduction on each color channel, then go back to Overall to make final tweaks.

In the illustration above, the noise is especially apparent in the pillow (left), but is smoothed after this filter (right).

Sharpening

Whether the lens was not as focused as it should have been, or whether we are just dealing with the inherent *softness* in digital images, a touch (or more) of sharpening can be required. Since we can't actually refocus the world after the exposure was made, we rely on the trick of enhancing the contrast near the edges in our images. Of course, we have to do this subtly so as not to create halos around those edges.

Adobe Camera Raw Lightroom

Four lovely sliders live in both Lightroom and ACR to give us images that are far more acceptably sharp than when they were born. Bear in mind that sharpening is a trick: we're just increasing contrast near the edges of things in our images, so we should show a little bit of restraint and caution.

To see what you're doing, zoom to 1:1 (aka 100% or Actual Pixels). In the Details panel (Lightroom) or Details tab (ACR), note these sliders:

- ► Amount—how much that edge contrast is being enhanced. Too much, and we risk making the image look "crunchy".
- ▶ Radius—Sharpening is a trick that increases contrast at edges. When the Radius is too high, you'll see halos near those edges. It's our job to keep the halos subliminally small. The default of 1 pixel is fine for most digital cameras. If yours is of lower resolution (3–5 megapixels), you should consider a smaller radius. If you acquire 20 megapixels a click, then you may go higher.
- ▶ Detail—the level of detail getting most sharpened: the lowest values weight sharpening to larger edges (good for portraiture); higher values give weight to fine, important texture (as in photos of wood or stone).
- ► Masking—a fantastic way of limiting what gets sharpened. Whereas Detail can *emphasize* texture or larger details, Masking can actually keep areas from being sharpened at all. option+drag /Alt+drag this slider to see a preview: white=sharpened areas, black=unchanged areas.

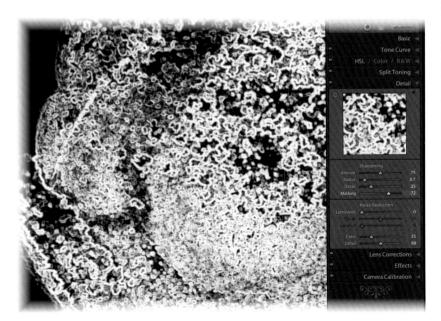

Not sharpened

Sharpened

Ps

Photoshop

Smart Sharpen

Photoshop CS2 introduced an excellent tool for sharpening images: the Smart Sharpen filter. This tool is both easier to use and sharpens better than the venerable Unsharp Mask. You should consider sharpening after you

have resampled your image (as you might just before printing).

If you want to be able to revisit your sharpening decisions, add a Step "0" to your sharpening tasks:

O. Optional but recommended:
Convert the Background or Layer to a Smart Object:
control+click / Right-click on the layer's name in the Layers panel and choose Convert to Smart Object. Then you'll be able to change the sharpening settings later—even weeks later.

1. The image to sharpen should have only one layer; but that layer

can be a **Smart Object** (see chapter 3). Smart Objects are essentially containers that keep your layer data safe. Plus, it's best if your image view is set to View>Actual Pixels, so you can preview the image well.

2. Select Filter>Sharpen>Smart Sharpen.

(OK)

Cancel

pixels

B 8

Angle: 0

More Accurate

Over-sharpening...too easy to do.

- 3. Within the Smart Sharpen dialog, set the Amount to 100%, the Radius to about 1.0 (see previous page), and the Remove option to Lens Blur if that's the issue, or Gaussian Blur if the image is soft from resampling. Turn on More Accurate—this slows down the filter, but the time that you allow this filter to run is well worth it.
- 4. Now adjust the Amount carefully: don't let the image look over-processed. If you find the Amount getting toward 300%, it may be that the image is simply too "soft". Learn to like it that way, or use another image. You may wish to experiment with the Amount to obtain the best sharpening, but be cautious, as too much can create harsh black and white lines ("halos") around any sharp details in your image.

Lens Corrections

Even the best glass can have flaws. When we use wide-angle lenses, especially zooms, and especially on SLRs, there will often be color fringing at the edges of the frame. This is because the lens can't focus all the colors onto the same exact spot. Thus, if you zoom in *very* close (e.g., 400%) on one edge of your image, and you see fringes of red and cyan, or blue and yellow, then these adjustments can be your friend. Move the sliders (or scrubby sliders) only a little at a time. Red/Cyan fringing is more common than Blue/Yellow, but if what you see is Magenta/Green, then you have both.

If you used a filter on your lens, or used the wrong lens hood, then you might have darker corners, or vignetting, in your final image.

Barrel and Pincushion Distortions

When lines in an image that should be parallel bow outward or inward, we say that the image is suffering from barrel or pincushion distortion, respectively. Both of these effects and chromatic aberration are more common in less expensive zoom lenses. They can be corrected with the **Distortion** control.

Convergence

When you aim your camera sharply up, notice how the subject's vertical lines converge as they go up. We can correct for some of this convergence with the Vertical and/or Horizontal Perspective controls.

Vignetting

With some lenses, you may notice that the corners of your images are darkened. All of our applications have provision to lighten those shadows—or add them.

Sensors

Chromatic Aberration

When a lens can't focus all the colors to the same point, you may see fringes of color at sharp edges like tree branches or architectural elements. Most commonly, these fringes are red/cyan, but blue/yellow can be present too. You won't see this in the center of the frame, where all the light rays go straight through the lens, but rather toward the edges of the frame.

Example of barrel distortion

Example of pincushion distortion

Example of convergence

Example of vignetting

Example of chromatic aberration

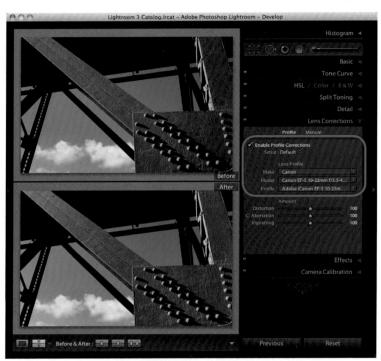

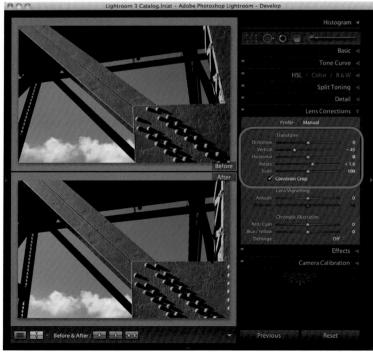

Lens Correction Tools

With a large and growing list of Lens Profiles, corrections for the major lens issues listed on the previous page are no longer difficult or time-consuming to do.

Simply Enable Profile Corrections, and if your exact camera and lens models are found, the correction is done in a moment! If the exact combination isn't available, you may still choose the Make and Model from the available menus.

Barrel and pincushion distortions, chromatic aberrations, and lens vignetting are all corrected. In the example at left, you may not be able to discern the chromatic aberration correction, but the vignetting improvement is certainly noticeable.

If you wish to work with rotations or convergence issues, choose Manual (Lightroom and ACR) or Custom (Photoshop). You may also do adjustments for the issues that a lens profile may not completely remedy. Here, I made the strong lines on the right more rectilinear.

You may use the Lens Vignetting sliders to lighten corners further. If you've cropped the image and now want to *add* some dark (or light) corners, use the Post-Crop Vignette in the Effects tab.

Drag the Amount slider left (to darken) or right (to lighten). Once that slider's been moved, the Midpoint slider awakens, so you can move the vignette farther into the image.

In Lightroom and ACR, you can remove Red/Cyan and Blue/Yellow chromatic aberration one at a time without seeing the other. Hold down option / Alt as you drag first the Red/Cyan slider and

then the Blue/Yellow (the modifier hides the other color fringe). If there is still a hint of abrupt color change near sharp edges, you *may* use the Defringe menu: this desaturates colors at those edges. However, there may be places in your image where desired fringes disappear, too.

Visit Adobe's website to find more on making your own lens profiles and downloading those of other users.

Photoshop

Lens Correction Filter

Photoshop's tool for performing these adjustments is Filter>Lens Correction. Within the filter's interface, you'll find a set of tools for straightening, removing barrel or pincushion distortions, correcting for perspective

(by straightening converging lines), and removing the fringes caused by chromatic aberration. I don't recommend this filter's option to scale up the image to crop it, however. For that, I prefer the control of the Crop Tool.

This filter also uses a database of profiles for camera/lens combinations. You can even create these profiles yourself with the free Adobe Lens Profiler application. Luckily, the combination used here, Canon 1Ds Mk III with EF24–105mm f/4L IS USM set at 24mm, is one of the supplied profiles.

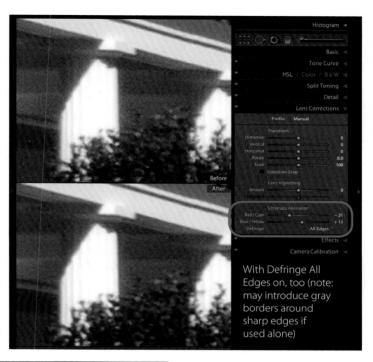

Left: we have vignetted corners and chromatic aberration. The grid helps us see some barrel distortion and slight clockwise rotation.

Below: Lens Profile found! All distortions are cured but rotation, for which the Straighten tool is dragged along horizontal girder. Done!

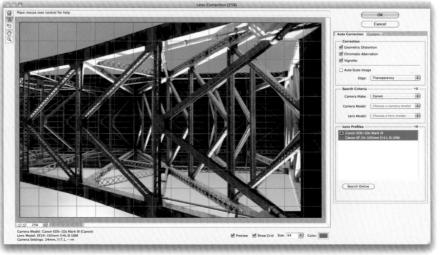

Ps

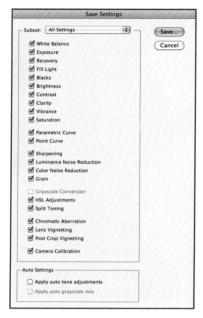

Saving and Using Develop Settings

Presets

If any combination of the many settings we've examined need to be applied to other images, espe-

cially from other shoots in the future, then you may wish to save them as presets.

When you click the tiny menu icon on the right of the tab, choose Save Settings...

In the dialog that appears, you can choose which settings you want to save: individually or by tab (via the menu at the top). This makes it easy to choose a particular group of settings that can be applied at

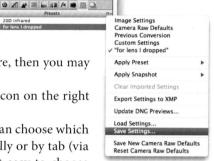

once or in sequence (e.g., a White Balance for *Brand X* lights, another for *Brand Y* lights). These presets can later be found under the Presets tab in ACR.

Once a preset is saved, you may also apply it in Bridge by selecting one or more image thumbnails, then <code>control+click</code> / <code>Right-click</code> on one of them. From the context menu, choose <code>Develop Settings>[preset name]</code>.

Using ACR with Multiple Images

Adobe Camera Raw can apply the same settings to multiple images. This is especially useful for images shot under similar lighting conditions and intended to be displayed together. Images processed together may show some variation in lighting, depending on exposure, but appear to come from the same scene thanks to consistent white balance. Obviously, processing multiple images together can speed up the work.

To open multiple images in Camera Raw:

- 1. In Bridge, select multiple image files and control+click / Right-click on one of the images. Choose Open in Camera Raw... You should probably select images shot under the same or similar lighting conditions. Alternatively, from Photoshop, select multiple RAW images using the File>Open dialog. Photoshop displays the Camera Raw dialog with a filmstrip along the left side with all the selected files.
- Click the Select All button at the top of the filmstrip to select all the images. You may also click on one image in the filmstrip, then use the shift key to select a range, or the #/Ctrl key to select discontiguous images.

- 3. Make adjustments to the Exposure, White Balance, etc., as you would for one image. Evaluate the displayed image as you make these adjustments. Examine the other images (without deselecting) by using the small arrows at the lower right of the Image window.
- 4. Once the displayed image appears accurate, select the individual images in the filmstrip (click on each) to inspect the effect of these settings on each image. Make small adjustments to each image as necessary.
- 5. Click **Done** if you're finished adjusting the images (for now).

Creating Copies for Photoshop Editing

- While editing a number of images in ACR, select the images that you'll want to open immediately in Photoshop, then Click on Open Images to process and open those images in Photoshop. It can take some time to open many images.
- ► Or, click on Save Images to process each selected image and save them. Since you cannot save a processed RAW file, save them in another file format; Photoshop (.psd) is a good choice. If there are many images to process, the image files will save in the background. You'll see a process report near the Save Images button. You may open the first processed image and begin working as soon as it's saved back to the folder.

Lightroom

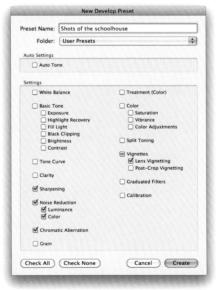

Once you have adjusted an image, you may wish to save the settings, or some of them, so they can be easily applied to other images. Remember that as you import images you can apply a Develop Preset right in the Import dialog! So, if you have settings that work very well for conditions under which you shoot often (a studio perhaps), you should save them and apply them automatically when downloading images from those conditions.

Of course, you can apply saved Presets anytime by clicking on a Preset's name in the Presets Panel (on the left side of your screen). To the right of the word "Preset" is a

"+" sign: this is what you click to save any or all of your current Develop settings as a preset.

Tip: Use Lightroom's Presets preferences to find your presets folder(s). Just click the button to "Show Lightroom Presets Folder...".

Move/Copy these to any computer that should use the same presets.

Copying and Disabling Settings

In the History panel (left side in the Develop module) you'll see a growing list of edits as you work. The difference between this panel and Photoshop's History panel is that the items here never go away unless you clear them! You can return to any stage in the image's life with a single click. Since all the edits you do in Lightroom are nondestructive, and all the edits are metadata, it's easy to do this. So relax and enjoy the process.

The next thing to note is that instead of ACR's tabs that you can see only one at a time, you have panels that can all be expanded and scrolled through. However, some find this to be quite a lot of scrolling. So, in order to see one panel at a time, <code>control+click</code> / <code>Right-click</code> on a panel's header (on the word "Basic" for example), then choose Solo Mode. Each panel's solid disclosure triangle becomes dotted, and as you go from one development panel to another, the previous panel will automatically close. Also, on the left edge of all the Develop panel headers except Basic, there is an on/off switch like we saw with the Filters. This is a nice, quick way of seeing a before and after just for sharpening, for example, or perhaps toggling a color adjustment on and off.

The buttons at the bottom of the Develop panels, **Previous** and **Reset**, apply the settings from the last image developed or clear all settings to their starting points, respectively. You can also **Copy** and **Paste** Develop settings via buttons under the History panel. When you choose to copy an image's settings, you're presented with a dialog box that lets you decide which settings you want to copy and which you don't.

Note: Copying the **Spot Removal** settings is a handy way to remove sensor dust spots in one image, then paste those repairs into all the images that share the same dust problem.

Photoshop

Copying Color Corrections

There are many times when you might wish to apply the same color correction to a number of different images. This generally happens when you have a number of images that were shot under very similar conditions.

It is possible to copy a color correction Adjustment Layer (or any layer) onto another image merely by dragging from the source image and dropping the layer onto the destination image. You can also copy a layer from one image to another by selecting that

layer in the source image and using the Layer>Duplicate Layer command; in the Duplicate Layer dialog, change the Destination Document to the destination image.

Ps

Local Adjustments

7

In traditional photography, a number of techniques have allowed us to alter one part of an image differently than another. In camera, we would use graduated density filters, perhaps tinted ones. The darkroom afforded many more methods: burning (increased exposure), dodging (blocked exposure), highlight and shadow masking, and preexposure. I'm sure most photographers have never dabbled in the latter two—and perhaps they should be thankful, as they are difficult, time-consuming, and prone to dust!

Photoshop has embraced software metaphors for these and other photographic techniques. It's called Photoshop, after all. And Lightroom and Camera Raw have graduated filters and painted adjustments. Combined with Photoshop's many tools for masking adjustments, it has become easier than ever to apply precisely the adjustment we want, and upon only the pixels that require it.

In this chapter, then, we will focus on local adjustments, and the selection and masking tools that make them possible. In these pages we'll start an adventure that may never end: in a room of Photoshop gurus, it's their masking techniques that they show off to each other. Now let's begin to develop yours!

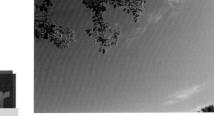

Starting point: The camera was rotated clockwise so the hazy horizon is at the lower right. Let's darken it to match the upper left, then put some "haze" along the bottom of the image.

Graduated Filters

Whether you're working in Adobe Camera Raw, Lightroom or Photoshop, it's possible to make adjustments that affect only parts of an image, or are stronger in one area than in another.

The first method I'll examine is producing a Graduated Filter with which an adjustment effect fades in (or out) from one part of an image to another.

To begin building a Graduated Filter, choose the Graduated Filter tool. Options will immediately appear. ACR's tool is illustrated above, Lightroom's below. They are quite similar, so I'll focus on Lightroom for this example.

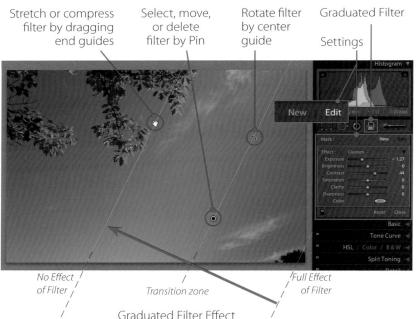

- Click on Graduated Filter (or press "M" in Lightroom, "G" in ACR). Settings drawer appears with New highlighted.
- Configure settings. Just guess!
 If you want to darken, pull
 Exposure leftward. Soft focus?
 Down with Clarity and Sharpness.
 You can change settings later.
- 3. Drag from where you want full effect to where you want none.
- 4. Adjust to taste:
 - ► Move filter by dragging the Pin
 - Compress or expand by dragging end guides
 - Rotate filter by dragging the center guide
 - Adjust settings. Note that Edit is now highlighted
 - Click New to create another filter

The options are not as plentiful as those for a global correction, but they are more powerful than any piece of glass we put in front of our lenses.

In this example, I am creating a "density" filter to compensate for the haze. I want to hide the fact that the horizon isn't parallel to the bottom of the image.

I did not need to colorize the Graduated Filter. If I wished to, I could have clicked on the color box and chosen a Hue and Saturation from the Color Picker. In fact, you can press and drag the eye dropper from the picker to anywhere on screen to select a color there!

Then I adjusted my adjustment. I made sure that my filter was in Edit mode, so as I moved the sliders and the filter itself I could see my image change.

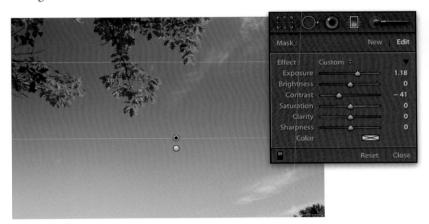

Finally, I added another filter that was essentially the opposite of the first one: lightening and reducing contrast by approximately the inverse of the amounts I used in the first. I dragged this new filter from the bottom of the image upward to create the illusion that the horizon, and a slight haze, were nice and parallel to the bottom of the image. Sneaky!

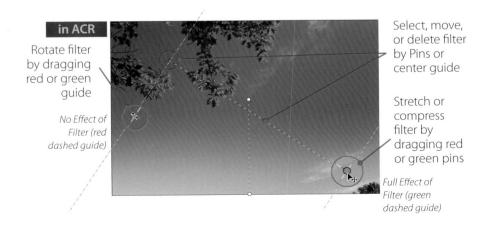

Photoshop

A Graduated Adjustment

In Photoshop, we can gradate any adjustment. There isn't one specific tool for the task, but instead, we use both Adjustment Layers and the Gradient tool, which can make many different types of gradients. Here are a few steps to get started.

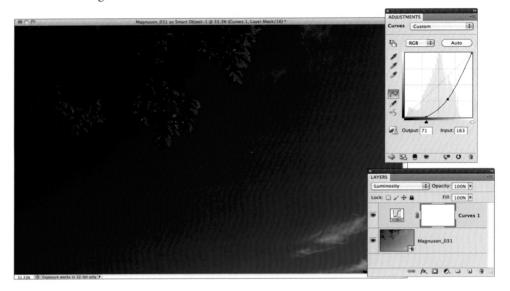

Here, I'm illustrating an adjustment similar to the one described in the preceding section. But remember: any adjustment can be gradated, and the initial settings have to be a guess.

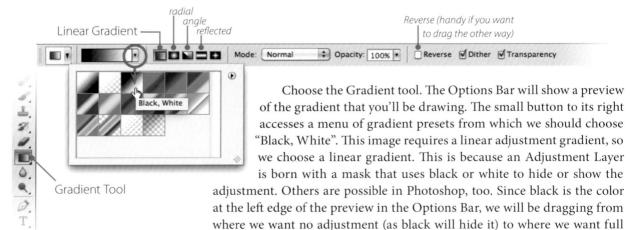

adjustment.

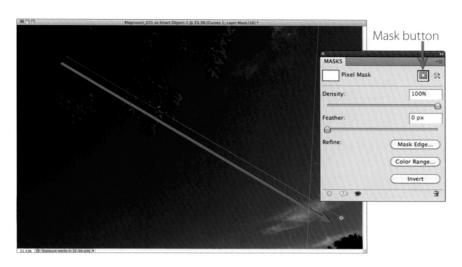

Just to be sure nothing is amiss, access the Masks panel: be sure you see "Pixel Mask" at the top. If not, click the mask button to bring it to the fore. You still have the Gradient tool, right? Drag from where you want no effect to where you want full effect. Use the Reverse checkbox in the Options Bar if you prefer to drag the opposite way.

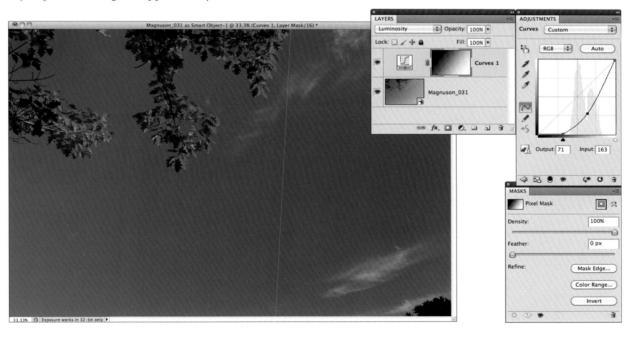

Have a look at your workspace: the mask on the adjustment layer will gradate from black to white. You should see this in both the Layers panel and the Masks panel. If it's backwards, click **Invert** in the Masks panel.

Graduated Photoshop Filters

Near the end of the last chapter, I discussed appying a few filters to images. In particular, it would be useful to review the section on Smart Sharpen. In that discussion, I said that an optional but useful step was the conversion of the layer or layers you want to sharpen to a Smart Object. To target an area for any filter effect, that step is really essential.

To convert the Layer(s) to a Smart Object: control+click / Right-click on the the layer's name in the Layers panel and choose Convert to Smart Object. If you followed my advice earlier in this book, you will already have a Smart Object if you're moving an image from Lightroom or ACR to Photoshop. Adobe Camera Raw's Workflow Options will change to "Open in Photoshop as Smart Objects", or from Lightroom, to "Open as as Smart Object in Photoshop". Soon you'll know why!

Apply the filter you want (like the Gaussian Blur I've used in this example). When you're done, notice that there's a Filter Mask listed under the Smart Object, and it's fully white, for now. You may target it for your gradient by clicking on its thumbnail in the Layers panel or on the appropriate button in the Masks panel.

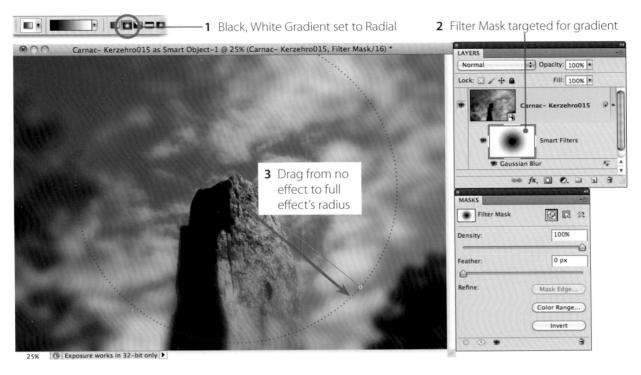

In the example above, I changed the Gradient tool options to create a Radial "Black, White" gradient. I dragged from where I wanted the image to remain sharp to a radius where it should be blurry. Note how the edges of the image have a ghostly blur to them while the center remains sharp. At this point, I can redraw the gradient and it will overwrite the previous one, or I can double-click on the Smart Filter entry for Gaussian Blur to edit the amount of blur applied to the edges of the image. And there's more!

Take a look at the Masks panel. If I lower the Density, the black part of the mask becomes lighter. This means the area formerly protected from the filter is now showing some blur. If that displeases, I can always return the Density to full, 100% again.

Photoshop has about 110 filters. OK, I admit that I haven't counted them lately, but there are enough to fill a weekend with experiments. Most of them can be applied to Smart Objects, so most of them can be masked and gradated. In fact, if you apply more than one filter to a Smart Object, that one mask will govern them all.

A last point: if the Smart Object was a RAW file (or DNG) that was passed to Photoshop from Lightroom or ACR, then double-clicking on the Smart Object thumbnail will let you edit the RAW settings in ACR again. This won't affect the original, but only the RAW data now in this Photoshop document. But this means you can combine the power of those RAW adjustments with Photoshop filters and continue to tweak and balance them until the image is exactly what you envisioned it should be.

Painting Adjustments

Adobe Camera Raw Lightroom

The adjustments that are available for being painted are the same as those for Graduated Filters. There are additional controls for affecting the qualities of the "brush" one is using to apply those adjustments, such as size and hardness. One additional control that is worthy of exploration and experimentation is Auto Mask. When active, this feature samples the pixels where you start to paint your adjustment, then applies that adjustment only to similar pixels.

1 Choose Adjustment Brush (tap K)

2 Guess initial adjustment

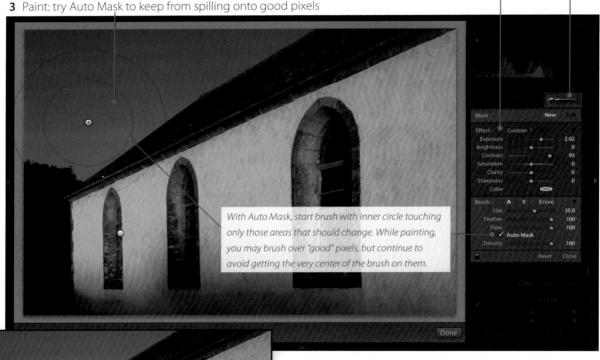

the final result

We'll start with an image that needs some help. Here, I chose the Adjustment Brush from the tools (above left in ACR, just under the Histogram in Lightroom). I configured the brush to lighten and increase contrast.

I also configured the brush to be somewhat large and soft (using the Size and Feather Sliders), then started painting on the sky with the inner circle on the sky (note the indicator Pin). From then on, I needed to keep only the very center of the brush off the other pixels.

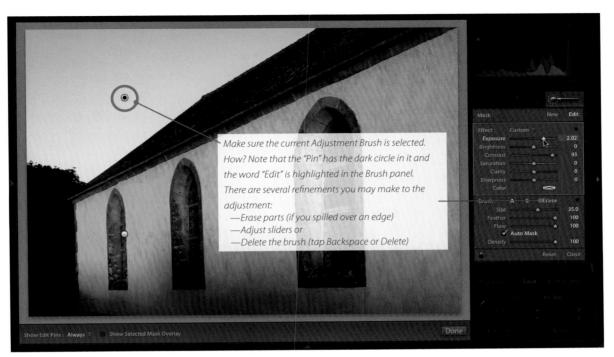

In Lightroom, if you hover over the pin, the cursor changes to allow you to drag. Dragging left diminishes the effect of the adjustment, while dragging right increases it. If any of the sliders that control the adjustment are at maximum or minimum, however, you may not be allowed to exceed those values.

You may apply more than one Adjustment Brush, too. Just click on New, change the settings, then begin painting. Here, I chose to use Auto Mask to keep a lightening adjustment on the structure. You may readjust the effect of any brush by clicking on

Check the Mask:

Hover your cursor over the Pin, tap "O" on the keyboard, or use the checkbox below the image to see your mask as a colored overlay. Change the color by tapping **shift+O**.

its Pin, then moving the sliders. You may also select a brush's Pin, then click the Erase button to paint away the effect. Using Backspace or Delete removes the adjustment.

Sometimes I start with an exaggerated adjustment so I can see where it's being applied, then reduce its effects as I've done here.

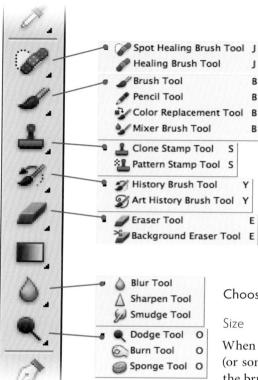

Photoshop

Understanding Photoshop's Painting Tools

There are many tools in Photoshop that use a painting metaphor (*left*); that is, as you click or drag your cursor across your image, either color or another effect builds up where you've dragged. Although there are many possible configurations of brush settings, we will focus on the three primary brush qualities that all these tools share: Size, Hardness, and Opacity.

Usually, a brush appears as a circle as you move the cursor over the image. The ability to edit the brush quickly and easily makes overall editing much easier. The basic techniques for manipulating brushes are so important that I have listed the steps here. Refer back to them whenever I introduce a new tool that uses brushes.

Choosing and Building Brushes

When you move a brush over your image, Photoshop displays a circle (or sometimes another shape) that represents the size of the brush. If the brush is very small, Photoshop displays a small crosshair. You can change the brush size easily in one of three ways:

- ► control+click / Right-click somewhere in the Image Window then choose a size in the box that appears.
- ► Use the square bracket keys, "[" (for smaller) or "]" (for larger).
- control+option+drag / Alt+Right-drag horizontally while watching the orange mask grow or shrink.

Once you become accustomed to the keys, it is much easier to select an appropriate brush size.

Brush Hardness

Sometimes you'll want the "paint" to blend into what's already there, and sometimes you'll want to produce a nice hard edge. To control this, set an appropriate Hardness for the brush, from 0% for very soft to 100% for a sharp edge. There are three ways to give your brush a harder or softer edge:

- ► In the Image Window, control+click / Right-click, then use the slider to choose a hardness value in the box that appears.
- ► Press **shift**+ [or]
- control+option+drag / Alt+Right-drag vertically while watching the orange mask get fuzzier or sharper-edged.

Brush Opacity

There are times when you'll want to apply a brushstroke lightly or heavily. In general, do not change brush color to change density—rather, change brush opacity. When using the Brush Tool, opacity represents the amount of color a brush puts down as you drag the cursor across your image. By changing opacity, you change how thickly you apply the color with the brush: 10% opacity for very thin coverage, 50% for heavier coverage, etc.

You can change the opacity level via the Opacity slider in the Options Bar, or by pressing the number keys: 1 for 10% opacity, 2 for 20%...up to 9 for 90% and 0 for 100%. When you press these keys, note how the brush opacity changes in the Options Bar. Press two numbers rapidly for more precision. For the Brush Tool, this is literally the opacity of the stroke, but for tools like the Blur Tool, Opacity is called "Strength" and is a measure of the intensity of effect.

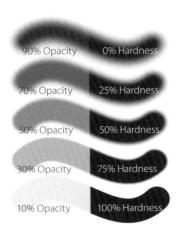

Choosing a Color

HUD (Heads-Up Display):

Access by control+option+\(\mathbf{#}+click\) /

Alt+Shift+right-click and hold while

painting. You may release the keys, but not the

Color panel:

27

Look for a thin black border. Here, it's on the Foreground. Just pick a color from the spectrum or use the sliders. One click on the black-bordered chip brings up the Color Picker. The gray-bordered chip can be targeted by single clicking on it.

Color Picker:

mouse, when HUD is active.

Summoned when you click on the Foreground or Background color at the bottom of the Tool panel. Colors may be specified by several numeric methods, or by choosing a hue (bar in center) then choosing brightness and saturation.

The Brush Tool uses the Foreground color as its paint color; interestingly, the Eraser Tool uses the Background color as its color, but only on the layer called *Background*. For Layer and Filter Masks, the best colors for painting are often the default colors of humble black and white. Use the **D** key to set the default colors.

If you need to switch the Foreground and Background colors, use the **X** key, or click on the small, two-headed arrow between the foreground and background colors.

If you click on the foreground or background color squares, Photoshop will display the Color Picker. Use this or the new HUD (Heads-up Display) to select colors. When the Color Picker is open, click on a Hue from the bar of color near the center, then choose from the large square on the left how light (top to bottom) and how saturated (left to right) a color you want. Remember: the Color Picker almost always requires these two clicks. On the right are fields where you might enter numerical values for colors. To summon the HUD, control+option+%+click/Alt+Shift+right-click and hold the mouse button down while choosing a color. This takes a little practice, but becomes much faster than the Picker.

A Simple Exercise with the Paint Brush

- 1. Select the Brush Tool—simply press B.
- Create a new layer: Layer>New>Layer... Give it a name like "painting exercise".
- 3. Move the cursor over your image and you'll see a circle, i.e., the brush. Resize the brush using the methods given on page 166.
- 4. Use the HUD or click on the foreground color and choose a color from the Color Picker. Paint with the brush on your image. Change the hardness of the brush via the methods listed on page 166.
- 5. Change the Opacity using the number keys. Paint some more. Click on the background color square and choose a color. Click OK. Switch between the foreground and background colors by using the X key. Reset your colors back to the defaults by clicking the D key. Even with a low opacity value, you should be able to paint a part of the image to pure black or pure white by repeatedly painting over the same spot.
- 6. Next create a new Adjustment Layer; Color Balance is easy to try. Hold down the option /Alt key while you choose the Color Balance adjustment from the Adjustments panel. Name this new layer "Lots of Red". In the Color Balance dialog, make a strong adjustment by moving the Cyan/Red slider all the way to the right.
- 7. The image will now appear very red. The "Lots of Red" layer will also appear in the Layers panel. Be sure "Pixel Mask" is at the top of the Masks panel.
- 8. Use the paint brush tool to paint on this layer mask. If your brush color is white, you'll merely be painting white onto a white mask, so start with a black brush. Remember, pressing X switches the foreground and background colors. You should be able to mask the red adjustment.
- Experiment with changing the brush size, edge hardness, color, and opacity. Notice how using a soft-edged brush and a moderate opacity can make the painted edges appear softer.

Make a habit of using the keyboard shortcuts/modifiers mentioned in this section as you work with the brushes so you won't need to move your mouse away from the image with every change. This will make editing a breeze.

Painting Adjustments Example: Dodging & Burning

Dodging results in lightening part of the image; burning results in darkening part of the image. Dodging and burning also affect local contrast. Dodging a light area of an image will reduce the local contrast; burning a light area of an image will increase it. The converse applies for dark areas. This technique uses two Adjustment Layers created via the Adjustments panel.

We'll start with this dark image and add some light to it, but only where we want it.

Starting point: a very dark image

Dodging

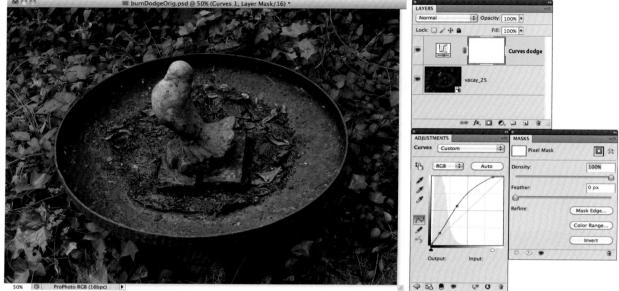

1. Hold down the option / Alt key while you choose the Curves adjustment from the Adjustments panel. This will give you a chance to name it "Curves Dodge" or similar.

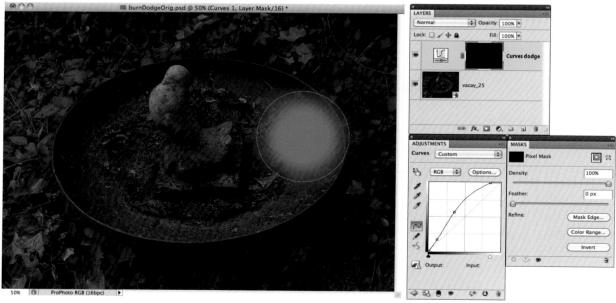

2. Use the Invert button in the Masks panel to hide the lightening effect—the mask is now filled with black.

3. Choose your Brush Tool and set the colors to their default if they aren't black and white. Adjust the size of the brush and choose a low hardness. Also, to dodge with subtlety, set the Opacity low, e.g. 25%. We'll be more bold here and leave the Opacity at full.

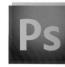

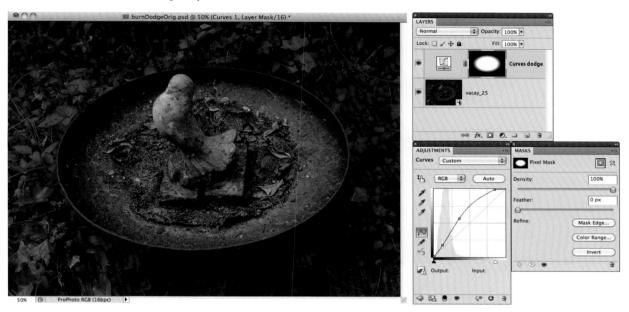

4. Paint with white on the Dodge layer's mask. With a soft-edged brush, the effect is subtle at the edges.

Ps

Burning

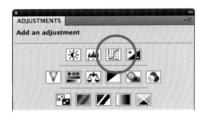

- 1. Hold down the option /Alt key while you choose the Curves adjustment from the Adjustments panel. This will give you a chance to name it "Curves Burn".
- 2. Use the Invert button in the Masks panel to hide the darkening effect.
- 3. Choose your Brush Tool and set the colors to their default if they aren't black and white. Adjust the size of the brush and choose a low hardness. Also, to burn with subtlety, you could use low Opacity.
- 4. Paint with white on the Burning layer's mask. Where the Opacity is low, you can build up effect by repeatedly painting over an area.

Precise Area Adjustments: Photoshop Only

So far, the local adjustments we've done have been rather loose in their application. True, you might use very small brushes and apply subtle adjustments, but sometimes you need to be precise and efficient. For that combination, creating good selections and generating masked adjustments from them is the ideal course.

A To-Do List

I have to say it: it's as easy as 1-2-3! However, each of these three steps can be involved. I'll list them here for convenience, then I'll go into the details involved in each step, explaining the vocabulary and concepts mentioned in this brief outline.

1. Make a selection. Once you've identified the image area to adjust, make a selection of this area. There are several good selection tools to use: the Quick Selection Tool, Color Range, the Marquee tools, and the Lassos. Use the best tool to make a basic selection, but the selection doesn't have to be perfect. Add to the selection with any selection tool using the shift key, subtract from it with the option / Alt key, or invert it using the Select>Inverse command.

You may also combine selection tools and painting tools to create your selection using the Quick Mask. You might need to refine that selection, especially around difficult areas like grass, hair, and other wispy things. If the selection edge needs adjusting, use the Select>Refine Edge command.

2. Make the adjustment. Create a new Adjustment Layer from the Adjustments panel. Photoshop automatically creates a mask based on the selection you created! Any pixels that were partially selected will be partially adjusted, too. The mask makes the adjustment apply only in the area of the selection.

One adjustment you might want to make is the Shadows/Highlights adjustment, but it is not available as an Adjustment Layer. To perform this adjustment, you must first create a Smart Object. Once you create a Smart Object, select Shadows/Highlights from the Image>Adjustment menu. You'll notice it's applied as a "Smart Filter". Indeed, you can apply many filters to the Smart Object, and they will be masked to your selection.

Work with the adjustment (or filter) until it provides the correct image. Don't worry if the area of the adjustment is not exactly correct at this point. It'll be good enough to visualize the adjustment.

3. Refine the mask, if necessary. Despite our best efforts while making selections, we sometimes simply don't see small errors until we think we should be done. So a final mask refinement is often necessary.

There are several tools for editing a mask. With Adjustment Layers, the mask is automatically selected for any edits. The most common options for editing a mask are found in the Masks panel (Feather, Invert, and Refine Edge). It is also common to paint on it using the Brush Tool. Refine Edge is the same powerful tool for making selections, but it's now found in the Masks panel.

Ps

Selection Tools & Methods

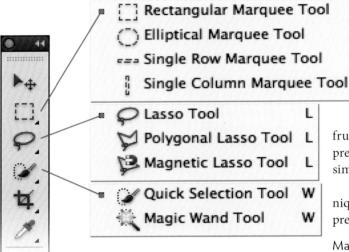

Given the task list for localized adjustments, you need to familiarize yourself with selection techniques. Selections can be quick and easy; most take less than 60 seconds. Some are more difficult. Users often try way too hard to create a very precise selection. With the basic selection tools this can be very

frustrating. There are definitely times when a very precise selection is needed, but most often a fairly simple selection is a great start.

Here are some of my favorite selection techniques. They're not listed in any particular order of preference. Try them all.

Marquee Tools

M

The Rectangular and Elliptical Marquee Tools are often maligned because of their simplicity. It's often easiest to make a very quick selection with a few clicks of these tools, feather this selection, and use this selection to make a quick localized adjustment. Pick the Elliptical Marquee Tool from the Tools

Rectangular Marquee Tool

Elliptical Marquee Tool

Single Row Marquee Tool

Single Column Marquee Tool

panel. If Rectangular Marquee is displayed, click and hold to display the Elliptical Marquee Tool underneath. (You can also select the current Marquee Tool by pressing the M key, and switch between the Rectangular and Elliptical Marquee Tools by pressing shift+M).

Make a few passes with a Marquee over the image part you want to select. Hold down the shift key to build up an irregularly-shaped selection quickly.

If you select too much of the

image with the Marquee, you can undo the most recent addition easily by hitting <code>\mathbb{H}+Z</code>/Ctrl+Z. Or you can subtract a piece from the current selection by holding down the option /Alt key while making a Marquee over the part you want to remove. This is an easy way to take a quick bite out of an existing selection.

Feathering

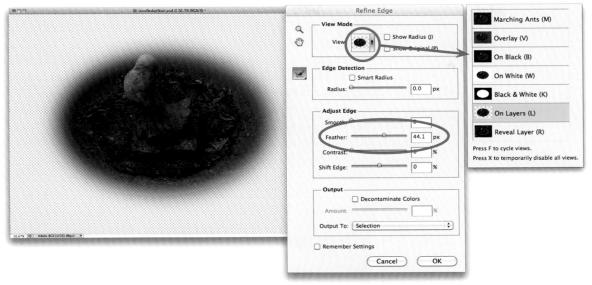

When making a selection using a Marquee Tool, you often will want to feather it to soften its edge. This is especially true in nature photography where perfect rectangles and ellipses are rare. Make the edges soft enough and the irregular edges of the selection won't be noticeable in the final image. Use Select>Refine Edge, choose a View mode that helps you visualize the feathering, then use the Feather slider.

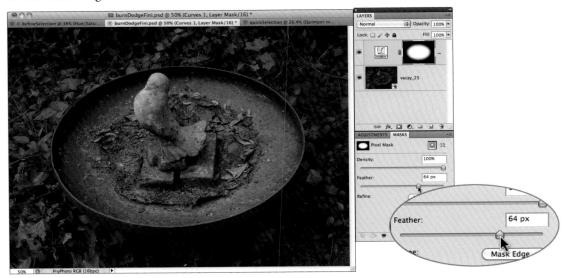

Above, the Adjustment Layer Mask is feathered *after* the adjustment is applied. A disadvantage to this method is that no part of the mask will be sharp-edged as long as the Mask Panel Feather is set higher than 0. However, you can use that panel's Refine Mask Edge button and get the same awe-some options as there are for the selection's refinement.

Ps

The Lasso Tools are easy tools for making quick, rough selections of irregular-shaped objects. You can then feather these selections to soften the roughness. I prefer the Polygonal Lasso Tool over the traditional Lasso Tool as it feels a bit easier on my overused wrist (a lot of years on computers). The Lasso Tool simply requires you to draw a selection on the screen in a free-hand manner, but the Polygonal Lasso allows you to make a series of clicks—more for greater precision, fewer for a less precise, more faceted selection. Choose the Polygonal Lasso Tool from the Tools panel. If the Lasso Tool is displayed, click and hold it to display the Polygonal Lasso Tool underneath. (You can also select the current Lasso Tool by pressing the "L" key, and switch between the Lasso Tools by hitting shift+L.)

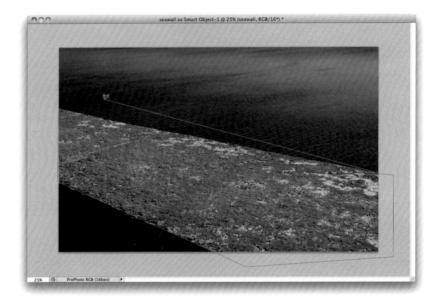

Use the Polygonal Lasso Tool by clicking along the edge of the area you want to select. I like working in one of the Full Screen modes (accessed by tapping the F key). If you come to the edge of the image in one of those modes, or after simply enlarging the image window (as above), click outside of the image (in the gray or black around it) to select pixels right along the edge. Click on the first point to complete the selection. Don't try too hard to make a perfect selection because you'll often feather or otherwise refine the selection you create with Lasso Tools.

Quick Selection Tool

This tool selects pixels intelligently, and it gets more intelligent as you build a selection. If you are trying to select an object in a photo, like the door in the example below, simply drag the cursor much like you would paint. Photoshop reads the pixels over which you paint, growing a selection to include pixels similar to the ones over which you dragged! This is based on color, tone, and proximity to where you're painting.

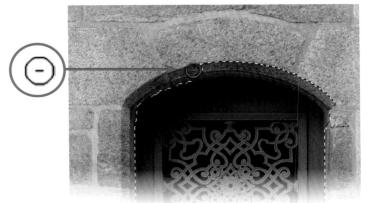

If Photoshop includes too many pixels, hold down the option / Alt key while dragging over the unwanted pixels; Photoshop will remove them, and pixels like them, from the selection. With this tool, you can build a complex selection very quickly.

As with painting tools, you can change the size and hardness of the brush you use to make selections.

Often, however, Quick Selections have imperfect edges. As we generally make masks from these, we can wait until they're masks and refine them using the Masks panel's Refine Edge function; or, we can refine the edge of the selection with the nearly identical Select>Refine Edge command. It's great to have choices! I usually wait until I make a mask. That way, I can see if and how much refinement is necessary.

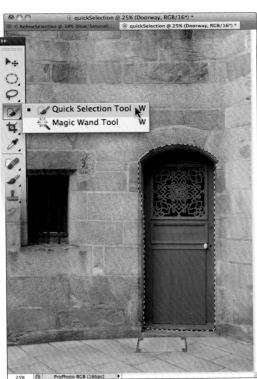

Ps

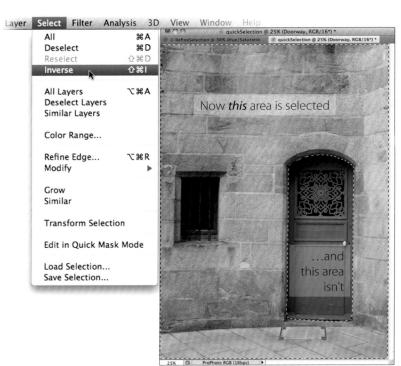

Inverting the Selection

It's often easier to select pixels that you don't want than to immediately select those you do. Just make a selection of everything you don't want, and then invert the selection by using the Select>Inverse command. In this example, it's easy to select the door with the Quick Selection Tool and then invert the selection to make a selection of the walls, window, and pavement.

An adjustment can then be applied to all but the area originally selected (below).

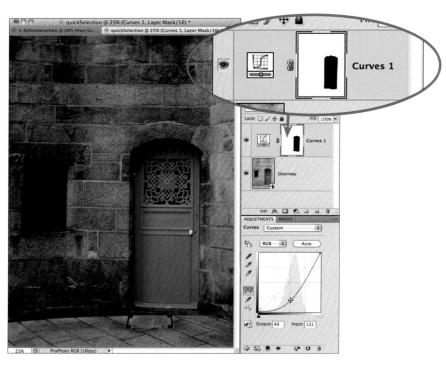

Color Range: Highlights, Midtones, Shadows

Color Range lets you select various tones (or colors) in your image. Selecting the Highlights selects the highlight pixels and also partially selects pixels with a density between highlights and midtones. That is, there will be pixels that get only some of the adjustment you are about to make. It's like feathering but based on a pixel's similarity to the ones you target. To make a quick density selection, choose the Select>Color Range... command to open the dialog. Use the Select menu at the top of that dialog box to access the options for Highlights, Midtones, or Shadows, as well as preset colors. It displays a map of the pixels that will be selected as white, and the ones that won't be selected as black. Grays are for partially selected pixels.

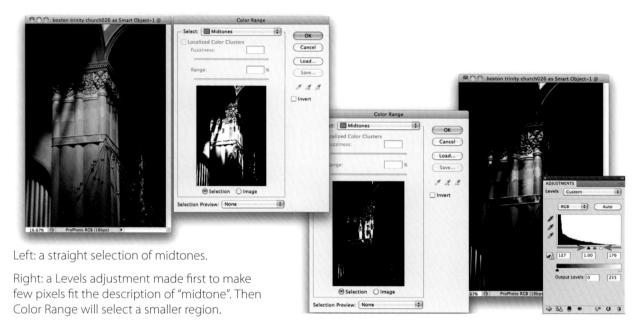

Photoshop selects a predetermined range of tones for each of the selections for Highlights, Midtones, or Shadows. These often work well for making a quick selection, but sometimes you may want to select only the darkest shadows or a more specific range of midtones. To target these precise tones, make a temporary Adjustment Layer to lighten or darken, or increase or decrease contrast, forcing the areas you want to select to fall into the expected range. For example, if you create a temporary Levels Adjustment Layer that increases contrast, this narrows the range of pixels that will be selected when choosing Midtones. When you're done, throw away the temporary Adjustment Layer.

Ps

Color Range: Sampled Colors

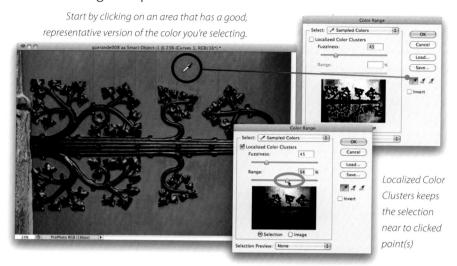

Most often, Color Range selects a range of pixels when you click on the image and Photoshop selects those and similar pixels. Open the Color Range dialog by using the Select>Color Range menu command. Create a selection based on a sampled color by clicking on a color in the Image Window. You may control+click/ Right-click to set averaging. The window in the Color Range dialog displays a black and white version of the selection it creates.

If you would like it to use proximity as well as color similarity, check the box for **Localized Color Clusters**. This engages a feature much like the Quick Selection Tool. The Range slider affects the size of the area within which you make the selection.

Color Range has one significant advantage over other tools. Like them, it completely selects pixels that are very similar to the pixel you click on. But it also partially selects pixels that are less similar to the pixel you click on, thus providing built-in feathering based on the sampled colors. The Fuzziness slider lets you adjust how broad a range of pixels will be selected or partially selected; increasing the fuzziness results in a larger selection.

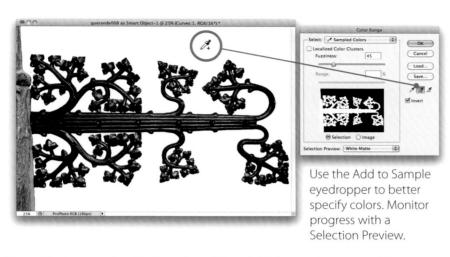

You will also use the "Add to Sample" and "Subtract from Sample" eyedroppers to increase or decrease the range being selected. Combined with Fuzziness, these allow you to define a very specific range of colors to be selected.

You can also display a Quick Mask over your image that shows the

selection by changing Selection Preview to Quick Mask, or a matte surrounding the selection (as in the example above) in either black or white.

If Color Range selects too many pixels, try reducing Fuzziness to limit the number of selected pixels. If Color Range selects too few pixels (very common), don't immediately increase Fuzziness. Rather, sample additional pixels by using the Add to Sample dropper or by holding the **shift** key and selecting more pixels.

You can restrict the area Color Range sees by making a selection before you activate Color Range. For example, if you want to select just one of several green objects in an image, you can make a quick selection using a simple tool like the Polygonal Lasso. When you open Color Range, the selection is restricted to pixels inside the first selection.

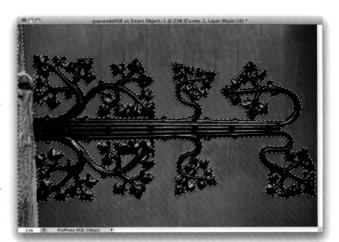

Ps

Refining Selections

Selections can be built by combining multiple selection tools: in fact, it's often easiest to do so. With any of the Tools panel selection tools, hold down the **shift** key while making a new Marquee to add the new area to the existing selection. Remember to *build* a selection rather than expect one tool to make a great selection in one quick step.

Take a chunk out of a selection by holding down the **option** / Alt key while making a new Marquee to subtract it from the existing selection. Use different tools to build up a selection from multiple pieces.

Refine Edge

Photoshop offers an elegant interface to refine your selection before you add your Adjustment Layer or Smart Filter, or after in order to finesse its mask. Refine Edge is my favorite way to feather a selection so it has a more natural edge. This interface allows you to better visualize your selection, and to refine its edge at the same time.

Choose Select>Refine Edge... which is also in the Options Bar for any selection tool.

When you open the dialog, you'll see five sliders, a couple of menus and checkboxes, and a few tools. The View Mode menu lets you visualize the selection and its refinement in seven ways! I usually press the F key to cycle through them and the X key to toggle them on and off. Hover your cursor over each choice for a note to explain it.

Radius sets the maximum distance from the original selection edge that Photoshop will look for other edges in the image. Those edges will then be used to influence the edge of the selection! The Smart Radius will try to tighten the radius around edges automatically within your slider-specified radius. If your selection already has fuzzy edges, you'll need a larger Radius set-

ting for really fine detail (as with selections involving hair).

The Refine Radius Tool allows you to paint more (or less) radius where you feel it's needed (on hair or splashing water, perhaps.)

Contrast makes fuzzy selection edges look sharper. Use the Black

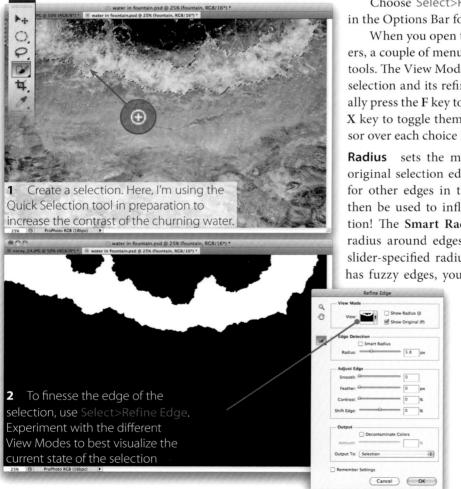

& White View mode (tap the K key) to see what I mean. Increase the Feather amount, introducing soft, fuzzy edges to the selection, then increase the Contrast to see an example of the effect.

Smooth smooths rough, "crinkly" edge selections. The Feather and Contrast combination is similar.

Feather, as mentioned above, gives a blurry edge to the selection so it blends into its surroundings.

Shift Edge is especially good with fuzzy selections when they're a little too big or small. Beware: the higher your Feather or Radius, the more this slider will affect your selection!

Let experimentation guide you. You'll soon find that selections of objects that are translucent will benefit from liberal painting with the Refine Radius Tool. Those involving hair seem to like large radii and generous painting with Refine Radius Tool. Larger file sizes, i.e., pixel-rich images, will need higher values in all sliders than smaller images.

Feathering a selection makes some of the pixels along the edge of the selection "partially" selected. Partially selected pixels result in a mask with some intermediate (gray) value,

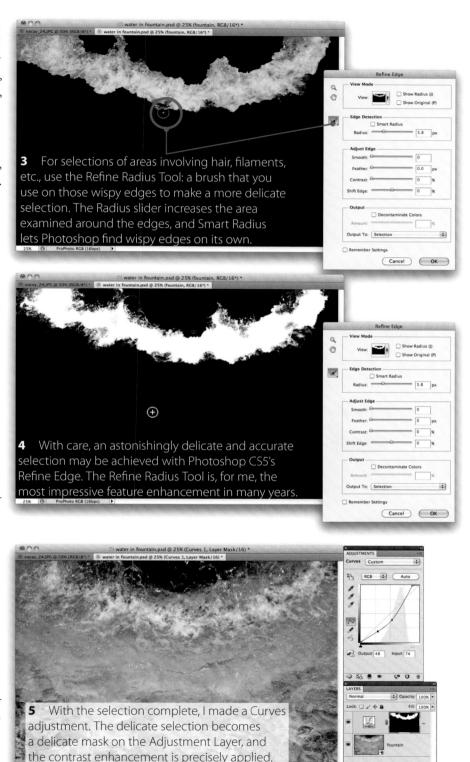

neither completely masked (black) nor completely visible (white). Pixels that have a gray mask have only a portion of an adjustment applied. This provides for a range of pixels along the edge of the selection to display a smooth transition from the complete adjustment to no adjustment.

What makes the Refine Edge interface in Photoshop CS5 so wonderful is that it supplies a great balance of white, black, and gray (or selected, nonselected, and partially selected) pixels, which are absolutely required for selections of hair, grasses, and blurry and translucent objects.

Saving Selections

There are times when you want to save a complex selection, perhaps to continue its refinement, or in case clients change their minds. When you use the Select>Save Selection... command, you create an extra channel in the Channels panel. These extra channels, called alpha channels, are rarely seen by anyone but you, the imagemaker. The first few channels, Red, Green, and Blue, are the foundation of your image. The extra ones I liken to stuff I store in my basement, amidst my house's foundation.

You're storing these channels in order to reload them later. Also, there are some Photoshop functions that can use alpha channels to limit their scope (like Content Aware Scaling) or to indicate depth (like the Lens Blur Filter). For now, let's focus on the simple use of saving a selection.

Alpha channels are grayscale images that can be edited. This is yet

another way to refine a selection. You may paint on an alpha channel, or use filters on it, or even do tonal adjustments to affect the balance of light to dark pixels. Why would you? Because when you reload an alpha channel as a selection (Select>Load Selection...), the light areas are selected, and the dark pixels are unselected. After using Color Range and Refine Edge, this should sound familiar.

To have the power of image editing tools while working with selections, without the overhead of extra channels, consider Quick Mask Mode. This creates a *temporary* channel on which you do image edits. Leaving Quick Mask Mode returns a Marquee.

Using Quick Mask

Imperfect Selections Many of the selection tools make decent selections, but they may still have imperfections. It's common for the Quick Selection Tool or Color Range to make a good selection but leave small, unselected areas within the field of color selected.

Painting Quick Mask Mode is an easy way to edit a selection by just painting using the Brush Tool. Quick Mask Mode makes it possible to edit a selection as if it were an image, using any of the image editing tools in Photoshop. I used the Brush Tool in the example above.

Engage Quick Mask Mode by pressing the Q key. Turn it off by pressing Q again. You can also enter Quick Mask Mode from the bottom of the Tools panel, or use Select>Edit in Quick Mask Mode. Photoshop shows you're in Quick Mask Mode by displaying "Quick Mask" in the image title bar.

Before you start painting, open the Quick Mask Options dialog by double clicking on the Quick Mask Mode button in the Tools panel. The Options dialog allows you to set the color for displaying the Quick Mask. A bright red color works for most images. If you want to change the color to something that will contrast with the image, click on the color square to bring up the Color Picker and pick a different color. Click on OK to close the Quick Mask Options dialog.

You can now use the paint brush to paint onto the Quick Mask. Just select the Brush Tool, set the paint colors to the default colors of Black and White (simply press D), then paint. Painting with white paints away the Quick Mask and therefore grows the selection; painting with black adds mask and creates less selection. Press the X key to switch the foreground color from black to white. Use the square bracket keys ([or]) to make the

brush larger or smaller. The mask appears in the image as a semitransparent overlay. Once you have painted the selection you want, press the **Q** key again to switch out of Quick Mask Mode and display your selection as a Marquee.

Be careful in Quick Mask Mode. Quick Mask Mode merely changes the selection into an image that overlays the main image. Most of the standard Photoshop tools still work in Quick Mask Mode, including the selection tools, but this can cause some confusion about the current state of the selection in Photoshop. It's usually best to switch to Quick Mask Mode, paint the selection, and then switch right out of Quick Mask Mode again.

Last Note on Selections

These are the selection methods I use most often. The best way to learn them is to experiment with them. Don't get caught using one tool all the time; it might be great for some selections, but very difficult for others.

Choose Your Adjustment

Once you have made your selection and refined it, immediately create the Adjustment Layer or Smart Filter for your target adjustment. I often say that selections have little purpose other than to be converted into masks.

Create an Adjustment Layer and perform the specific adjustment you determined at the beginning of this process. Photoshop automatically converts the selection into a mask for this Adjustment Layer.

If you need to convert a layer into a Smart Object (because the adjustment, such as Shadows/Highlights or Lens Correction, is not available as an Adjustment Layer), control+click / Right-click on the layer's name in the Layers panel and choose Convert to Smart Object.

Now you can apply the Filter or Adjustment as a Smart Filter. The result should be an Adjustment Layer or Smart Object Layer that contains the appropriate adjustment, and a mask that localizes this adjustment to a part of the image.

Refining the Mask

The final task for localizing adjustments is editing the mask. Often the mask is just fine for the adjustment you want, in which case you can skip this step. But the mask might be further improved by some basic edits.

I use two main methods to fine-tune a mask: painting and refining.

Painting on the Mask

Make some simple changes to a mask by painting on it. Be sure to select the mask for painting. Just click on the mask in the Layers panel to select it or click the mask icon in the Masks panel. (Otherwise you might paint on your image.)

Select the Brush Tool from the Tools panel, set the foreground and background colors to the default values (white and black), and start painting. Painting black adds to the mask (hides the adjustment) and painting white removes the mask (reveals the adjustment). Change the size of the brush using the square bracket keys ([or]). Paint more gradually by changing the opacity of the paintbrush to paint gray values on the mask.

Refine Mask Edge

This is identical to refining the edge of a selection. Often the selection may not have been feathered sufficiently, or you may have painted the mask using a hard-edged brush. You'll be surprised how many carefully prepared images are improved by feathering or otherwise tweaking the mask.

To permanently and irreversibly blur a mask, simply select Filter>Blur>Gaussian Blur and adjust the radius of the blur. The filter previews the result of this edit. You can use any filter on a mask, provided it can be used on a grayscale image. This opens up many possibilities! But to do a simple blur, you may also use the Masks panel's Feather slider. This provides a reversible way to blur a mask.

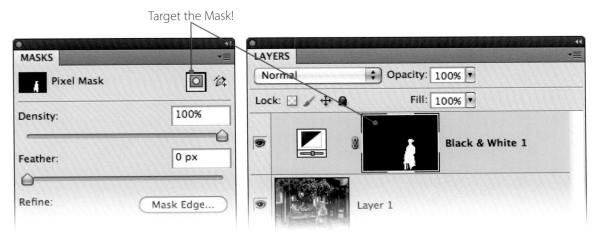

Targeting the Image or the Mask

One of the biggest challenges that many new users have with Photoshop is determining if a layer or its associated mask is selected. It isn't very obvious in the Photoshop interface.

If you click on an image thumbnail, that layer's image is selected. You can tell by the addition of a thin black line around the image thumbnail in the Layers panel, and by a "color-mode" reference in the image's title bar—typically RGB, CMYK, or Gray. Any painting or other editing then directly changes the image part of the Image Layer.

If you click on the associated mask thumbnail for a Layer, the mask is selected. You can tell by the addition of a thin black line around the mask thumbnail in the Layers panel, and by a "Layer Mask" reference in the

image's title bar. Any painting or other editing then directly changes the associated mask of the Image Layer. The Masks panel will also give an indication that you are editing the Pixel Mask.

Inadvertently editing the wrong element (image vs. mask vs. adjustment) is probably the number one problem users encounter when editing adjusted images in Photoshop. Don't worry, though. If you happen to edit the wrong element, just undo the last step, select the element you really want, and repeat the edit. <code>#+Z/Ctrl+Z</code> is your ally! Use <code>#+option+Z/Ctrl+Alt+Z</code> for going back more than one step.

Reducing Local Color Casts (e.g., Teeth Whitening)

Digital cameras and color film can both produce skin tones with too much red or magenta. Sometimes shadows exhibit too much blue. And those of us who photograph people often find ourselves whitening and polishing teeth in Photoshop, too.

Each of these issues can be dealt with fairly easily with a roughly targeted Hue/Saturation adjustment.

- Make a rough selection of the area that has the color cast (select the redfaced person's face, the yellowish teeth, or the bluish shadows, excluding things of that hue that shouldn't be adjusted).
- 2. Create a Hue/Saturation Adjustment Layer via the Adjustments panel.
- 3. In the menu at the top of the panel, pick the hue that needs help. If, for example, you are trying to make a magenta cast in skin merely reddish, choose Magentas. In the example on the next page, I selected yellow. You may also click on the problematic color in the Image Window with the Targeted Adjustment Tool (TAT).
- 4. Refine the range of color affected by clicking in the image on the color you're trying to change and by moving/narrowing the adjustment slider (between the spectra at the bottom of the panel).

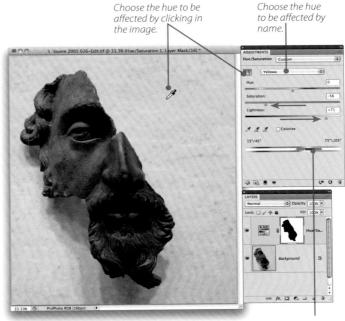

Further refine affected hue by narrowing the range of hues—the darker gray is under the hues most adjusted. Dragging the lighter gray patches broadens or narrows the "ramp" of hues.

Tip: for teeth whitening, start with yellows, click on a tooth with the TAT, then desaturate and lighten.

- 5. For this example and the others mentioned, lowering the saturation is one adjustment that helps reduce a cast. I also lightened this example a bit.
- 6. If necessary, paint white or black on the Adjustment Layer's mask to spread or limit, respectively, the effect of your adjustment.

Cleanup and Retouching

8

Once, I was asked to be interviewed on the radio. The topic? Photography. I was apprehensive, as radio is not the most visual medium. But it became clear that I wouldn't have to find my inner poet to describe pictures. The interviewer was deeply interested in the power of Photoshop to change photographs, and the ethics around that power.

It's easy get into a discussion about the ethics of retouching. But there are many kinds of retouching, from the wholesale reshaping of people to removing the traces of sensor dust. In this chapter, I hope to introduce you to the tools that can get you, too, into many interesting conversations!

Removing Dust & Blemishes

Cloning

The way retouching has been done from very early in Photoshop's history is by "cloning" pixels from one part of an image and using them to obscure blemishes we don't want. The mechanism is a tool that uses a brush metaphor, called the Clone Stamp Tool in Photoshop or Spot Removal in Lightroom and ACR. Quite simply, it simulates selecting an area, copying it, then pasting it elsewhere, but very quickly.

Healing

An advancement over Cloning, the Healing function uses the same painting procedure as Cloning, but rather than simply making an identical copy of the pixels used, it blends them into the new area by pulling color and luminosity from the surrounding pixels. In a way, Healing clones texture only, drawing on the context used to determine color and tone.

In Photoshop, there are three tools that can "heal": the Spot Healing Brush, the Healing Brush (my favorite), and the Patch Tool. ACR and Lightroom use the same Spot Removal Tool but have a provision for setting it to either clone or heal.

Filling

For many years, Photoshop has had a Fill command that does far more than pour a color onto the canvas. However, CS5 brings a new and important twist: Content Aware Fill. This function automatically pulls parts of the surrounding image into a void in an attempt to fill it. It sometimes does odd things, but most often, it astonishes.

Adobe Camera Raw

Spot Removal Tool

To use the Spot Removal Tool, you must choose it from the tools at the top of the Adobe Camera Raw dialog box.

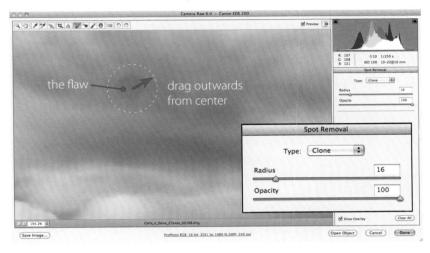

1. Line up the cursor on the *center* of the flaw you wish to remove. Optional: adjust the size of the brush by using the [and] keys. Then hold down the mouse button and, without releasing, drag outward encompassing the flaw.

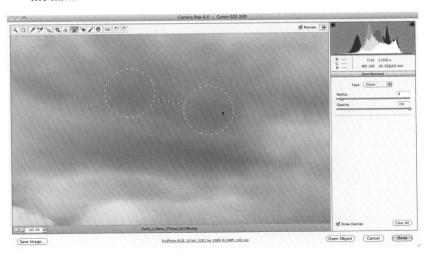

2. ACR will now show a red and white circle around the flaw and a green and white circle around its guess for good replacement pixels.

acr

- 3. Adjust the clone. Toggle the Show Overlay checkbox to check for accuracy. You may move either the source (green) or the destination (red) areas by dragging them from their centers. You may also resize both by dragging on the edge of either.
- 4. To delete a Spot Removal pair, click on it with the Spot Removal Tool (you'll see the green and red), then use your delete key.

Remember, you can copy any settings, even Spot Removal, by using Edit>Develop Settings>Copy Camera Raw Settings...

If you're getting rid of sensor dust, you can paste the Spot Removal on all images with the same dust spots!

Healing vs. Cloning

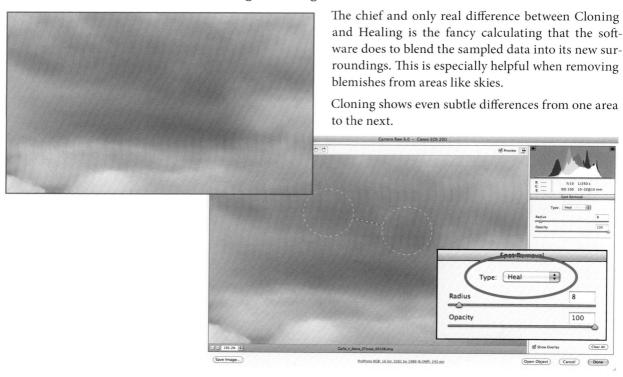

But a switch to Heal makes all the difference!

Lightroom

Although very similar to its sibling in ACR, the Lightroom Spot Removal Tool has a couple of subtle differences in procedure. Read the preceding on ACR's method to get your bearings.

- 1. In Lightroom's Develop module, choose the Spot Removal Tool. I leave mine set to Heal unless I really need an exact, literal clone of some area.
- 2. Position the over the blemish, then use your mouse's scroll wheel or the square bracket keys to adjust the size of the brush.
- 3. Press the mouse button down and drag to a clean, logical source area, releasing the mouse when you get there. This step is optional: if you just click on the flaw, Lightroom will try to find a good source area. It often does well; but nearly as often, I wish I had chosen it, so I usually just do it myself.
- 4. To evaluate your success, press and hold the H key to hide the circles. They'll come back when you release it.

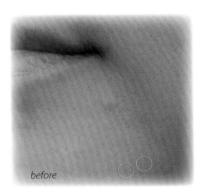

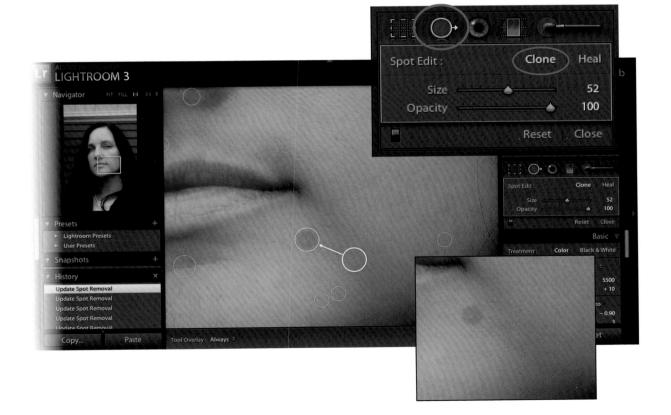

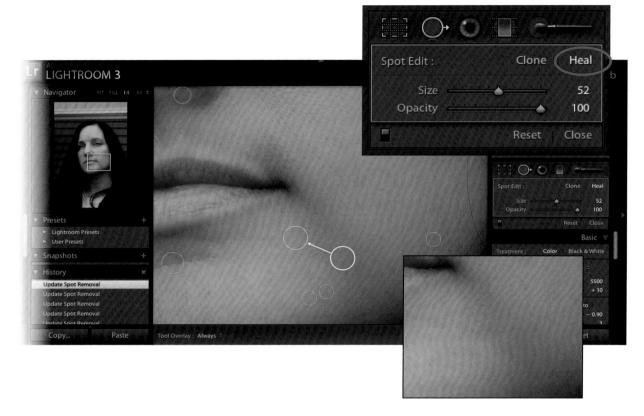

5. You may move either circle or resize the circle over the blemish to resize both. If you synchronize settings across many images, you may wish to include Spot Removal if you notice a lot of sensor dust, or to exclude it if your images require very different retouching.

Photoshop

In Photoshop, we employ three essential tools for spot removal: the Healing Brush, the Spot Healing Brush, and the Clone Stamp. These work by sampling "clean" pixels and using them to repair or replace defective pixels. As you may be unsure whether some spots actually are defects, I recommend creating a separate layer just above the original image to hold your retouching, in case it needs to be revisited.

Note that I put this between my original's layer and any Adjustment Layers I may have. Just create the retouching layer, then move it if it's in the wrong place.

The only complication in doing your retouching on a separate layer is that you must inform each of the retouching tools that they are to pull the "clean" pixels from the layer below. So for each tool, note the menu in the Options Bar called Sample. Choose Current & Below. The Spot Healing Brush has only a checkbox labeled "Sample All Layers". Use that instead,

Note: For each retouching tool, use the menu in the Options Bar called "Sample". Choose Current & Below to sample pixels from the original image while working on a retouching layer without confusing Adjustments.

but you will have to turn off (make invisible) any Adjustment Layers you made above the retouching layer.

Clone Stamp Tool

In Photoshop, it is rare to use the traditional Copy and Paste functions. One reason is that when you copy something, it can be many megabytes of material that clogs your computer's memory. There are more useful and elegant ways of copying material.

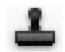

- Zoom in. View>Actual Pixels makes it easier to see dust spots and defects you might otherwise miss. Periodically hold the H key to access the Hand tool. Use this to move along to new areas to retouch. Release the H key to resume retouching.
- 2. Find a blemish in the image and note an adjacent area without a blemish but with a similar texture, color, and density. You'll clone from this clean area onto the blemish or spot.
- 3. If the defect is small like a dust speck, select a brush slightly larger than the defect. Otherwise, a brush of between 20 and 100 pixels will often do nicely.

4. Place the pointer over the clean area of the image. It appears as a circle the same size as the selected brush. Hold down option / Alt to display a small target, then click on the clean area. Important: Once you designate the clean area as your Clone Source, release option / Alt.

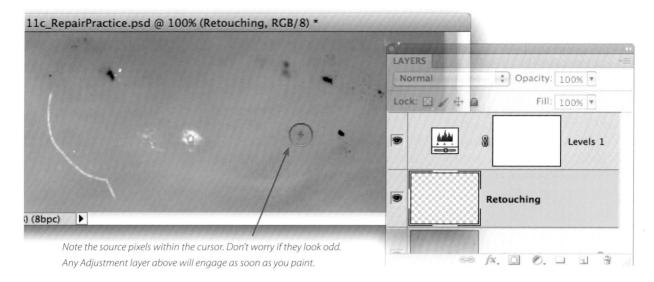

- 5. Move the cursor over the spot to be removed. Notice how the cursor shows you the material it picked up and that you will be painting shortly. If you have an Adjustment Layer above the retouch layer, the material may look discolored, but it will paint correctly if, in the Options Bar, you choose to sample Current [*layer*] and Below.
- 6. Paint over the spot. You will see two cursors while you paint: the center of your source marked with a + cursor, and the circle of your brush. There is a spatial relationship between them that will be maintained until you define a new source point. So, if you define a source above and to the left of where you paint, when
 - to the left of where you paint, when you paint elsewhere the source will be above and to the left of the cursor in its new location. The trick is to keep an eye on each cursor to be sure that as you paint, your source doesn't drift toward areas inappropriate to cover your blemishes.

I strongly suggest that for larger defects, and for areas with many defects, that you change your source point frequently to avoid noticeable repeats of a pattern.

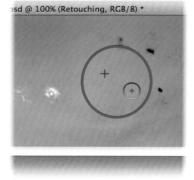

Healing Brush

The Healing Brush Tool is very similar to the Clone Stamp in that you specify a source point by option / Alt clicking, then paint away defects. It also loads the cursor with the sampled material. But there is a huge difference, too.

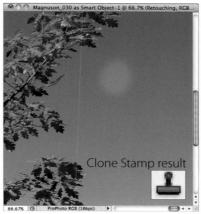

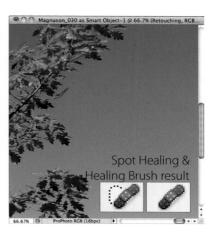

When you paint over the defect, you must paint it all away in one brush stroke. When you release the mouse, Photoshop does its magic: it uses the texture of the source pixels, but then uses the color and density surrounding the flaw. So there had better be no flaw left! Even if your source pixels are very different in color and density from the flawed area, but have a similar texture, the resulting repair will be seamless. Essentially, you define a texture to use, then fix areas with the same texture (sky texture for defects in a sky, or stone texture for defects in stone, etc.).

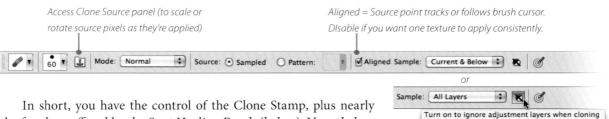

the freedom offered by the Spot Healing Brush (below). Nonetheless, use the Clone Stamp when you need a literal copy of pixels. Use the Healing Brushes when a copy is the wrong color, density, or both.

Sometimes the Healing Brush fails and creates an obnoxious smudge. This is common if the dust spot is right along a strong edge, or especially if the flaw is in a corner of the image. If this happens, press #+Z / Ctrl+Z. If the flaw is in a corner, first use the Clone Stamp, then Heal. For flaws along edges, use a source point further along the same edge.

Spot Healing Brush

The Spot Healing Brush is an alternate version of the Healing Brush. It works by merely painting on a dust spot or defect in the image without first defining a source.

Click or paint on the defect, and Photoshop eliminates it—usually. It picks its own source material. If it chooses inappropriately, use the Healing Brush or Clone Stamp.

Just paint on flaws—no keys held down, no source defined—and Photoshop finds various sources to fill the area! New in CS5 and brilliant!

The Spot Healing Brush has several options. Keep the Detail Mode set to Normal and the Type set to Content-Aware.

The Spot Healing Brush works best with a hard-edged brush—a soft-edged brush doesn't completely fix a defect. Choose the tool, then control+click / Right-click anywhere on the image to choose the brush's hardness.

Save the Clean Image

After you have completed the image clean-up, use File>Save. If the file is a RAW image, you will be presented with the Save As dialog, as Photoshop edits cannot be saved into RAW files. JPEGs cannot hold Layers, and so Photoshop will give a Save As dialog for them, too.

Remember to change the label in Bridge, so you know that the file has been cleaned and whether it needs more work.

Very Large Defects

Patch Tool

Selection is around defect: Patch Source

Patch works only on a standard image layer,
Selection is around the patch (good pixels): Patch Destination

not on Smart Objects or transparent layers.

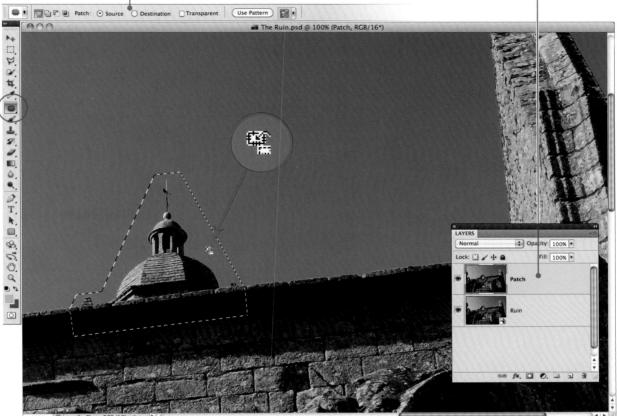

The Patch Tool is like a custom-shaped, excessively large Healing Brush. Rather than painting, we use selections to indicate what should be fixed. Unfortunately, the Patch Tool doesn't work on Smart Objects nor does it have a "Use all Layers" option. We must work directly on standard image pixels.

- If you have only a Smart Object, create a new, empty layer via Layer>
 New>Layer... and give it a reasonable name.
- 2. Merge a copy of the image into this new layer by using the shortcut <code>#+option+shift+E</code> / Ctrl+Alt+Shift+E. I know it's a handful...but you'll thank me someday. This merges a copy of everything you see into this one layer. Now you can patch.

3. Make a slightly loose selection around the flaw with any selection tool, including the Patch Tool itself.

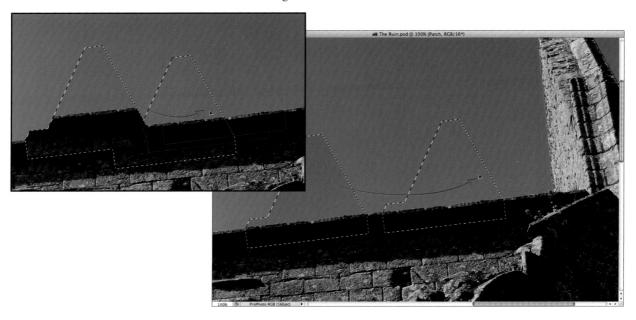

4. Now the cool part: with the Patch Tool, drag the selection to an area you would like to use as your patch; that is, good pixels that can be used for their texture and detail. Don't worry about color or lightness as there will be a healing calculation when you release the mouse.

5. Release the mouse and deselect. Nice!

Content-Aware Fill

For years Photoshop users have joked about, and Hollywood has "shown", that dramatic image editing is as easy as a few clicks. But to convincingly remove large areas quickly has always been somewhat difficult. The Patch Tool is great if there's an area big enough to use as a patch. But what if there isn't?

In Photoshop CS5, we can simply select an area, fill it with "content awareness", and Photoshop will find bits and pieces of the image to fill in that selection.

The first few steps are identical to those for the Patch Tool:

- If you have only a Smart Object, create a new, empty layer via Layer>
 New>Layer... and give it a reasonable name.
- 2. Merge a copy of the image into this new layer by using the shortcut **#+option+shift+E**/**Ctrl+Alt+Shift+E**. This merges a copy of everything you see into this one layer.

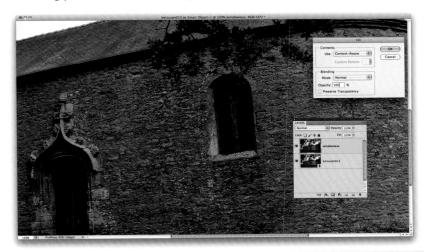

- Make a slightly loose selection around the flaw with any selection tool.
- Choose Edit>Fill... From the Use menu in the Fill dialog box, choose Content-Aware.
- 5. Click OK, then retrieve your jaw from the floor.

Transformations

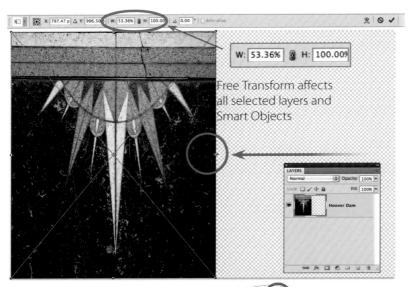

Bending images is a fun and practical endeavor. Let's look at a couple of ways to get images to fit your visualization.

Free Transform

Free Transform scales (and skews, etc.) all the pixels that are selected. However, you have a few modes to choose from. The standard transform is rectilinear and wholesale.

Choose Edit>Free Transform or use the keyboard shortcut ##+T/Ctrl+T. Once in the interface (a box with handles on the edges), you may drag a corner or edge. If you have a

specific amount of distortion in mind, you may enter it in the fields in the Options Bar. Use the **Enter** key to commit the transformation.

You may also engage Warp mode to get a more fluid transformation. Choose Warp mode with the button that appears on the right side of the Options Bar when Free Transform is active. You may choose a preset Warp like Flag (*left*), or create your own via Custom. With the Custom interface, you may drag on the grid or the "handles" along the edge to sculpt the selected pixels in fluid and natural ways.

Liquify Filter

For a painterly distortion, use the Liquify Filter. Access it by Filter>Liquify and choose a tool in the upper left. Adjust the characteristics of the tool, always brushlike, on the right side of the interface.

But the fun is had in the middle. Paint with the Warp Tool, and you sculpt pixels. Use the Pucker Tool, and you can see why this filter is used extensively in fashion photography.

Keep in mind that Liquify cannot be applied to Smart Objects but only to typical image pixels.

- If you have only a Smart Object, create a new, empty layer via Layer>New>Layer... and give it a reasonable name.
- 2. Merge a copy of the image into this new layer by using the shortcut <code>#+option+shift+E</code>/Ctrl+Alt+Shift+E.

 This merges a copy of everything you see into this one layer. Now you can Liquify.
- 3. Choose Filter>Liquify. Use tools like Warp, Pucker, and Bloat to "sculpt" the image. Use the Reconstruct Tool to paint the image back to its original form.
- 4. Have fun!

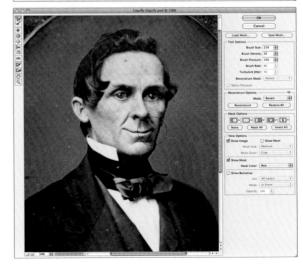

Content Aware Scaling (Seam Carving)

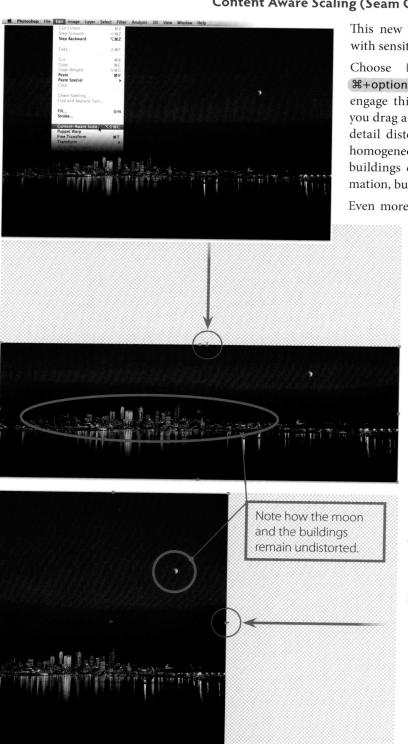

This new function is like Free Transform, but with sensitivity to the content in your images.

Edit>Content-Aware Scale use 第+option+shift+C/Ctrl+Alt+Shift+C engage this function. What you'll notice when you drag an edge or corner is that areas with fine detail distort far less than areas that are more homogeneous. So in this example, the moon and buildings don't change with a modest transformation, but the sky and water are carved away.

Even more powerful is the combination of this tool with a saved selection. If you first create a Marquee (perhaps with the Quick Selection Tool), then save that selection, you'll see the name of that saved selection in the Options Bar under the Protect menu.

- Create a selection around important content, especially if it contains areas without fine detail.
- Choose Select>Save Selection... and give your selection channel a name.
- With a single image layer selected, but not a Smart Object, choose Edit>Content-Aware Scale or use \#+option+shift+C / Ctrl+Alt+Shift+C
- 4. In the Options Bar, choose the name of your saved selection from the Protect menu.
 - Scale the layer.

Transformations

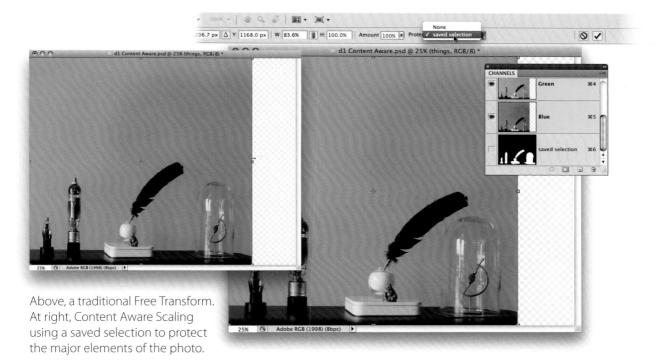

Creative Edits & Alternates

9

As Ansel Adams long espoused, photographers seek to make the images they visualize. The visualized image may, or may not, perfectly reflect the scene before the eyes of the photographer. After all, Adams and many others used dense filters and extreme darkroom techniques to bend the image to their desire, bringing strong contrast where the world offered little, grayscale where there was color, and clarity where there was haze.

Masters in the darkroom can achieve much, and with our digital darkroom, the possibilities are multiplied many times. For the creative image maker, the ability to more easily combine images, to blend and stitch them, and to bend and twist them is dizzying! For journalists and documentarians, these techniques and abilities raise difficult questions. But the same features used to add or remove people from a photo, a journalistically questionable act, can be used to create panoramic images, which raise no eyebrows. Tools that are used to color-correct images can be used to recolor them, too.

Although in this chapter I will discuss these features and tools in a creative or even radical way, remember that they can be used in a more mundane and innocent fashion, too.

Combining Images

Compositing Two or More Images

There are times when the image you want is the marriage of two or more images in your library. Here, I want to show you a typical method (but far from the only one) for combining images to make one coherent composition.

- 1. With both images open, use your Move Tool to drag one image to the other's tab, wait for the other image to appear, then drag into the Image Window and release the mouse. Drag the new layer around to recompose if needed. Don't be timid: be sure the cursor makes the journey all the way into the destination image before releasing. Tip: If you're holding down your **shift** key as you release the mouse, the image you're dragging will be centered on the other.
- 2. Name your layers! You'll thank yourself later as they proliferate and you won't have to puzzle over what "Layer 47" contains.
- 3. If necessary, reorder the layers. In this example, the trees layer is now be obscuring the Jennifer layer. Our objective is to make the sky pixels of the Jennifer layer transparent so we see the trees a bit. The final image will be of Jennifer in front of a more colorful background. So I moved the trees behind Jennifer (below in the Layers panel).

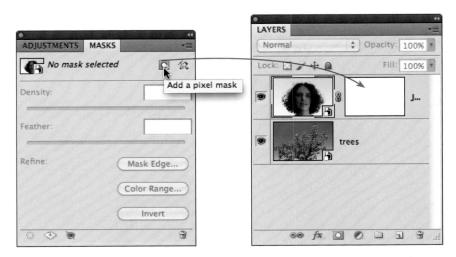

4. Plan your mask. Often, the best way to make a **Layer Mask** is to select the pixels that should remain *visible*, then click the **Add a Pixel Mask** button in the Masks panel. The Quick Selection Tool or Color Range are frequently the ideal tools, especially for complex selections based on color or tone. If necessary, you can refine a selection by using Select>Refine Edge...

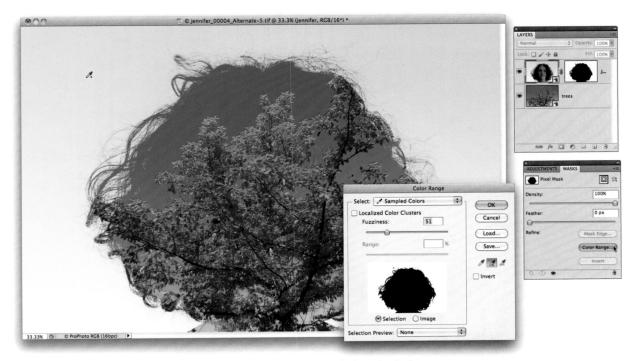

But here, I want to use Color Range to select all the pixels but the light blue, sky-colored pixels: Jennifer. The Masks panel lets me first make the mask, then use Color Range to refine while I watch the masked results. I prefer this to making a Color Range selection first.

Ps

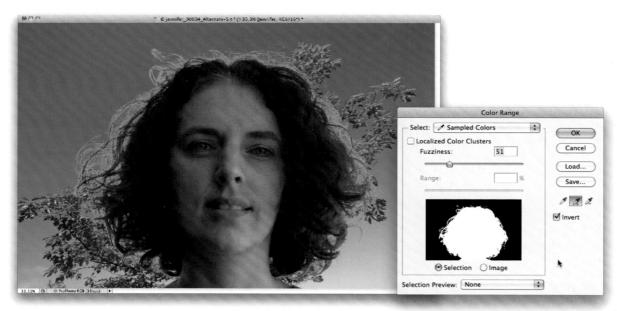

Since the blue-sky pixels are easier to isolate with Color Range, I clicked on one part of the sky, then used the Add to Sample dropper to get them all. The result is interesting, but wrong. So I use the **Invert** checkbox to get Jennifer's pixels selected. The result now is promising, but needs refinement around the hair.

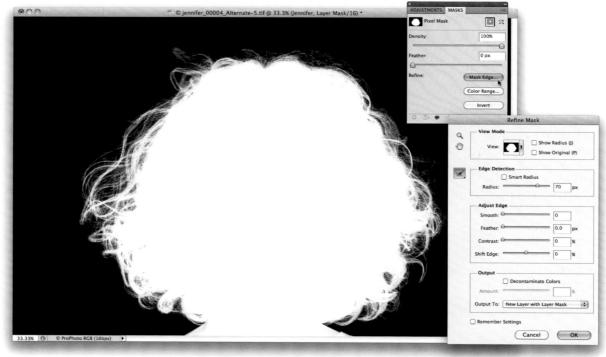

5. For images of complex objects like trees or hair, you'll almost certainly need to refine the edge of the mask. Choose the Masks panel's Refine

feature, Mask Edge... Once in that interface, choose a View mode that helps you evaluate your progress. I usually go between the On Layers and Black & White views.

I need Photoshop to detect edges anywhere in the area around Jennifer's hair, so I pump up the radius. 70 pixels seems to encompass even the wispiest parts.

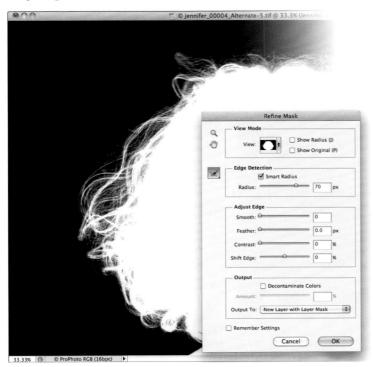

6. To beef up the more interior parts of the selection, I check **Smart Radius**, too. This varies the radius (edge detection zone) based on image content.

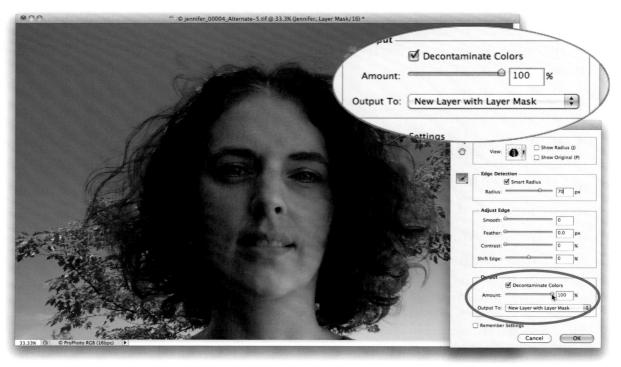

7. It's time to see how the mask is doing in the image's context, so I tap the L key to go to **On Layers** view mode. As there is still blue in the most delicate areas, I enable **Decontaminate Colors** at 100%. This will trigger the creation of a new layer since color will be added to the image pixels. Our original image will remain untouched.

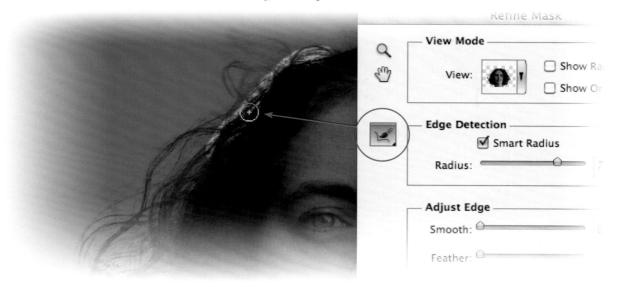

8. Now there are just a few areas where Smart Radius just wasn't smart enough. The Refine Radius Tool is what we need. We use it to tell

Opacity: 100% •

Photoshop where it needs to look harder for edges. While painting, it looks like you're ruining the mask. Paint a little, pause, and watch the redraw. You'll see the program recalculating based on the new information you painted.

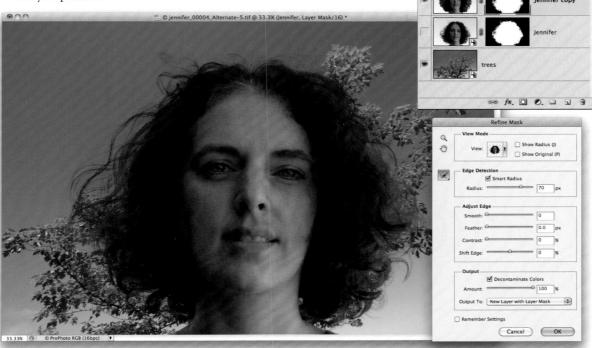

- 9. Note the result. Gorgeous.
- 10. Nonetheless, I often adjust color a bit to help the introduced image fit in better with its new surroundings. In this example, I added a warming and lightening adjustment that is clipped

to the layer below

it. To do that, create the Adjustment Layer in the normal way via the Adjustments panel. Then click the clipping button at the bottom of that adjustment. The layer indents and affects only the layer immediately below it.

Blending

Opacity

The opacity of a layer is easy to understand. Lowering the opacity makes the image semi-transparent. Opacity is the opposite of transparency—a 100% opaque layer can't be seen through at all; at 50% opacity, the layer is 50% transparent, and the layer blends 50/50 with the pixels below; at 0% opacity, the layer is 100% transparent, and you can see right through it. Just select the topmost layer in your image and change the opacity of the layer to experiment with it.

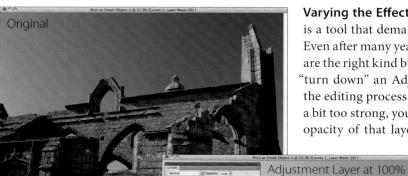

Varying the Effect of Adjustment Layers Photoshop is a tool that demands some subtlety for editing images. Even after many years, I still often make adjustments that are the right kind but too strong. Opacity is a great way to "turn down" an Adjustment Layer. If you decide during the editing process that a particular Adjustment Layer is a bit too strong, you can reduce it by merely reducing the opacity of that layer—an Adjustment Layer set to 50%

opacity is essentially the same as applying half the adjustment.

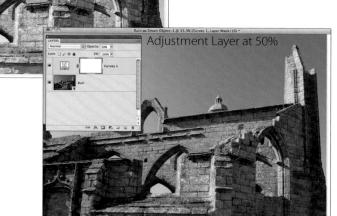

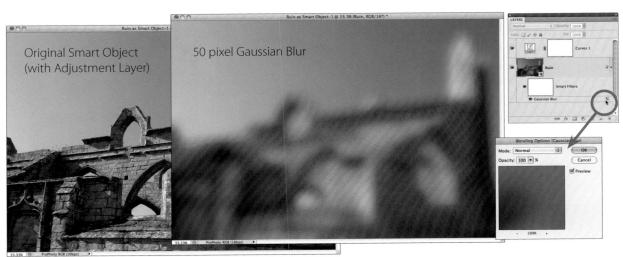

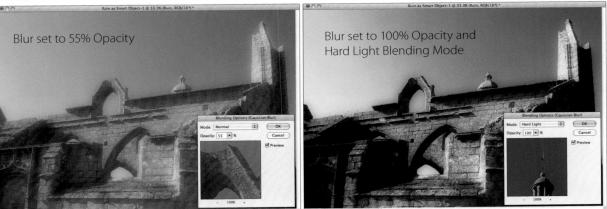

Smart Objects & Smart Filters Lowering the opacity also works for Smart Objects or, more interestingly, the filters applied to them. In fact, it's great for Smart Objects, since it makes it easy to adjust the effect of a Smart Filter without having to create a new layer with the filter applied to it, then lower its opacity.

- 1. To try this yourself, convert a layer into a Smart Object if it isn't already. You can do this by using a control+click / Right-click on the layer and choosing Convert to Smart Object.
- 2. Choose a filter (I chose a simple Gaussian Blur of about 50 pixels in Radius).
- 3. To adjust the filter's opacity or other blending options, double click on the slider icon (돛) to the right of the filter's name in the Layers Panel (see above). Then you may change the Opacity or the Blending Mode.

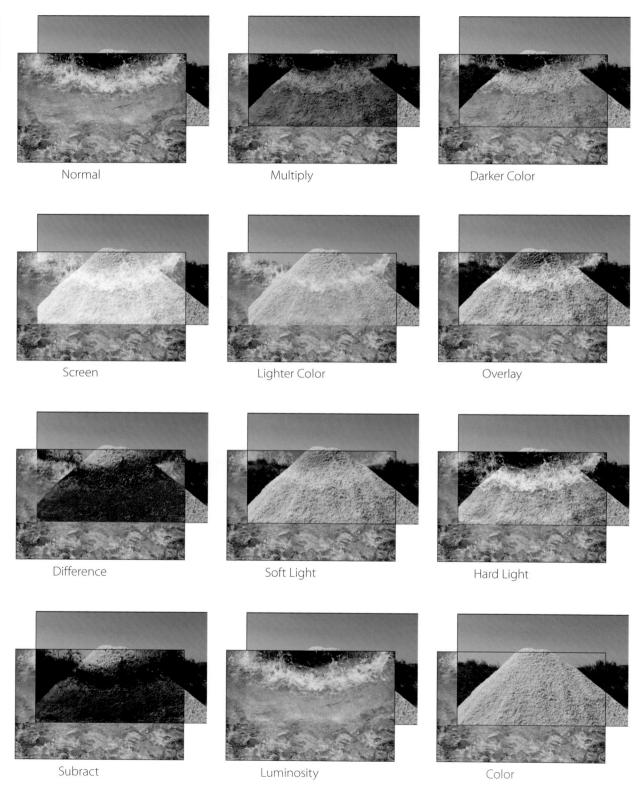

Blending Modes

The Blending Mode for a layer sets how the pixels in that layer visually blend with the pixels in layers below it. The default "Normal" Blending Mode is simply no blending.

The various Blending Modes can be divided into four basic categories: Darken, Lighten, Contrast, and Color modes.

The Darken modes make the resulting image darker by either yielding the darkest pixels of the blending layers (via the comparative modes Darken and Darker Color) or by using the colors of each layer to reinforce each other. Multiply is probably the most definitive of the group. Imagine stacking two photographic slides one upon the other, then looking at the two on a light box: this is the same visual result as Multiply.

The Lighten modes make the resulting image lighter by either comparing the blended layers and yielding the lighter pixels (Lighten and Lighter Color) or by using the lighter pixels of the layer to which the mode is applied to brighten the layer below (Screen). Let's continue the slide analogy: instead of "sandwiching" the slides, let's imagine projecting two slides onto the same screen. Where each is lighter, it lets more light reach the screen, seeming to bleach away the other image. This is the result of Screen mode.

The Contrast modes make the result darker where the layer to which the mode is applied is darker than middle gray, and lighter where that layer is lighter than middle gray. The key here is Hard Light: where the layer to which it's applied is lighter than middle gray it "Screens"; where it's darker than middle gray, it "Multiplies". What about where the layer is exactly middle gray? Then it's completely invisible! But, by emphasizing light and dark, overall contrast seems to increase. Overlay is probably more commonly used than Hard Light, however, as it leaves more of the underlying colors and textures present and "feels" more subtle.

The Color modes cause the layer to which they're applied to change only one aspect of the underlying layer(s): Hue, Saturation, Color (Hue+Saturation), or Luminosity (density). The two that get the most use are the last two, Color and Luminosity, as they are the complementary ingredients of an image. That is, if you remove the color from an image, all you're left with is the Luminosity or grayscale part, or what most of us think of as the detail in an image. Color is somewhat more abstract. If you look through colored glass, it changes the colors you see but not the luminosity as much. Similarly, if you paint with colors on a layer to which Color mode has been applied, then you can simulate "hand-tinting" of the image below, changing its color but not its tonal details.

Ps

Blending Adjustments

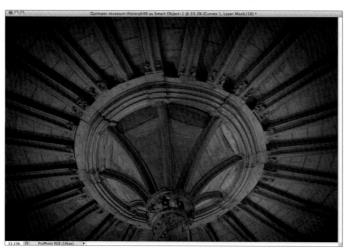

The Luminosity mode is especially useful with Adjustment Layers if you want an adjustment to change only the luminosity (or density) of the image and not its color. It is common for Adjustment Layers that apply significant density changes to also produce some moderate color changes. A Curves Adjustment Layer that adds a moderate amount of contrast can also result in a slight change in color—changing the Blending Mode of this Curves Adjustment Layer forces the layer to change the luminosity and not the color.

The Color Blending Modes can be used for most common Adjustment Layers that adjust brightness, contrast, color, or saturation. In general, a brightness or contrast layer should

only change luminosity (so the Blending Mode should be set to Luminosity); a color or saturation layer should change only color or saturation.

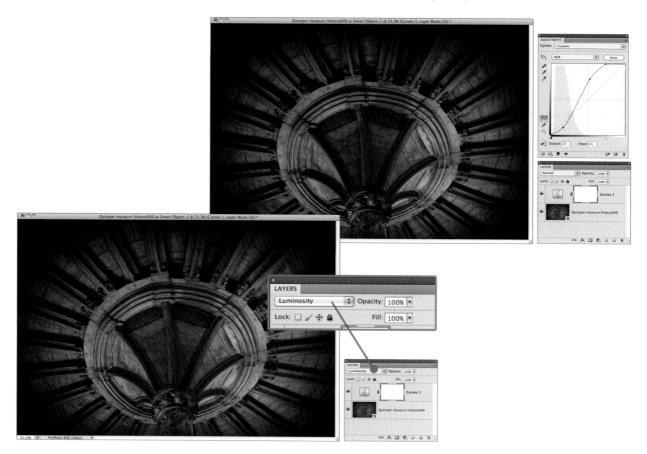

Merging Images

Photoshop is a marvelous tool for combining not just completely different images, but also multiple frames of the same or similar subjects. Let's look at ways of combining exposures to make High Dynamic Range images, overlapping frames to make panoramas, or merging images with focus on different planes for one image with apparently deep depth of field.

HDR: High Dynamic Range Images

If you have a subject with extremes of light and dark that cannot be captured in one exposure despite the powerful highlight and shadow recovery

of Adobe Camera Raw, you can instead bracket several exposures, 1 to 2 f-stops apart, using shutter speed only.

The process that follows creates a Photoshop HDR (High Dynamic Range) image, which cleverly uses 32 bits per channel to describe an immense range of tonal detail.

Once your bracketed images are downloaded to your computer, use the command File>Automate>Merge to HDR Pro... to choose them for the creation of the HDR image. Press OK.

Of course, you may push the files from Bridge or Lightroom.

Tools>Photoshop>Merge to HDR Pro...

Lightroom

control+click / Right-click on a thumbnail image then choose Edit in>Merge to HDR Pro in Photoshop...

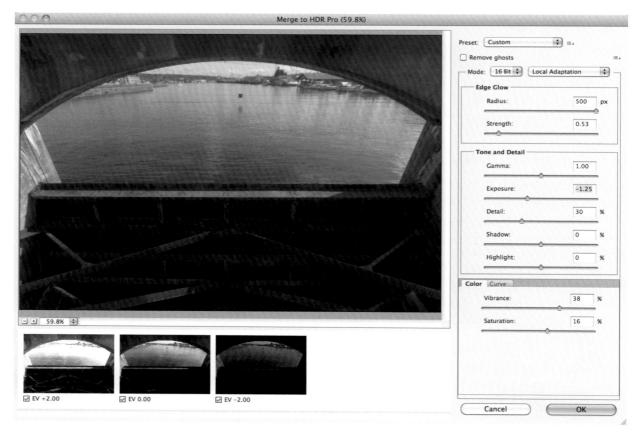

- Welcome to the HDR preview window. Almost everything you need to create the perfect image is here. Start near the top and work down:
 - ▶ Mode—Choose 32 bit if you want to keep all the data for later downsampling to 16- or 8-bit images, or go straight to sharable, printable versions now.
 - ► Conversion Methods—The CS5 default, Local Adaptation, offers the greatest control. Although the others offer few if any options, try Equalize Histogram, Exposure and Gamma, and Highlight Compression to see if one simply delivers the perfect image with no further intervention.
 - ▶ Edge Glow Radius— defines the size of what Adobe calls the "glow effect". I prefer to think of it as helping to define tonal regions in an image. In the one illustrated here, the light and dark parts are almost completely separate, and my Radius is set really high so Photoshop will calculate contrast for each region more pleasingly. If the lighter and darker areas were entangled, a lower radius (like the default of 26 pixels) would serve better.
 - ► Edge Glow Strength— controls the intensity of the glow.

- ► Gamma—This is a control of contrast.
- ► Exposure—This moves you through the image's tones as if you were changing the camera's exposure. Very useful.
- ▶ Detail—Similar to Lightroom and ACR's Clarity, this controls local contrast.
- ► Shadow & Highlight—These control the lightness of the shadows and highlights. If your shadows need a bit more light, drag the slider right.
- ▶ Vibrance & Saturation—Most images require these adjustments after the HDR process. I prefer to use Vibrance first, then Saturation if I need more.
- ► Curve—A tone curve finesses the journey from darkest shadow to bright highlight.
- 2. Hit OK. The preview you were just looking at will be flatter than the result.
- Adjust as you would any other image to fine-tune. Here, I actually darkened the foreground, keeping just a hint of what HDR was giving me generously.

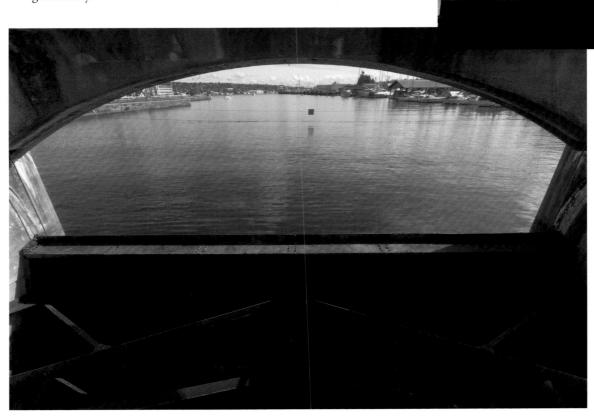

Panoramic Images

When combining overlapping images of a subject too expansive to capture in one go, Photoshop's Photomerge is brilliant. Whether you're trying to simulate a fisheye effect (as illustrated here), or stitching a series of photos covering a full 360°, this tool is the ticket.

To merge images for a panorama, do one of the following:

- ► In Bridge, select the images that should make up the panoramic image, then choose Tools>Photoshop>Photomerge...
- ► In Lightroom, select the images for the panorama, control+click / Right-click on a thumbnail image, then choose Edit in>Merge to Panorama in Photoshop...

Auto: Always try first if you're unsure.

Perspective will try to ensure that straight lines stay straight.

Cylindrical is good for wide panoramas.

Spherical is for truly full 360° panoramas.

Collage fans out the images like prints, but perfectly overlapped.

Reposition will not distort or even rotate the images.

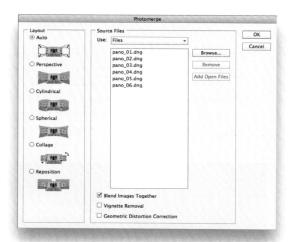

When you gather images for Photomerge either from Bridge or Lightroom, you have a number of options. Along the left edge of the dialog box, you'll see choices for the layout of the images. Auto is always a great place to start. If it fails, simply don't save the result and try again.

A couple of other choices are at the bottom. Blend Images Together creates intricate (read: hard to edit later) Layer Masks. The edges of these masks are intelligently along edges that have similar tone and color, and thus usually help line up images.

If your images have darkened corners, and you haven't manually removed these vignettes, check the box for **Vignette Removal**.

Finally, to compensate for fisheye, barrel, or pincushion distortions in the individual images, choose **Geometric Distortion Correction**.

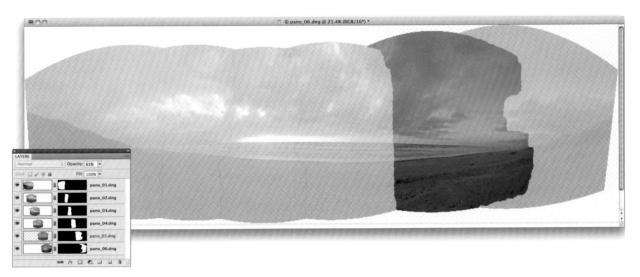

Above, I've lowered the opacity of all layers but one so you can see the intricate shapes that Photoshop created in each layer's mask. Note that the right edge of the one layer *exactly* corresponds to the left edge of the layer below. I cropped the bottom and extreme left and right. I then used Content-Aware Fill and a touch of Content-Aware Spot Healing. These are proving to be *the* awesome new features in CS5!

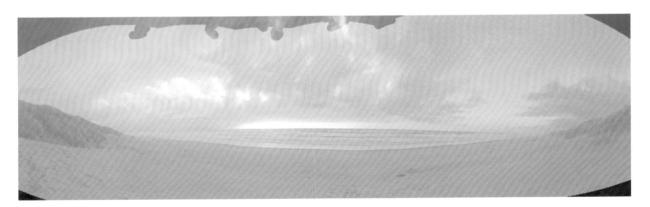

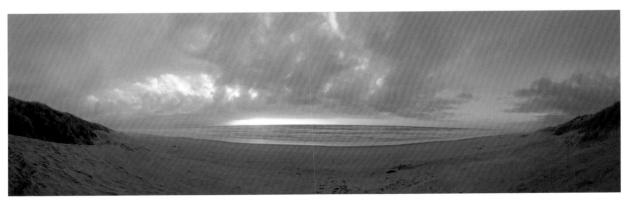

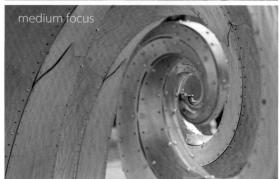

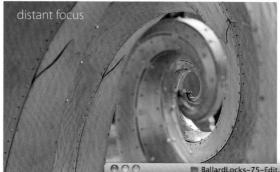

Depth of Field Merge

An alternate method of merging images can be used to combine images focused on different planes to create a single image that, in principle, appears to have the whole depth in focus. I say "in principle" because in practice I've had less than satisfying results with all but the simplest compositions. However, your results may be more favorable, so here's how to do it:

- 1. Load the images into Photoshop as layers.
- ► From Bridge—Select the images with various planes in focus, then choose Tools>Photoshop>Load Files into Photoshop Layers...
- ► From Lightroom—Select images with various planes in focus, control+click / Right-click on a thumbnail image, then choose Edit in>Open as Layers in Photoshop...
- 2. Select all the layers: \(\mathbb{H} + \text{option} + \text{A}\) \(\text{Ctrl} + \text{Alt} + \text{A}\)
- Choose Edit>Auto-Blend Layers... Check the box for Seamless Tones and Colors. Click OK.

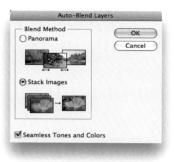

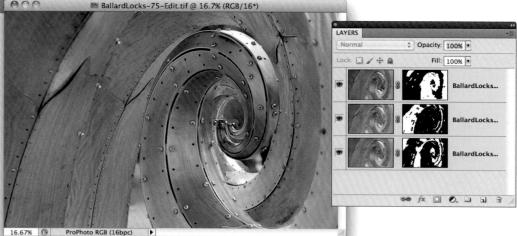

Passerby (and Noise) Removal

Has the following ever happened to you? You're trying to photograph a scene, but vehicles, animals, or people keep passing in and out of it. Photoshop has a feature that will examine multiple images and average them. The result is that those parts of the scene that are static and consistent remain, but those that are in only one frame disappear. The more images you make of a scene, the better this feature works.

In order to engage the averaging ("Median" in this case), you have to load the images as a stack of Photoshop layers converted to a Smart Object.

Load the images into Photoshop as layers.

From Bridge-Select the images, then choose Tools>Photoshop>Load Files into Photoshop Layers...

From Lightroom—Select images, control+click / Right-click on a thumbnail image then choose Edit in>Open as Layers in Photoshop...

Select all the layers: #+option+A / Ctrl+Alt+A

Choose Edit>Auto-Align Layers... Choose Auto Projection. Click OK.

Choose Laver>Smart Objects>Convert to Smart Object. Get ready to return to that menu.

5. Choose Layer>Smart Objects>Stack Mode>Median. You may need to

wait for a while and then crop a

bit to clean up edges.

After some processing (it can take a few minutes), the images will be averaged, grain/noise will be reduced, and random elements should vanish. Very cool!

Keep in mind that even though we've shown how this works with people as the random elements, this also works wonderfully to combat the noise that plagues digital images, especially in long exposures at night.

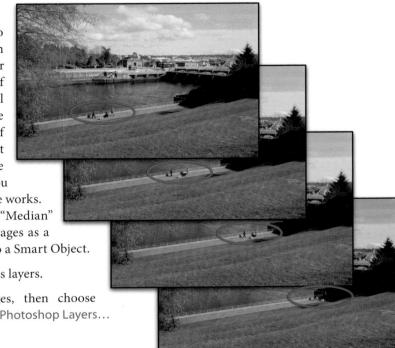

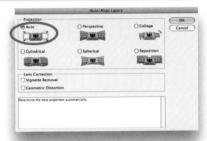

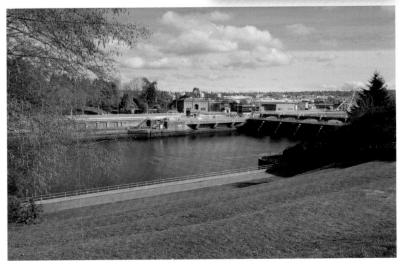

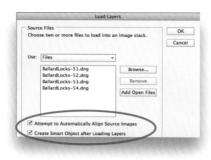

Instead of pushing the images into Photoshop from Bridge or Lightroom, you can pull them in instead, and save a few steps, too.

Steps 1–4 above can be substituted with the following:

Choose File>Scripts>Load Files into Stack... "Browse" to your images, then check both boxes at the bottom of the dialog to align the images and convert the layers to a Smart Object.

Smoothing Motion

If you engage nearly the identical procedure used for passerby removal (above), but replace the Stack Mode Median with Mean, you will see ghosts in the resulting image. This ghosting is handy to smooth water and other moving objects.

A series of seven images, each 1/10 second exposure (like the one at left), can be averaged to look like one, much longer exposure (below).

Photographic Effects

Lens Blur

You may have an image with a good subject but a distracting background. Use focus (or lack of focus) to separate the subject from the background and make the image stronger. The Lens Blur Filter is an excellent, if time-consuming, tool for defocusing part of the image.

- Create a duplicate Layer on which to perform the Lens Blur. If you only have a background layer, duplicate it by selecting Layer>Duplicate Layer... Name this the "Lens Blur Layer". Sadly, Lens Blur is too complex a filter to be applied to a Smart Object.
- Make a selection around the subject. Use whichever tool best suits the image. I used the Quick Selection Tool to make the initial selection around Carla in this image, then Refine Edge to make the edge more delicate.

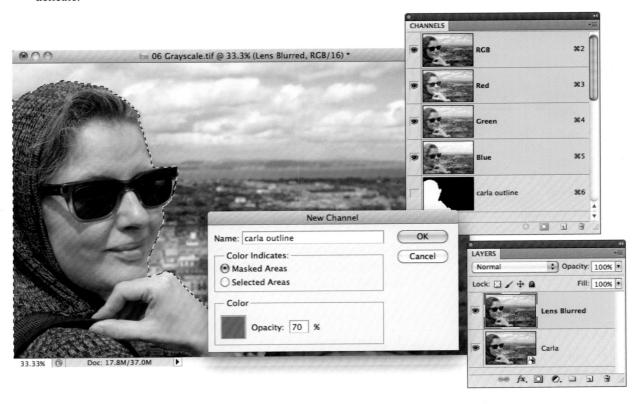

3. Once you have a good selection, save it by selecting Select>Save Selection... and provide a name for the selection that refers to the blur: perhaps "depth map", referring to depth of focus. After saving the selection, deselect (Select>Deselect).

4. Select the Lens Blur Filter, Filter>Blur>Lens Blur... Use the Source menu under Depth Map and choose the selection that you saved. This defines where the blur should occur. Drag the Radius option on the right to set the amount of blur. More blur is often better, but a stronger blur will also make flaws in a less than perfect selection more obvious. If the subject becomes blurred (rather than the background), just reach into the image and click on the part that should be sharp! Yes, Photoshop has autofocus. Actually, the grays in the saved selection channel are referenced by the Blur Focal Distance slider. 0 equals black, and 255 is white. So in our case, the channel is white where we want focus, and we set that slider to 255.

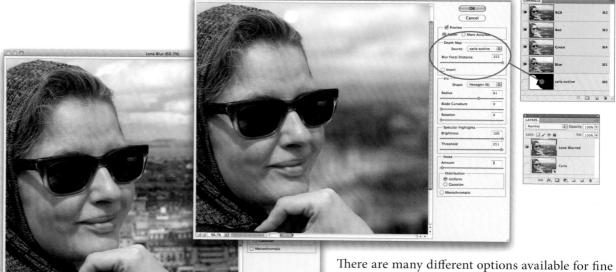

There are many different options available for fine tuning the Lens Blur that mimic the effects of real photographic lenses.

- 5. When specular highlights are present, a real photographic lens will shape them into the shape of its aperture. The Lens Blur Filter can simulate that in the Iris section. Here we used a hexagonal aperture simulation. You can see this subtly demonstrated above Carla's brow. I'll get rid of that in the final, though.
- To control how strong those specular highlights are, and what brightness in the image triggers their presence, you can adjust the Brightness and Threshold sliders respectively.
- 7. Finally, since blurring removes grain, noise, and other artifacts that a real lens wouldn't, this filter has a provision for introducing noise that is proportional to the amount of blur. If part of the image isn't blurred, it gets no noise. You might prefer to simulate film grain yourself. I'll do both.

Film Grain

Film Grain in photographic film may be due to the clumps of silver or dye in the emulsion, but it has its own important aesthetic in photography. You may wish to *add* simulated film grain to bring abstraction to your images, create a more classic or dreamy appearance, or even to mask softness or digital noise. This technique will also demonstrate how to apply Photoshop filters that are not immediately available in 16 Bits/Channel Mode. Even Lightroom now offers a Film Grain effect!

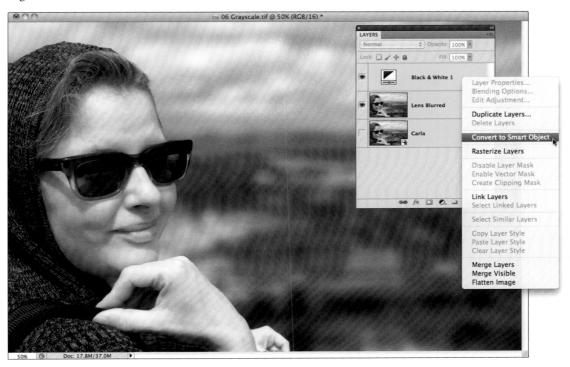

- Select all the image and adjustment layers that are used to "construct" your image, then use the Layers panel menu or choose Layer>Smart Objects>Convert to Smart Object.
- 2. If the image is in 8 Bits/Channel Mode skip this step. If not, use Image>Mode>8 Bits/Channel. What's great is that the Smart Object's contents retain their greater bit depth, but now you can apply filters that you couldn't in 16 Bits/Channel!
- 3. There are many filter choices at this point, but a good place to start is Filter>Texture>Grain. It will present you with a lot of grain types: experiment! In this image, I chose Clumped. Don't worry about how colorful it is—we'll deal with that shortly.

4. When the filter is applied (it will be a Smart Filter), edit its Blending Options by double-clicking on the icon to the right of the filter's name. Choose Luminosity as the Mode so the grain's *color* will disappear. I've also lowered its opacity.

Combined with some optional painting on the Smart Filter Mask, and perhaps an Adjustment Layer, we can make a beautifully "retro" image.

Virtual Copies

Lightroom

Some edits are much more than technical: they are experimental and/or aesthetic. Many of these Creative Edits (as I call them in this book) can be achieved in Lightroom. Consider some of the Develop Presets that come with the application: Antique Grayscale, Sepia Tone, etc. Often, you'll want to apply these only to copies of your images.

But if the edits you want to make are available in Lightroom, I recommend that you make a Virtual Copy.

Simply control click/Right-click on an image or its thumbnail (in the Library Grid or the Filmstrip) and choose Create Virtual Copy. This Virtual Copy's thumbnail will have a "page-turn" icon in its lower left corner. Then any edit you try will simply be another set of metadata, nondestructive and free for experimentation.

Layer Comps

Although there is no virtual copy feature in Photoshop *per se*, you can use different Layers and settings, then capture these with **Layer Comps**. This feature is so useful, yet so simple to use, you'll wonder how you got along without it! To make a Layer Comp:

- Make some layers of a document visible, and others invisible (click on the eye icon to the left of the layer).
- 2. Optionally, you may move the content of one or more visible layers and adjust the parameters of any Layer Style (Drop Shadows, etc.).
- 3. Click the New Layer Comp button at the bottom of the Layer Comps panel. Give your Comp a name and description. I usually also check all three boxes as I will often affect all of those attributes (Visibility, Position, and Appearance).
- 4. Later, when you need to get back to the state of the document that was saved as a Layer Comp, click in the space to the left of the Comp's name.

Ps

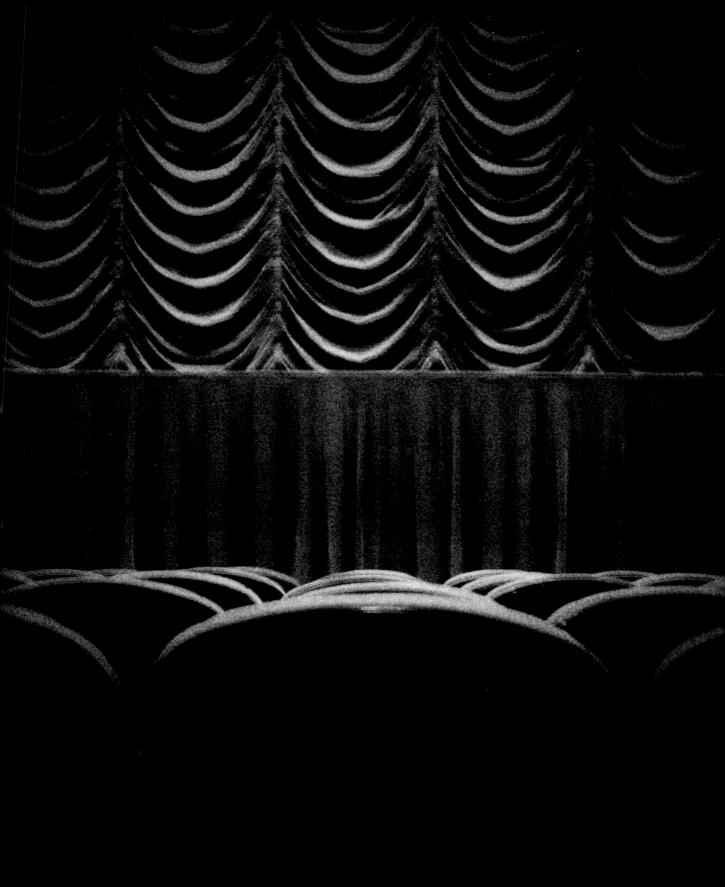

Output—Print, Web, and Presentation

10

Printing should be easier than it is, especially after all these years of digital imaging. With this release of Photoshop, the method I outline is simpler than ever. But since it uses profiles that describe your printer's characteristics to achieve stunning consistency and optimal results, you'll have to keep focused nonetheless. This method also can allow you to experiment with many more papers than your printer manufacturer supplies.

Today, more images are placed onto the web than printed. The web has become a primary medium for communication, and images are as important on the web as they are for any print media. This chapter covers some considerations for web images and provides some tasks useful for creating images for the web. It does not describe the entire process for creating websites, nor for creating complex web elements like rollovers and buttons, as these topics would certainly require much more space than these few pages.

It is important for anyone involved in image creation and editing to know a few essential steps for targeting images for the web. Some of these tasks can be done in a simple way, such as saving a JPEG to send via email, and others will allow you to quickly build whole web galleries.

Finally, I'll have something to say about presenting slideshows of your images.

Print Output

Best Practices

The real challenge in printing is to accurately match your printer colors to the image colors. A print image may not accurately match the color of the image as displayed on your monitor, but it may if you follow the three key steps of Color Management:

- 1. Calibrate and profile your monitor.
- 2. Set up an image "Color Space" (a "working space").
- 3. Configure your printer driver for the print.

Follow these steps for color management in order for their monitor and printer images to match as closely as the laws of physics allow.

Components of a Good Print

Printer

Many people believe only expensive, dedicated photo printers produce excellent images. But many desktop printers print very well. The biggest advantage of dedicated photo printers is prints that will last many years; some manufacturers claim over 100 years. This isn't trivial if you want your photos to last. The best photographers look to the newer photo printers with inks designed to print extremely rich colors and gorgeous black and whites.

But don't run out and buy a new, expensive photo printer right away. First, learn the process for good image editing and printing on your current printer. If you're in the market to buy one, at least buy an inexpensive, modern desktop printer. As you learn, you'll better determine your own needs and will be able to make a more informed choice when you buy a professional level printer.

Paper

Paper is one of the most important components of a good-looking print, yet it is often the most overlooked. Even inexpensive printers can produce excellent prints with the correct premium paper. Most printers and papers are manufactured to work specifically and especially well with each other. Check your printer manual for papers designed specifically for your printer. Choose the best paper to get the best print. For basic printing, use the printer manufacturer's premium photo papers. Advanced printing using printer profiles allows for a vast array of papers from various manufacturers. However, you should still stick to using your printer manufacturer's inks.

Color Profiles

The main advantage of printing with profiles is a more precise match between the edited image, the monitor, and the printer. This allows careful editing of print colors on the computer before you print, and the ability to use most or all of the color range available from your printer. In order to print with profiles, you will need to obtain the appropriate profiles for your printer/paper combination.

Manufacturer's Profiles

The easiest source of profiles is from the appropriate paper manufacturer (including the printer manufacturer for the papers that they sell for that printer). Profiles are widely available for many photo printers on the websites of a number of paper manufacturers. Many make excellent profiles for their papers on a number of printers popular with professional print makers. Epson, Ilford, Legion Paper, Red River Paper, Pictorico, and others provide printer profiles for their papers via the Internet. Often the paper's included instructions provide a website URL for profiles.

You need to obtain profiles for your specific printer model *and* paper type. Usually, profiles are only available for the printer manufacturer's inks, but if the printer can use multiple types of ink (like the Epson R2880), be careful about which inks you use. For example, if your printer uses either matte or "photo" black ink, you need to use a profile for the black that is in use by your printer. Additionally, find specific instructions that may be included for each profile on how to configure the printer driver. If the driver settings are not configured on your computer in the same way as they were when the printer profile was created, the profile probably won't print properly. The specific settings to look for are media type (one chooses a paper supported by the printer), resolution, and quality setting. Other items may be specified.

Custom Profiles

You can also have custom profiles made for you by a professional profile service. These have some advantages but cost money. A web search for "custom printer profiles" found several services for around \$40. These companies provide a test target and instructions on how to best print this target. You print the target, snail mail the physical target to the profile service, and they email you the specific profile. It is necessary to purchase a profile for each paper type you'll be using. One service that makes this process a bit easier, including the installation of the profiles (see below), is provided by a company called Chromix (chromix.com).

Some photographers choose to make their own custom profiles. However, this requires expensive hardware and software, plus a solid understanding of color management practices.

Installing Profiles

Once you download the profiles, you need to install them. Some of the manufacturer's profiles include an installer that installs the profile for you, but most require that you install them yourself.

On Mac OSX, copy the profiles to the appropriate directory. If you have administrator privileges for your computer (most users running their own desktop computers have such privileges), use the <drive>/Library/ColorSync/Profiles folder. Just move the profile files to this location. If you don't have administrator privileges, use the <drive>/Users/<username>/Library/ColorSync/Profiles folder. You'll have private access to profiles in this folder. Once installed, you'll be able to use these profiles from within Photoshop or indeed any program.

With Windows Vista and Windows 7, use the Color Management control panel to add profiles for any number of devices.

Profile Names

A good profile name includes a reference to the printer model, paper, and ink (if appropriate). A typical Epson profile is named "EP2200 EnhancedMatte 2880MK.icc"—the printer is Epson 2200, Enhanced Matte paper, Matte Black (MK) ink, a printer resolution 2880dpi. And yes, each of those variables can affect color!

Printer Driver Settings

The printer driver includes settings for specifically supported papers, print quality, and color correction. It is important that all are set properly. Check your printer manual for specific instructions. The number one cause of bad prints is incorrect printer driver settings. I'll have some tips for things to look for later in this chapter.

Viewing Lights

Printers are generally designed to create images that look accurate when viewed under daylight. But most people view their prints indoors under tungsten lights, which are much more yellow and dimmer than sunlight. Viewing under tungsten lights results in images that appear to have little shadow detail. It's best to get a good viewing light. Professionals use expensive D50 (5000K is another designation) or D65 viewing lamps available from quality lighting stores. Many office supply stores carry more moderately priced desktop daylight fluorescent lights. Other photographers use desktop halogen lights—the 20W–35W models produce a good bright light. Even though halogen light is still noticeably more yellow than daylight, it is often considered a better match for viewing prints indoors. Get a good bright light for viewing your prints. Not all of us can do what a friend of mine does: he goes outside to view his prints—but he lives in Southern California where he enjoys extended periods of "daylight balanced" outdoor lighting, as well as warm breezes.

Photoshop

The Final Print

Up to this point, the work that you have done to your image isn't particularly dependent on the final size or print medium. But now you will perform edits on your image that are. We often don't know how our images will be printed when we start working on them, or we want to be able to print an image in a few different ways; so we make sure that these printer specific steps are performed after we have completed all of our other edits, and have saved and labeled the edited image. In fact, we often create a separate, duplicate image made specifically for a given print medium and size.

This may seem like a lot of work to just get your image ready to print, but with some practice, you will be able to perform all of the steps required in about a minute.

Here's a summary of what follows:

- ► Save the Edited Image—You have been working on your image for a couple of hours now, and before you rush into printing it, save it. The printing process involves several steps that alter your image in ways that are specific to a particular size or paper type. Save the file as a Photoshop file to keep all of the edits and layers.
- ► Create a Flattened Duplicate Image—Once you have saved your master file, the duplicate will not need to have all those layers; in fact, it's often much faster to print flat files.
- ► Crop the Image (if needed)—Often, the final print needs to match a particular aspect ratio (i.e., 8" x 10" or 5" x 7"). If you need to match a specific height and width, then you will likely need to crop the image to fit.
- ► Resize/Resample the Image—Resize/resample the image to the target print size (i.e., 8" x 10") *and* the appropriate printer resolution.
- ► Sharpen the Image—Digital images generally improve with a modest amount of sharpening, especially after resampling.
- ► Soft Proof—Use Photoshop's Proof Setup to get a more accurate idea of the paper version of your image on your monitor.
- ▶ Print—Make sure you have Photoshop *and* the printer driver set to the optimal settings for your particular paper.
- Save the Print File—If you like the results, save the print file; this file is specific to a particular print size, printer, and paper. If you're not satisfied, go back to the master file you saved in the first step and continue editing.

Now, let's look at each of these steps in detail.

Save the Edited Image

Likely, you will already have a saved file for your edited image. After you have completed all of your other edits and are confident that it reflects your vision, save this image so that you have a protected version that includes all your edits and layers (File>Save). In Bridge, label the image as your Master (I use the blue label for this).

Create a Flattened Duplicate

Duplicate your master image—maybe this is overly cautious, but I recommend making a duplicate of your edited image so you can perform all of your print prep steps with far less concern or confusion. Select Image>Duplicate.... in the Duplicate Dialog, change the name to "[My Image]_Print" (or an even more specific name that includes the printer and size, like "Tower of London E2200 8x10_Print"). Select Duplicate Merged Layers Only to flatten the image if necessary.

Save this duplicate in the same folder as your original. Before you forget, you should use Bridge to label it as an Alternate (purple), then "Stack" it with the original so you can always tell the master from this duplicate.

Crop Your Image

Often your image is not the right shape to fit your final print. Typically, images from digital cameras mimic the long format of 35mm film, a format that has the proportions of $4" \times 6"$. If you want to fit this into a more traditional print proportion, like $5" \times 7"$ or $8" \times 10"$, you will need to crop off some of the long end.

- 1. Select the Crop Tool from the Tool Panel.
- 2. In the Options Bar for the Crop Tool, input the Width and Height for the target print; this will ensure that you crop to these specific proportions. Make sure the Resolution is blank; you will set the resolution when you resample the image (next stage).
- 3. Drag the Crop Tool across your image to roughly define the area of the crop; the Crop Tool restricts the crop to the proportions entered in the Options Bar. You can make the crop any size you want. If the Crop Tool restricts you to a vertical crop, and you want to make a horizontal one

(or vice versa): hit **Esc** to cancel the crop, then hit the switching arrows between the Width and Height to exchange these. Then drag the Crop Tool across your image again. Drag from within the crop area to reposition the crop as necessary.

Once you have drawn and positioned the crop to fit your final image, hit the **Enter** key to accept the crop.

Resize/Resample the Image

Note: You should not have resampled your image at any point yet—there should be as many pixels in the uncropped area as there were when the image was born. Computers are very good at resampling and scaling images, but there are some potential problems with resampling. Generally, you should only resample your image once—when you are getting ready to output.

The resolution of your image doesn't really matter to Photoshop; Photoshop views the image merely as a large array of pixels without any specific "size". As you edit, your image may have a wide range of possible resolutions—many digital camera images have a resolution of 72ppi, and sizes around 20" x 24"; scanned 35mm film usually has a resolution around 4000ppi, and a size of about 1" x $1\frac{1}{2}$ ". You'll set the appropriate size and resolution right before you print.

To resize and/or resample, select Image>Image Size to open the Image Size dialog.

Make sure that the option for Constrain Proportions is set to ensure that you don't stretch or squish your image. Also, make sure the option for Resample Image is set.

Input the target Width or Height; since these will change in proportion, changing one will also change the other.

Input the target Resolution for your printer. Almost all print devices print at a resolution of ~300ppi; if you don't know your printer's resolution, set it to 300ppi. For Epson printers, use a resolution of 240ppi. For images with very sharp details printed onto glossy papers or film, Epson printers can also use a resolution of 360ppi.

Some printers used by online services to print onto traditional photographic papers (like Lightjet, Chromira, or Frontier printers) have unusual resolutions like 304.6ppi. But these printers generally do a very good job of resizing your image to this exact resolution. So for these printers, set the resolution to 300ppi.

Finally, you need to set the appropriate resample algorithm. Up at the top of the dialog are the new (and old) pixel dimensions for this image; if the new dimension is larger than the old one (you are adding pixels to your image), then set the resample algorithm to Bicubic Smoother; if the new dimension is smaller than the older one, set the resample algorithm to Bicubic Sharper.

There are lots of add-on tools for Photoshop that perform sophisticated resampling algorithms; these tools often provide some benefit for resizing images to large sizes while maintaining sharp detail. This was a major issue for earlier versions of Photoshop, but the options available beginning with Photoshop CS2 are quite good for most images.

Output Sharpening

Output sharpening is a step often overlooked in printing. After resampling an image, it is important to reclaim some of the image's original sharpness.

- Convert the Background or your only Layer to a Smart Object: control+click / Right-click on the the layer's name in the Layers panel and choose Convert to Smart Object.
- 2. Select Filter>Sharpen>Smart Sharpen.
- 3. Note that the Smart Filter has a mask. Select the Brush Tool, set the default colors, switch these so that the foreground color is black, and paint over the image where you want to hide the sharpening. This allows the sharpening to be focused on the important parts of your image.

On-Screen Proof

One advantage of printing with profiles is the ability to soft proof the image before printing. Soft proofing allows Photoshop to mimic the look of the final print on the monitor.

To set up a soft proof, select View>Proof Setup>Custom...

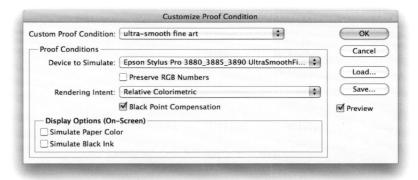

- For Device to Simulate, select the printer profile for the printer/paper combination you'll use to print. You may also choose a printing press condition if you intend to print a simulation of that press on your own printer!
- 2. Set Rendering Intent to Relative Colorimetric and turn on Black Point Compensation. This matches the black point in your image to the darkest black of the chosen printer profile. Compare with Perceptual rendering while studying saturated areas in your image. Perceptual better preserves details in saturated areas but Relative tends to be more accurate. Compare, then decide which should be used for the image you're about to print.
- 3. Save a proof setup you use often by clicking the Save button. Give it a useful name incorporating the printer and paper names, like "EP R2400 Prem Luster Rel Col". This name then appears at the bottom of the View>Proof Setup menu for easy access in the future.
- 4. Photoshop now displays a soft proof of how your image will print using this profile. There might be some minor color shifts.

Add an Annotation

With Annotations, you can add notes to the print file. Select the Note Tool from the Tool Panel (behind the Eyedropper) and click on the image. Type in details like the printer, paper, printer settings, profiles, etc. Months from now, you'll thank yourself, especially if the printer settings were unusual.

Print Dialog

1. Select File>Print... In the Print dialog, select Page Setup to access the page setup dialog, then select the appropriate paper size and orientation.

The print preview on the left will show your image centered on the paper size you selected. If your image appears much larger or smaller than the paper size, you probably didn't follow the print prep steps to resize your image properly. Cancel out of the Print dialog, then resize the image.

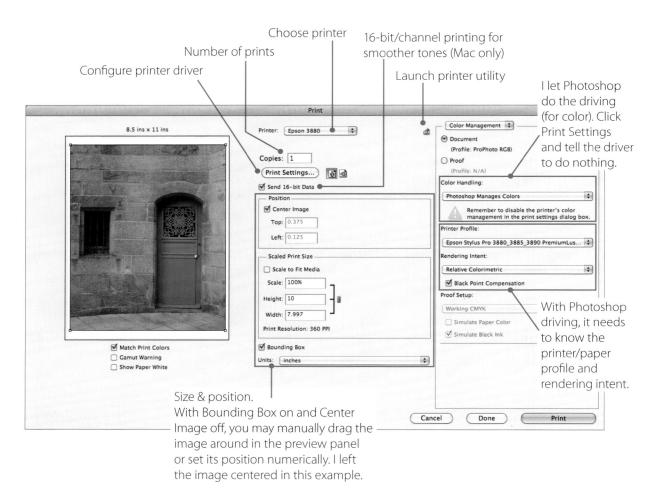

2. Set basic options (which printer, number of copies) and your sizing and positioning options (in the center of the dialog). Notice the "Match Colors" checkbox below the image on the left. This gives you a soft proof here in the Print dialog! Gamut Warning would put gray over colors that will shift the most.

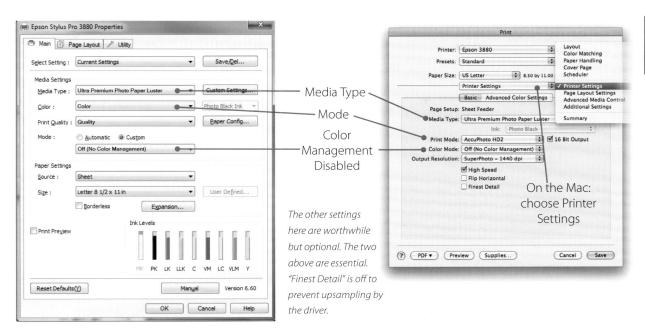

 Click Print Settings. This synchronizes the printer software with your Photoshop settings. Set paper size and type (very important!), as well as other options.

Note: In the Mac OS Print Settings dialog, choose the Print Settings option from the menu to access the settings for your printer driver.

These settings differ for each type of printer, but almost all printer drivers have options for Paper (or Media) Type and Quality. Set Paper Type to match the paper you're using. (You'll only have choices of the manufacturer's papers; here Epson's "Ultra Premium Photo Paper Luster", which always amuses me.) Choose a color mode and set Resolution, if available, to the highest setting that will not upsample the image (here, 1440dpi). Check your printer's manual for details on these printer settings.

Most critical is to be sure that only one piece of software does the color handling. We'll chose Photoshop, so change the Color Mode or Correction option to Off (or None or No Color Adjustment, depending on the printer). For most printers, the default Color Management option is set to Color Controls or Automatic; although fine for most consumer-level printers, it's not fine for us.

When finished, click OK or Save. Now we can finish configuring the Print dialog.

Rendering Intent:

Relative Colorimetric

I Black Point Compensation

Proof Setup:

Working CMYK

Perceptual

I Black Point

Proof Setup:

Compares the white of the source color space to that of the destination color space and shifts all colors accordingly. Out-of-gamut colors are shifted to the

closest reproducible color in the destination color

space. Relative colorimetric preserves more of the original colors in an image than Perceptual.

Aims to preserve the visual relationship between colors so it's perceived as natural to the human eye, even though the color values themselves may change. This intent is suitable for photographic images with out-of-gamut colors.

 Set Color Handling to Photoshop Manages Color. Notice the little note that appears immediately under that choice that says: "Remember to

disable color management in the printer dialog". You will shortly! Choose the **Printer Profile** for your printer/paper/ink combination (likely the one you just "proofed"). This section is also where you set the **Rendering Intent** (method used by Photoshop to convert to your printer's color profile). Some downloadable (and custom) profiles indicate an Intent. However, you may wish to experiment while soft proofing.

To learn more about these mysterious intents, choose either **Perceptual** or **Relative Colorimetric**, then hover your cursor above that choice. You'll see a description of that Intent in the space below. The short version is this: Relative Colorimetric will give a better match to your edited images' colors, but may lose gradations in *very* saturated areas (e.g.,

intense blue skies). Perceptual won't clip your saturated colors, but it tends to make colors throughout the image more bland and shadows less deep.

5. In the menu in the upper right, you may choose Output. The dialog displays options for Printing Marks and other options such as Bleed.

Save the Print File

Once you have a print file that you like, and you suspect you may print it again in the same way, save it under a name that will help you to identify the image and printing process later. Include the print size and print technique in the file name, perhaps: "My Image Print E2200_8x8" for an Epson 2200 print at 8″ x 8″. Save the Print file as a TIFF or PSD file.

Test Prints

Small Version

While working, and before making your final print file, you can make a quick test print to see where the image really stands. Make it big enough to give an idea of the final print's qualities (about 5" x 7" or 12cm x 18cm) but small enough to print quickly on a desktop printer. Print it onto an A4 or letter-sized sheet of paper; the unused white space provides a good frame for this test print or can be used for the next test.

To quickly print a small test version of your image, there is no need to use Image>Image Size... Change the print size in the Print dialog box. For final prints, do not resize your image in this dialog, since it's not as precise

as using the Image Size dialog, nor does it give provision for sharpening. But it is adequate for a quick proof print.

- 1. Select File>Print. In the Print dialog, change the long dimension (Height or Width) under Scaled Print Size to about 7"; changing one dimension will automatically change the other.
- 2. The preview will display the layout of your image on the page. To select letter or A4 size paper, or to rotate paper orientation, you may need to select the Page Setup option. The Preview should display the 5" x 7" version of your image nested inside an A4 or letter-sized layout.
- 3. Finish by printing normally (as described on the last several pages). Note: The next time you open the Print dialog, ensure that Scaled Print Size is set back to 100%.

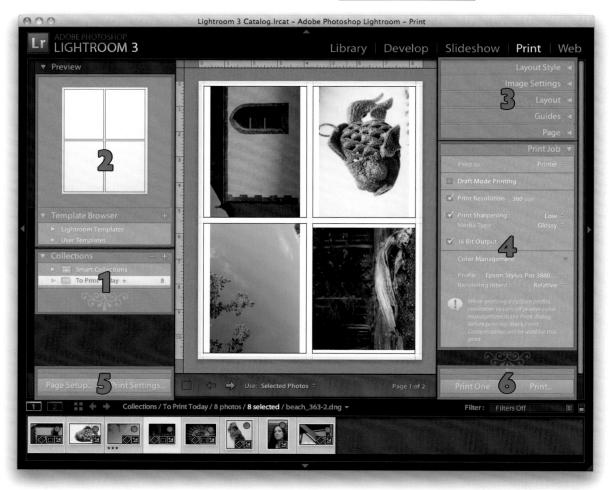

- 1. Collect Your Images to Print—Create Collections for the purpose.
- 2. Choose a Template in the Print Module—This may be only a starting point that will be refined. Essentially, the big decision is whether this is a Single Image, Contact Sheet, Picture Package, or Custom Package.
- 3. Fine-tune Layout settings—These include everything from spacing between multiples to overlays, watermarking, and more.
- 4. **Set up Print Job Panel**—This is where our color management, output sharpening, and resolution choices are.
- 5. Configure and Save Printer Driver Settings
- 6. **Print**—Use the Print One button to use all the settings as they are, or the Print button to have one last chance to change the driver options, including the number of copies.

1 Collect Your Images

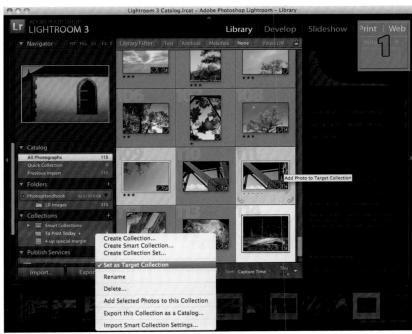

Create an ordinary Collection in the Library module, or create a Print Collection in the Print module. Either will remember the settings you last used for any output, but a Print Collection at least has a special icon to remind you what it's for. To add images to the collection, first control+click/Right-click on the collection and set it as the "Target". Then go through your Library selecting images and tapping the B key, or clicking on the circle in a thumbnail's upper right when you hover over the thumbnail. You can even designate the Painter to add images to a Target Collection.

When you're ready, select the Collection. Of course, you may also choose and select images arbitrarily.

2 Choose a Template

As you hover your cursor over the templates in the Template Browser panel, the Preview Panel will give you an idea of the layout. By name and preview, you should choose a template as a starting point. Then the fun begins.

Be sure you have a few images selected so that the template populates with images, giving a more solid idea of the final output. In the following example, we'll start out with the "2x2 Cells" template. Of course, you may experiment with any layout.

3 Layout Settings

There are three layout engines that you can use: Single Image/Contact Sheet for one or more uniformly sized prints, Picture Package for printing a variety of sizes of each image (like portrait studios often produce), or Custom Package for more elaborate and unique layouts.

For all, identity plates and watermarks can be used to mark your prints and discourage unwelcome reproduction.

Layout Panel

You may have chosen a template to start with, but that doesn't mean you can't make modifications! In the illustration on the next page, you'll note that I checked the box Rotate to Fit in the Image Settings panel. That way, both portrait and landscape format images will make the best use of the space in their cells.

In that same panel, you can apply a border to the images or have the images fill their cells completely. The remaining option, Repeat One Photo per Page, fills each template page with one of your selected images. So if you needed four each of 12 images, this would be a quick way of getting there.

The Margins can also be adjusted a bit to make room for the Crop Marks. Under Guides, it may be tempting to turn off a few things, but only one is really redundant: Image Cell lines. Page Bleed grays out the outer parts of the page on which the printer can't reliably print.

Overlays

You may want a little bit of text to help you or your clients identify which images are which.

Aside from the Identity Plate, there doesn't *appear* to be much other information you can attach to the image. We can add Crop Marks, as promised, and we can turn on Photo Info, too, for Contact Sheets. When you look at the menu to decide *which* file info to add, the list is short, but it includes Edit. When you choose that, you find a dialog box in which you can construct quite a string of info, including text you type in yourself.

- ► In the field at the top, insert your cursor where you'd like some data to be inserted.
- ► Then find the data in the list below, and click Insert when you've found it.
- Add text to the field where and how you'd like, perhaps adding punctuation or other arbitrary text.
- When done, save your customization as a preset so you can use it again later.

Watermarking

Also a new feature, this allows you to add opaque or translucent text in almost any position, font, and color. In the Page panel, check the box for Watermark, then use the menu to create one or more watermarks. After they have been created, you may choose them at any time.

Single Image/Contact Sheet

Single Image/Contact Sheet uses a grid which you define in the panels below Layout Style. Customizing a few templates will quickly reveal the kinds of options here. The most crucial, however, are in the Image Settings panel. Those four little checkboxes make a huge difference in what you see. Zoom to Fill has caused many photographers to wonder why Lightroom was cropping their pictures.

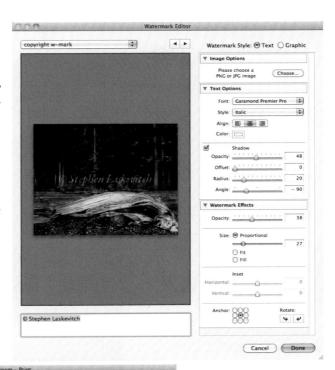

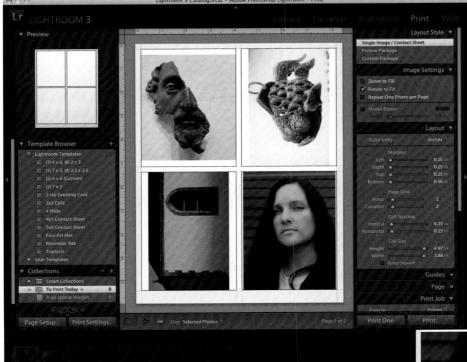

Picture Package

Picture Package creates multiple sizes of each image printed. There are many choices for how many images and what sizes. Auto Layout is handy for at least lending ideas when you're unsure of what sizes fit well with others. As you add more images, Lightroom may add more pages, or you may do so yourself with the New Page button.

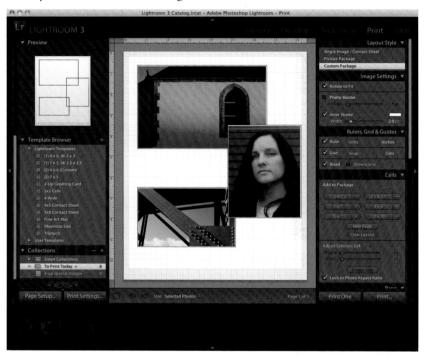

Custom Package

Custom Package, new in Lightroom 3, allows for sophisticated and elegant (or riotous and cluttered) layout. You may freely add cells of whatever size, then drag images from the filmstrip into them. They may then be resized and repositioned. With multiple pages, you can create your own sequencing and patterns.

4 Print Job Panel

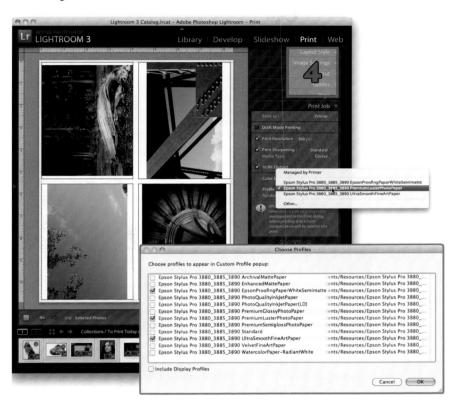

This panel is more approachable if you've been printing from Photoshop. What's different? You choose the resolution to which you would like to resample your image. (Adobe recommends Low for smaller images, Medium for images roughly filling Letter or A4 paper, and High for images filling larger than Tabloid or A3). Since resampling may result in diminished sharpness, you can apply some sharpening. You can also choose "Glossy" for paper surfaces other than matte.

Importantly, Color Management is governed here. I recommend printing with profiles from Lightroom. However, the first time you look at the Profile menu, you won't see a list of profiles at all! You'll see Managed by Printer and Other... Choose Other to see the list you're looking for. What's nice about this interface is that you can choose which profiles you will see in the Profile menu later. Click the checkboxes of the profiles for the papers/printers you use and click OK.

From then on, you can choose your profiles from a mercifully short list.

5 Printer Driver Settings

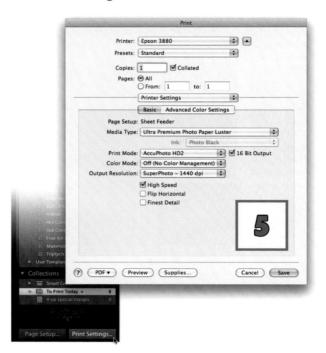

The settings here are identical to those you would have selected had you been printing from Photoshop. For those options, see the Mac and Windows examples earlier in this chapter.

The difference, however, is the button that commits your choices: it says Save. Once you've saved your settings, they're set until you change them.

6 Print

All that remains is clicking Print One or Print... at the bottom right. Since you've chosen to let Lightroom manage color, remember to disable color management/correction in your printer's driver should you want to change anything there.

Web

A Note on Web Images

Images made for the Web are almost always JPEGs and will almost certainly use the sRGB color space profile. Luckily, the products we're using have this consideration baked into their code.

Photoshop

Images with fewer than about 7.5 million pixels (about 21 megabytes) can be output as JPEGs with Adobe's Save for Web and Devices. Larger images may need to be dealt with manually. I'll start with the latter.

A Fully Manual Approach

Most programs used to create web pages are optimized to render images quickly rather than accurately. If you provide an image to a web designer that must be resampled, or worse, if you place an image on a web page that is resized by the browser, awful results can occur. Resample your images to exactly the pixel dimensions needed on the Web. If you're making a JPEG simply to have a version that is smaller in file size, but not in pixel dimensions, then this approach is for you, too.

Note: Save your full-size image before proceeding. We're about to make a copy for the Web, and we don't want our master image to be hurt in the process.

Bicubic Sharper Interpolation

Photoshop provides options for interpolating/resampling. The Bicubic Sharper option is especially good for Web images, as most images are *downsampled* for use on the Web. This option applies that gentle amount of sharpening which downsampled images usually require.

Choose Image>Image Size. Check the Resample Image box then immediately choose Bicubic Sharper from the menu at the bottom of the dialog box. It's easy to forget to do this, as this is usually not the default method. If you create Web images regularly, you may consider making this method the default (via Photoshop's General Preferences).

Specify the required Pixel Dimensions at the top of the Image Size dialog—these are determined during a site's design.

Convert to sRGB

The Web assumes images are in the sRGB color space. If your RGB working space is Adobe RGB or another color space, then you will need to convert all of your images to sRGB before saving them for the Web. This is essential, since your Adobe RGB images will appear flat and desaturated when they are displayed in most browsers.

To convert an image to sRGB, select Edit>Convert to Profile. Set the Destination space to sRGB... and set the Intent to Perceptual. Click OK to convert. Likely, your image will appear unchanged. This is a good thing!

If your image is using 16 bits/channel, Photoshop CS5 will automatically convert it to 8 bits. You may do this manually by choosing Image> Mode>8 Bits/Channel.

Save As JPEG

Choose File>Save As then choose JPEG as the file format. In the dialog box that results, you can preview your image as you choose a Quality setting. For a moment, choose 0 to see the kinds of artifacts that JPEG compression might introduce if allowed. Increase the Quality, toggling the Preview periodically to gauge the fidelity of the resulting JPEG.

Sometimes a Web designer may specify a maximum file size which you

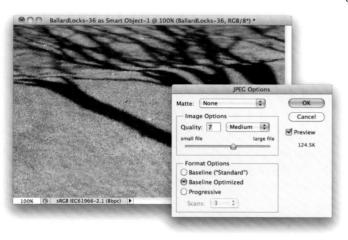

can monitor in this dialog as well. Most often, we aim for the lowest Quality setting that renders an acceptable version of our image. To squeeze out a slightly lower file size, you can try to use the Baseline Optimized or Progressive Format Options, but these are less compatible with some older browsers and email programs.

Web files need to be small and still render a high quality image. The JPEG file format provides an excellent compromise between size and quality. Use JPEG files for your Web images, and be willing to use the moderate quality settings that allow your files to be very small.

Ps

Save for Web & Devices

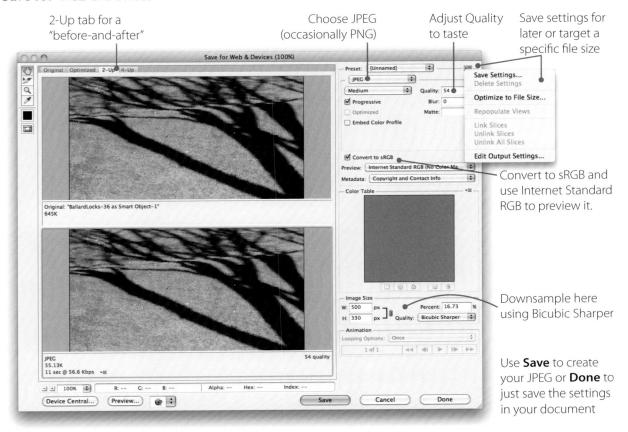

An alternative to the process in the previous section is the Save for Web dialog. In principle, you would open your full-size Adobe RGB image, then use File>Save for Web & Devices. This will work well if the image is no more than a seven or eight megapixel image.

Note that there is a "fly-out" menu where you can choose to save your settings. Use it! Once you work hard to dial in what you use, give it a name.

In the dialog, you will choose JPEG as the format and choose a Quality setting. Although the scale runs from 0 to 100 rather than 0 to 12, as in the Save As dialog, the values really do represent the same range. There is a provision to resample in the lower right that allows you to specify the desired pixel dimensions and resampling method. I use this for most images.

Use the Convert to sRGB setting. If you choose Internet Standard (No Color Management) as a Preview, the preview will accurately predict what a typical browser will show. To be sure, you may also use the Preview button in the lower left to see the image in a real browser.

Lightroom

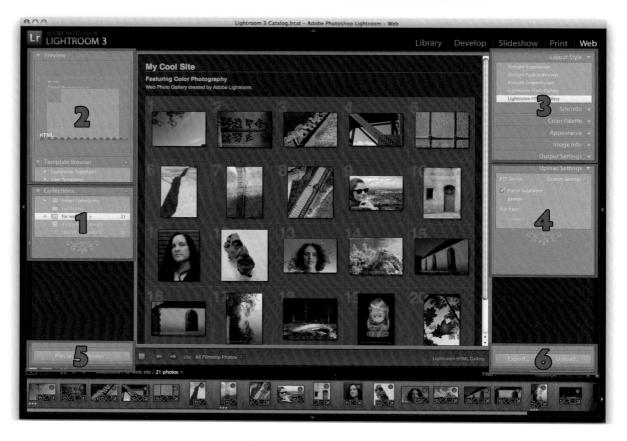

- 1. **Collect Your Images**—Use a methodology similar to that outlined for printing: use collections to organize and recall settings.
- 2. Choose a Template in the Web Module—This may be only a starting point that will be refined. Essentially, the big decision is whether this is an HTML, Flash, standard, or third party template.
- 3. Fine-Tune Layout and Output Settings—What text should accompany your images? What colors should decorate the gallery's pages? How big should your thumbnail and large images be? These are the questions you get to answer in these panels.
- 4. Configure Upload Settings—Use this if you're building a site (or part of one) that is to be uploaded. When you're done, you might also choose to Export the Web gallery so it can be viewed on a CD, for example. Your Upload Settings include FTP (or SFTP) username and passwords, the URL to which you're uploading, and the exact directory/folder to which your Web gallery files should go.

- 5. **Preview in Browser**—Although the Preview area acts like a browser and does a good job, there is no better test for a website than a real Web browser.
- 6. **Upload or Export**—Uploading will prompt you for your FTP password (as supplied by your Web hosting service provider). Export will prompt you for a location for your export.

1 Collect the Images

Create or choose a Collection, or create a Web Gallery Collection. Target a Collection, then select images and tap the B key, or click on the circle in a thumbnail's upper right corner when you hover over it.

When you're ready, select the Collection—it will "remember" its settings.

2 Choose a Template and/or Engine

Flash or HTML?

The left side of the Lightroom window is dedicated to the Template Browser and its Preview. I've picked Charcoal. It happens to be a more traditional HTML-based gallery. The other popular choice is Flash, which has nicer transitions. However, we're comfortable editing HTML code, and Lightroom's is very elegant and straightforward to customize later (if you have HTML experience).

Note: The work area (the central window) responds to the choices you make as you build your website, and it does so as a browser would. If you make your window larger, the work areas will re-center your content as a Web browser will. Better still, it navigates like the Web will, too! If you click on a thumbnail, it brings you to the larger version; click on the larger image, then you're back to the thumbnails.

3 Fine-Tune Layout and Output Settings

Site Info Customize your site's text. You may even use a little light HTML if you know it. If you enable your Identity Plate, you can also designate that it become a link when the site is generated. Usually, this links to the main page of the site, so the default is "index.html", which is the name of the main page on many sites. Since I'm putting this site in a subdirectory, I made the link in the example differently. Determine whether the thumbnails should have numbers or not.

Note: The link you specify under Web or Mail Link is the Web address to which a person is whisked if they click on the text you entered under Contact Info.

Color Palette I started with the Charcoal template, but I thought I'd add a little color. This panel is where you do that. However, to see all the things that are affected, use the main window as you would the Web browser: click on a thumbnail to see the larger image. Note the text on that page is also available for colorization.

Appearance Just click in the grid to create a thumbnail array with as few as nine to as many as 40. You will need to go from the Grid pages to the Image pages to evaluate your decisions.

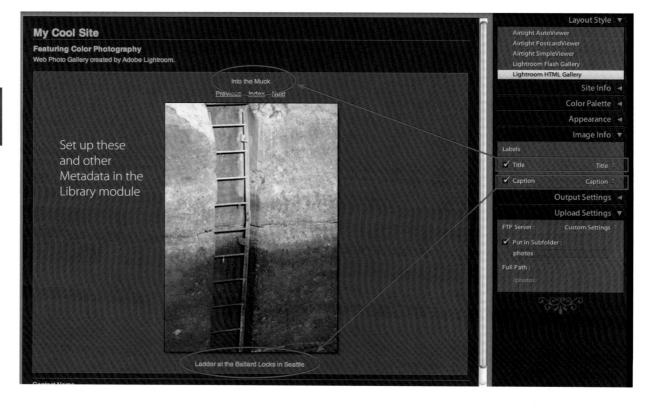

Image Info (*above*) You may have text above and below the large versions of your images, whether the Filename or any of the other things we saw in the Print Module's image info. You can also include Custom Text.

Output Settings This allows you to set the size of the large JPEG versions of the images. You can choose widths of 300 to over 2000 pixels. Of course, such size differences greatly affect the look and feel of the page and may restrict who can use the site (bigger images favor owners of bigger monitors). You also must choose the JPEG's Quality. Here, I've used 70. Since the image will be resampled, apply some sharpening, too. Standard works well. Finally, choose which metadata gets included in the image and whether a copyright watermark appears on it.

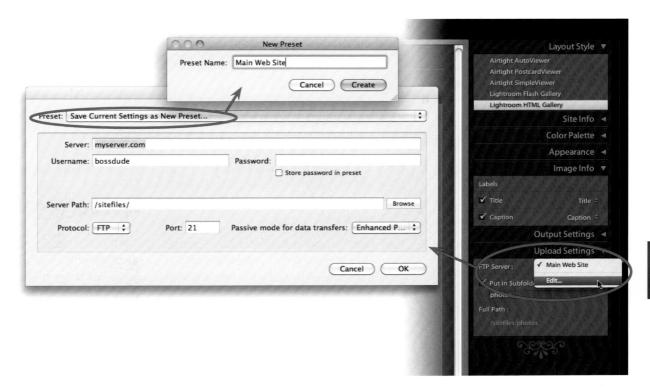

4 Configure Upload Settings

This last, small panel is where you configure upload (FTP) settings. If you already have a website, you may simply add another directory/folder containing the site you just built here in Lightroom.

5 Preview in Browser

To see your work in a real Web browser before you're ready to commit to uploading it where the world can see, use the Preview in Browser button below the work area window.

6 Upload or Export

To upload to a site, use the Upload button at the lower right. It will use the settings from the Upload Settings panel.

Perhaps you just wanted to make a functioning website to burn onto a CD-ROM to permit a client a private look with a pleasant interface. Then you would use the Export... button. Give the containing folder a name, then the site gets saved to your specified location.

It's rarely so easy.

Slideshows

Lightroom

Overview

- 1. Create or Choose a Collection—Sound familiar yet?
- Choose a Template in the Slideshow Module—This may be only a starting point that will be refined. Essentially, the big decisions are what, if any, metadata is shown with the images and what music will go with the images.
- 3. Fine-Tune Layout and Appearance Settings—What text should accompany your images? What colors should decorate each slide? How large should the images be and what margins should accompany them? These are some of the questions you get to answer in these panels.
- Edit Intro and Ending Screens—You get to create and/or edit identity plates to use on otherwise blank slides that begin and end your slideshow.
- Configure Playback Options—You must determine how long each slide remains on screen, how long the transition is between them, and what music is to be playing, if any. You can choose any MP3 file for your accompanying music.
- 6. Preview and Play—Always preview your show before presenting!
- 7. Export Slideshow as PDF or Video—Sometimes you need to make a presentation on a computer that doesn't have Lightroom installed. In that case, you might use the free Adobe Reader to show a PDF (there will be no music), or create a video (complete with music) that can be viewed with the Adobe Media Player, Apple Quicktime, or Windows Media Player 12.

Create a Collection

Use either a Standard Collection or create a Slideshow Collection when you choose this module.

In the Filmstrip, you can rearrange the images, changing the order in the slideshow. All that remains for you to do is to choose the appearance and behavior of your Slideshow.

Slide Layout

Start with a Template. It's much easier to adjust something already made, unless you have a very clear idea of what your slides should be like.

Most likely, you will not simply work your way down the list of panels on the right. Rather, you'll find yourself going among them, balancing, for example, the margins in the Layout panel with room needed for your identity plate, or judging the effectiveness of a background image (in Backdrop) with your particular images. You'll experiment with the slide duration, trying to let each image have a chance to be appreciated but not bore your viewers. That is, you'll try some settings, then either use the Preview button or the Play button in the lower right. Either way, you'll notice a delay before the music begins the first time.

To edit your Identity Plate, open the Overlays panel, then click on the small version (with a dark checkerboard). A menu appears where you can choose Edit. The dialog box that appears is where you can edit the text of your Identity Plate, including font and size, or you can insert a small graphic you've built.

If you want a generic text overlay, perhaps a title for the slideshow or explanatory text, click on the ABC below the main Image window. A field appears for you to enter your custom text, or you may choose metadata. Once you've committed your text overlay (for custom text, by pressing Enter), a scalable box appears anchored to the lower left corner of the slide area. You can drag the box and/or its anchor, resize it, anchor it to the frame or part of the image, or use the Custom Text field to change it. Use the Text Overlays section of the Overlays panel to edit the opacity, color, and font for the selected text overlay.

Playback

If you choose an MP3 file, you can then have Lightroom figure out the duration of each slide so the show ends gracefully with the music.

Exporting Slideshows

When you've dialed in your slideshow, you'll want to show it, of course! You may either show it directly from Lightroom, in which you get all the bells and whistles, or you can export it as an Acrobat PDF. PDFs don't support music, and the transitions won't be so elegant, but neither you nor anyone else will need Lightroom to play the PDF version of your slideshow. All that is needed is the free Adobe Reader software.

You may also create a video, with music, that can be viewed with Adobe Media Player, Apple Quicktime, or Windows Media Player 12.

	Playback ▼
✓ Soundtrack	
11 Tagsim.mp3 Duration: 0:02:34	
Select Music	Fit to Music
✓ Slide Duration	
Slides	4.0 sec
Fades -	2.5 sec
☐ Color	
Random Order	
✓ Repeat	
✓ Prepare Previews in A	Advance

Bridge

Impromptu Slideshow

In a hurry? Has your client, boss, or instructor just walked into the room expecting not a messy Bridge window but a presentation of your work? Just select the first image of those you want to present, then tap the **spacebar**. Suddenly, you're in Full Screen Preview. Tap the arrow keys to advance and the **esc** key to exit Full Screen.

Slideshow with Options

If you have just a little more time, configure a proper slideshow with View>Slideshow Options... You may specify any of several transitions and their duration, as well as scaling of the images to the screen, and whether and how the filename and ratings appear. A Full Caption displays the file data in the lower central portion of the image in large type, whereas Compact discretely places a smaller version in the lower left corner. You might also choose just page numbers or no data at all.

Have Fun!

No matter what you photograph, or to what medium you output, make the process an enjoyable one. Experiment, allow happy accidents, and if they're unhappy, call them learning opportunities!

Thanks for reading. Now go outside (or to the studio) and get shooting.

Index

Α

aberration, chromatic, 149-151 ACR. See Camera Raw Actions panel, 48 Actual Pixels mode, 50-51 Adjustment Layers, 53-55, 57-58 Adjustments panel, 46 Adobe Digital Negative (DNG) files. See DNG files Adobe Lens Profile Creator, 78, 149-151 AdobeRGB, 20-21 alpha channels, 184 annotations, prints, 243 Apple Time Machine, 100 application conventions, 3 Arrange Documents, 51 Auto Color, 140-141 automatic image import, 84-85

В

Background layers, 57-58 backing up files, 99-101 Lightroom catalog, 40, 100 barrel distortion, 151 Bicubic Sharper interpolation, 255 bits defined, 13-14 depth, 14-15 per channel, 14-15 black and white conversion, 129-133 pixels, 14 point adjustment, 117-119 blacks, 113, 115-119 blemishes. See retouching

blending Blending Mode, 219–220 opacity, 216-218 blurring, 229-230 Bridge backing up files, 99-100 Collections, files, 97 depth of field image merge, 226 file storage, 99-101 HDR (High Dynamic Range) images, 221 importing images, 81–83 interface, 60-63 keywords, 91, 92-93 labels, 95-96 metadata, 36, 62 metadata templates, 63, 91–92 metadata, location of, 98 Mini Bridge, 61 Photomerge, 224 preferences, 35-37, 82 presets, saving, 152 rating system, 88-89 slideshows, 264 brightness, 113, 116-117 browsers, previewing web images, 261 Brush panel, 47 brushes, painting, 166-168 burning and dodging, 169-172 bytes defined, 13-14

C

cache, Bridge preferences, 36 calibration, monitors, 18, 141 Camera Raw blacks, 113 Bridge preferences, 37 brightness, 113 clarity, 113 contrast, 113 crop and straighten, 105 exposure, 113

fill light, 113	files, 97–98
graduated filters, 158–159	printing, 249
grayscale conversion, 126	slideshows, 262
histograms, 108-109	web images, 259
HSL, 125	color. See also tone
hue, 110, 125	Auto Color, 140–141
interface, 64–65	balance, 121
lens corrections, 149–151	bit depth, 14–15
luminance, 110, 125	bits, 13–14
noise reduction, 145	channels, bit depth, 14-15
nondestructive editing, 104	channels, RGB model, 15–17
painting adjustments, 164–165	CMYK, 16-17
preferences, 31	Color Checker, 107
presets, saving, 152–153	Color modes, 219–220
recovery, 113	Color Range tool, 179–181
saturation, 110, 125	colorimeter, 19
sharpening, 147	correction, numeric, 142-144
split toning, 110, 133	corrections, copying, 155
Spot Removal tool, 193–194	desktop, 29
tone curves, 109, 119	handling, prints, 246
vibrance, 113	hue, 110, 125, 127-128
white balance, 107, 111	luminance, 110, 125
capturing images, 78–80. See also importing images	management, 17–21
casts, color, 188–189	monitor profiles, 17–19
catalog, Lightroom, 24–25, 40–41, 100–101	noise reduction, 145–146
channels	painting, 167–168
Channels panel, 48	printer profiles, 19–21
color, bit depth, 14–15	reducing local color casts, 188-189
color, RGB model, 15–17	reference images, 141
contrast, 113, 117–119, 138–139	saturation, 110, 125, 127-128
chromatic aberration, 149–151	settings, preferences, 34
Chromix, 237	space, 20–21
Clarity, 113	web images, 260
cleaning up. See retouching	white balance, 107, 111–112
clipping, 113–114	combining images, 210–215, 221–228
Clone Source panel, 47	Compare view, Lightroom, 68
Clone Stamp tool, 197–198	compositing multiple images, 210–215
cloning, 192, 194, 197–198	computers
CMYK color, 16–17	desktop color, 29
collapsed panels, 44–46	performance preferences, 32
Collections	requirements, 28
Bridge, 63	configuration

Bridge preferences, 35–37	desktop color, 29		
color settings, 34	Develop Module, Lightroom, 67		
computer requirements, 28	Develop Presets, 233		
Lightroom preferences, 38–41	Develop Settings, 152–155		
Photoshop preferences, 30–33	digital images		
work environment, 28–29	defined, 10		
Configurator preferences, 33	interpolation, 12–13		
contact sheets, prints, 251	native resolution, 13		
Content-Aware fill, 203	pixels, defined, 10		
Content-Aware scaling, 206–207	resampling, 12–13		
contrast, 113, 115–119, 138–139	resolution, dots and sensors, 10–11		
Contrast modes, 219	resolution, pixels, 11–12		
conventions, 2–3	size, 11		
convergence, 151	disable settings, Lightroom, 154		
copying	distortion		
color corrections, 155	barrel and pincushion, 151		
files, 99–101	images, 204–207		
flattened duplicates, 240	DNG files		
Layer Comps, 233	importing images, 81		
layers, 55	overview, 22		
settings, Lightroom, 154	Do-Dad, 120		
virtual copies, 233	docked panels, 44-46		
copyright data, 91–93	dodging and burning, 169–172		
cropping	dots, defined, 10–11		
crop and straighten, 106	DPI (dots per inch), defined, 10-11		
for printing, 240–241	drivers, printer, 238, 254		
cursor preferences, 32	Drobo, 99		
Curves, 122–124	duplicates, flattened, 240		
curves, tone, 109, 119–120	dust, removing. See retouching		
customizing			
Photoshop menus, 49–52	E		
printer profiles, 237	editing, nondestructive, 104		
	effects, photographic, 229–232		
D	engine, web images, 259		
	ETLA, 9		
Darken modes, 219			
Datacolor Spyder, 19	exporting Lightroom Catalog, 100–101		
deferred import, 81–82	slideshows, 263		
Defringe, 150			
deleting	web images, 261		
layers, 56	Exposure, 113		
random content, 80	exposure		
depth of field image merge, 226	capturing images, 79–80		

Index

histograms, 108–109	global adjustments
Extension Panels, 33	Auto Color, 140–141
External Editing, Lightroom, 39	black and white, 129–133
	blacks, 113, 115–119
F	brightness, 113, 115–119
	clarity, 113
feathering tool, 175	color balance, 121
files	contrast, 113, 115–119, 138–139
archiving, 99–101	crop and straighten, 105–106
backing up, 99–101	Curves, 122–124
Collections, 97–98	exposure, 113
formats, 22–24	fill light, 113
handling preferences, 31, 39, 40	
managing, 97–101	grayscale conversion, 126
metadata, location of, 98–99	HDR Toning, 138
moving, 99–101	histograms, 108–109
Fill Light, 113	HSL, 125
filling, 192	hue, 110, 127–128
Film Grain effect, 231–232	lens corrections, 149–151
Filmstrip, Lightroom, 67	Levels dialog, Photoshop, 115–119
filtering, Bridge, 62	luminance, 110
filters	noise reduction, 145–146
graduated, 158–163	nondestructive editing, 104
layers, 58–59	numeric color correction, 142–144
Lens Blur, 229–230	Photo Filters, 136
lens correction, 151	presets, 152–154
Liquify, 205	recovery, 113
Fit on Screen, 50	saturation, 110, 127–128
flags, ratings, 88	Shadows/Highlights, 136–137
Flash, web images, 259	sharpening, 146–148
flattened duplicates, 240	split toning, 110, 133–135
folders, files, 97	tone curves, 109, 119–120
Font Size, User Interface, 30	vibrance, 113, 127
formats, file, 22–24	white balance, 107, 111–112
Free Transform, 204, 207	Gradient Map Adjustment, 134–135
FTP settings, web images, 261	Gradient tool, 160–161
Full Screen Mode, 52	graduated filters, 158–163
	grayscale
G	color channels, 15–17
	conversion, 126
G-Technology, 99	pixels, defined, 10
gamuts, 20–21, 32	Grid view, Lightroom, 68
Gaussian Blur, 58–59	grouped panels, 44–46
Getty Images, 19, 141	

Н	metadata location, 98	
Hand tool, 51	RAW+JPEG, 78	
Hardness, brush, 166	Web, 256	
HDR (High Dynamic Range) images, 15, 80, 221–223	17	
HDR Toning, 138	K	
healing, 192, 194, 199–200	keyboard shortcuts, 25, 49, 68	
Healing Brush tool, 199	keys, operating systems, 4	
hidden panels, 44–46	keywords	
Highlights, 179	Bridge preferences, 36	
Histogram panel, 46	organizing images, 91–94	
histograms, 108–109		
History Log, 30	L	
History panel, 47	labels	
HSL, 125. See also hue; luminance; saturation	Bridge preferences, 36	
HTML, web images, 259	star-ratings, 88–90	
HUD (Heads-up Display, 168	tracking workflow, 95–96	
hue, 110, 127–128	Lasso tool, 176	
	Layer Comps, 233	
I	layers	
i1 Display 2, 19	Adjustment, 53–55, 57–58	
icons, conventions, 3	Background, 57–58	
Identity Plate, 250, 263	copying, 55	
Image Layers, 53, 57–58	filters, 58–59	
importing	Image, 53, 57–58	
images, 81–85 (<i>See also</i> capturing images)	Layers panel, 47, 56	
keywords, 91	masks, 56–58	
Info panel, 47	naming, 55	
installation, printer profiles, 238	overview, 52–58	
interface	Smart Objects, 53, 55	
Bridge, 60–63	layout	
Camera Raw, 64–65	settings, prints, 250–252	
Lightroom, 66–68	slideshows, 263	
Photoshop, 44–59	web images, 259	
User, Font Size, 30	Lempel-Ziv-Welch (LZW) compression, 23-24	
interpolation, 12–13, 255	Lens Blur filter, 229–230	
inverting selections, 178	lens corrections, 149–151	
	Lens Profile Creator, 78, 149-151	
J	Levels dialog, Photoshop, 115–119	
IDEC flor	Library Module, Lightroom, 67	
JPEG files	Lighten modes, 219	
bit depth, 14–15	lighting, work environment, 28, 238	
format, 24	Lightroom	

272

blacks, 113	virtual copies, 233
brightness, 113	web images, 258–261
catalog, 24–25, 40–41, 100–101	white balance, 107, 112
clarity, 113	Link Layers, 56
Collections, files, 97–98	Liquify filter, 205
contrast, 113	local adjustments
crop and straighten, 105	burning and dodging, 169–172
depth of field image merge, 226	graduated filters, 158–163
exposure, 113	painting adjustments, 164–172
file storage, 99–101	precise area adjustments, 172–189
fill light, 113	reducing local color casts, 188–189
graduated filters, 158–159	Locking Points, Curves, 124
grayscale conversion, 126	Loupe view, Lightroom, 68
HDR (High Dynamic Range) images, 221	luminance, 110, 125, 145
histograms, 108–109	Luminosity mode, 219
HSL, 125	LZW (Lempel-Ziv-Welch) compression, 23–24
hue, 110, 125	
importing images, 84–85	M
interface, 66–68	Mac operating system, 3–4
keyboard shortcuts, 68	magnification, 51
keywords, 91, 93-94	manufacturer's profiles, printers, 237
labels, 95–96	margins, prints, 250
lens corrections, 149–151	Marquee tool, 174
luminance, 110, 125	masks
metadata presets, 91, 93	layers, 56–58
metadata, location of, 99	Masks panel, 46
noise reduction, 145	Quick mask, 185–186
nondestructive editing, 104	refining, 186–188
painting adjustments, 164–165	Maxwell, James Clerk, 16
Photomerge, 224	measurements, preferences, 33
preferences, 38–41	megapixels, defined, 10
presets, saving, 153–154	memory, computer requirements, 28, 32
prints, 236–238, 248–254	menus
rating system, 88, 90	conventions, 3
recovery, 113	Photoshop, customizing, 49–52
saturation, 110, 125	merging images, 221–228. <i>See also</i> combining images
sharpening, 147	metadata
slideshows, 262–264	Bridge, 62, 63
split toning, 110, 133	Bridge preferences, 36
Spot Removal tool, 195–196	Lightroom preferences, 41
tone curves, 109, 120	location of, 98–99
vibrance, 113	organizing images, 91–94

Midtanes 170	charmoning prints 242	
Mini Bridge, 61	sharpening, prints, 242 slideshows, 262–264	
Module Picker, Lightroom, 67	web images, 255–261	
monitors	overlays, prints, 250	
calibration, 18	Р	
computer requirements, 28	r	
gamuts, 20–21	painting adjustments, 164–172	
profiles, 17–19	panoramas, 80, 224–225	
resolution, 10–11	paper	
sensors, 19	choosing, 236	
soft proofing, 243	settings, prints, 244-245	
motion, smoothing, 228	Parametric Tone Curves, 119–120	
mouse buttons, 4	passerby removal, 80, 227–228	
multiple	Passport, 107	
computers, moving files, 101	Patch tool, 201–202	
images, Camera Raw, 152–153	PDF file format, 24	
images, combining, 210–215, 221–228	Perceptual, Rendering Intent, 246	
selection tools, 182	performance preferences, 32	
windows, 51	Photo Downloader, 82–83	
	Photo Filters, 136	
N	photographic effects, 229-232	
names	Photomerge, 224–225	
layers, 55	Photoshop	
printer profiles, 238	Auto Color, 140-141	
native resolution, 13	black and white, 129–133	
navigation, Photoshop, 50-52	blacks, 115–119	
noise	Blending Mode, 219–220	
exposure settings, 79–80	brightness, 115–119	
reduction, 145–146	burning and dodging, 169–172	
removal, 227–228	Clone Stamp tool, 197–198	
nondestructive editing, 104	color balance, 121	
notes, print files, 243	color correction, numeric, 142–144	
numeric color correction, 142–144	Color Range tool, 179–181	
	combining images, 210–215	
0	computer requirements, 28	
	contrast, 115–119, 138–139	
on-screen proofs, 243	copying color corrections, 155	
opacity, 216–218	crop and straighten, 106	
Opacity, brush, 167	Curves, 122–124	
operating systems, 3–4	depth of field image merge, 226	
orientation, print, 244, 250	feathering tool, 175	
output	file format, 23	
print, 236–254	me format, 23	

Film Grain effect, 231–232	selection tools, 174-186
Gradient tool, 160–161	Shadows/Highlights, 136-137
graduated filters, 160–163	sharpening, 148
HDR (High Dynamic Range) images, 221–223	smoothing motion, 228
HDR Toning, 138	split toning, 134–135
Healing Brush tool, 199	Spot Healing brush, 200
histograms, 108–109	tone curves, 109
hue, 127–128	versions, 3
interface, 44–59	vibrance, 127
inverting selections, 178	viewing, 50–52
keyboard shortcuts, 49	web images, 255-257
labels, 95–96	white balance, 107
Lasso tool, 176	workspaces, 44–49
Layer Comps, 233	Picture Package, 252
layers, 52–58	pincushion distortion, 151
Lens Blur filter, 229–230	pixels
lens corrections, 149–151	bits, 13-15
Levels dialog, 115–119	bytes, 13–14
Marquee tool, 174	defined, 10
menu customization, 49–52	resolution, 11–12
navigation, 50–52	ruler preferences, 33
noise reduction, 146	platforms, 3–4
nondestructive editing, 104	playback
opacity, 216–218	Bridge preferences, 35
painting adjustments, 166–172	slideshows, 263
panels, 44–49	plugins, 33
panoramas, 224–225	Polygonal Lasso tool, 176
passerby removal, 227–228	Post-Crop Vignette, 150
Photo Filters, 136	posterization, 14
Photomerge, 224–225	precise area adjustments, 172–189
Polygonal Lasso tool, 176	preferences
precise area adjustments, 172–189	Bridge, 35–37, 82
preferences, 30–33	Camera Raw, 31
prints, 236–247	color settings, 34
Quick Mask, 185–186	Lightroom, 38-41
Quick Selection tool, 177	Photoshop, 30–33
reducing local color casts, 188–189	presets
Refine Edge tool, 175, 182–184	Lightroom preferences, 38
refining masks, 186–188	saving, 152–154
refining selections, 182	Preview in Browser, 261
saturation, 127–128	Previous button, 154
saving selections, 184	Print Module, Lightroom, 67

printers	proofs, on-screen, 243
choosing, 236	ProPhotoRGB, 20–21
driver settings, 238, 254	PSB file format, 23
profiles, 19–21, 237–238	PSD file format, 23
resolution, 10–11, 13	Pucker tool, 205
prints	pucks, 19
annotations, 243	
collecting images, 249	Q
color handling, 246	•
contact sheets, 251	Quick Collection, 98
cropping images, 240–241	Quick Mask, 185–186
Custom Package, 252	Quick Selection tool, 177
flattened duplicates, 240	R
layout settings, 250–252	n
Lightroom, 236–238, 248–254	RAID, file storage, 99
margins, 250	RAM, computer requirements, 28, 32
on-screen proofs, 243	random content, deleting, 80
orientation, 244, 250	rating systems, 88–90
output sharpening, 242	RAW files
overlays, 250	bit depth, 14–15
paper settings, 244–245	capturing images, 78–80
paper, choosing, 236	format, 22
Photoshop, 236–247	Recovery, 113
Picture Package, 252	reducing local color casts, 188–189
Print Dialog, 244–246	reference images, 141
Print Job Panel, 253	Refine Edge tool, 175, 182–184
printers, choosing, 236	refining
process, overview, 239	masks, 186–188
Rendering Intent, 246	selections, 182
resampling, 241–242	Relative Colorimetric, Rendering Intent, 246
resizing, 241–242, 244	Rendering Intent, 246
resolution, 241–242	resampling, 12–13, 241–242, 255
saving images, 240	Reset button, 154
templates, 249	resizing prints, 241–242, 244
test, 246–247	resolution
watermarks, 251	dots and sensors, 10–11
profiles	native, 13
custom, 237	pixels, 11–12
defined, 17–18	prints, 241–242
lens, 78	retouching
monitor, 17–19	Clone Stamp tool, 197–198
printer, 19–21, 237–238	cloning, 192, 194
printer, 15 21, 257 250	Content-Aware fill 203

filling, 192	slideshows, 262–264	
healing, 192, 194	Smart Collection, 63, 97	
Healing Brush tool, 199	Smart Filters, 58–59	
layers, 196–197	Smart Objects, 53, 55, 59	
Patch tool, 201–202	Smart Sharpen, 148	
Spot Healing brush, 200	smoothing motion, 228	
Spot Removal tool, 193–194, 195–196	soft proofing, 243	
transformations, 204–207	sorting, Bridge, 62	
RGB	spider, 19	
color model, 15–17	split toning, 110, 133–135	
values, pixels, defined, 10	Spot Healing brush, 200	
Rights Usage Terms, 91	Spot Removal tool, 193–194, 195–19	
rulers preferences, 33	SpyderCube, 107	
	sRGB, 20-21, 256	
S	stacks, 61	
S-curve, 123–124	Standard Mode, 52	
sampled colors, Color Range, 180–181	star-rating images, 88-90	
Saturation, 110, 127–128	storage, files, 99–101	
saving	straighten and crop, 106	
images for printing, 240		
presets, 152–154	Т	
retouched images, 200	tabs, opening documents as, 30	
Save keyboard shortcut, 25	Targeted Adjustment Tool, 120	
selections, 184	temperature, white balance, 107, 111	
web images, 256-257	templates	
scanners, resolution, 10–11, 13	prints, 249	
scheduled backups, 100	slideshows, 263	
seam carving, 206–207	web images, 259	
searching, Bridge, 63	test	
selection tools, 174–186	images, monitor profiles, 19, 141	
sensitivity, capturing images, 79-80	prints, 246-247	
sensors	thumbnails, 35, 260	
cameras, noise, 145	TIFF file format, 23–24	
monitors, 19	Time Machine, 100	
resolution, 10–11	TLA, 9	
Shadows, 179	tone. See also color	
Shadows/Highlights, 136–137	brightness, 113	
sharpening, 146–148, 242	clarity, 113	
shortcuts, keyboard, 25, 49, 68	contrast, 113	
sidecar files, 98	Curves, 122–124	
size, brush, 166	curves, 109, 119–120	
	curves, 109, 119–120	

histograms, 108-109 recovery, 113 split toning, 110, 133-135 vibrance, 113, 127 tools Clone Stamp, 197-198 Color Range, 179-181 Content-Aware fill, 203 feathering, 175 Gradient, 160-161 Hand, 51 Healing Brush, 199 inverting selections, 178 Lasso, 176 Marquee, 174 painting, 166-169 Patch, 201-202 Polygonal Lasso, 176 Pucker, 205 Quick Selection, 177 Refine Edge, 175, 182-184 selection, 174-186 Spot Healing brush, 200 Spot Removal, 193-194, 195-196 Tool panel, 48-49 Warp, 205 transformations, 204-207 transparency preferences, 32 transparency, images, 216-218

U

UI settings, 30 Undo command, 49 units, preferences, 33 upload settings, web images, 261 User Interface settings, 30

٧

versions, Photoshop, 3 Vibrance, 113, 127 videos, slideshows, 263 views, Photoshop, 50–52 vignetting, 149–150 virtual copies, 233 visible panels, 44–46

W

Warp tool, 205
watermarks, prints, 251
web images
Lightroom, 258–261
Photoshop, 255–257
Web Module, Lightroom, 68
white balance, 111–112
Windows operating system, 3–4
windows, arranging, 51
work environment, 28–29
workflow, overview, 72–74
Working Color Space, 20–21, 37
workspaces, Photoshop, 44–49

X

X-Rite Colormunki Photo, 19 XMP sidecar files, 98

Z

zooming, 51

Uwe Steinmueller · Juergen Gulbins

Fine Art Printing for Photographers

Exhibition Quality Prints with Inkjet Printers 2nd Edition

Today's digital cameras continue to produce increasingly higher definition image data files making high resolution, large-format output possible. As printing technology moves forward at an equally fast pace, the new inkjet printers are capable of printing with great precision at a very fine resolution, providing an amazing tonal range and significantly superior image permanence at a more affordable price. In the hands of knowledgeable photographers, these printers are capable of producing prints that are comparable to the highest quality darkroom prints on photographic paper.

The second edition of this best selling book provides the necessary foundation for successful fine art printing: the understanding of color management, profiling, paper, and inks. It demonstrates how to set up the printing workflow, and guides the reader step-by-step through the process of converting an image file to an outstanding fine art print. This new edition covers the most recent lines of high-end inkjet printers.

May 2008, 298 pages 978-1-933952-31-4 US \$ 44.95, CAN \$ 49.95

rockynoc

"A good photograp is one that communicates a fac touches the heart leaves the viewer a changed persor for having seen it

IRVING PENN

Rocky Nook, Inc.

26 West Mission St Ste 3 Santa Barbara, CA 93101-243:

> Phone 1-805-687-8727 Toll-free 1-866-687-1118 Fax 1-805-687-2204

E-mail contact@rockynook.com www.rockynook.com

George Barr

Camera to Computer

How to Make Fine Photographs Through Examples, Tips, and Techniques

Ever wonder what it would be like to get inside the head of an accomplished photographer as he chooses a subject, works the scene, selects an image, and then edits the result into a piece of photographic art? As a follow-up to his successful first book Take Your Photography To The Next Level, author/photographer George Barr now applies the practice to the theory. Go along with George as he searches for subjects, sorts out scenes, refines his composition, and then moves From Camera to Computer to edit his images, not only correcting flaws, but also making the

images match his vision. See proof sheets and "not quite there" images, and learn tips on image editing from someone who is focused on creating a fine art image. With his friendly, easy-to-understand approach George goes beyond how to edit your images by teaching the whys behind the editing process. This book is certain to help you dramatically improve your own images.

October 2009, 200 pages 978-1-933952-37-6 US \$ 39.95, CAN \$ 47.95

rockynook

"If you already know precisely what you are looking for, you are not being creative."

ALAIN BRIOT

Rocky Nook, Inc.
26 West Mission St Ste 3

Phone 1-805-687-8727 Toll-free 1-866-687-1118 Fax 1-805-687-2204

E-mail contact@rockynook.com www.rockynook.com

Christian Bloch

The HDRI Handbook

High Dynamic Range Imaging for Photographers and CG Artists

The HDRI Handbook reveals the secrets behind High Dynamic Range Imaging (HDRI). This cutting-edge imaging technology is a method to digitally capture and edit all light in a scene. It represents a quantum leap in imaging technology, as revolutionary as the leap from black and white to color imaging. Serious photographers will find that HDRI is the final step that places digital ahead of analog. HDRI emerged from the movie industry, and was once Hollywood's best kept secret. Now a mature technology, HDRI is available to everyone. The only problem was

that it was poorly documented... until now. The HDRI Handbook is the manual that was missing. In it is everything you need to build a comprehensive knowledge base that will enable you to become really creative with HDRI. This book is packed with practical hints and tips, software tests, workshops, and hands-on tutorials. Whether you are a photographer, 3D artist, compositor, or cinematographer, this book is sure to enlighten you.

November 2007, 344 pages, Includes DVD ISBN 978-1-933952-05-5, Price: \$49.95

rockynoc

"Vision is the art of seeing things invisible."

JONATHAN SWIFT

Rocky Nook, Inc. 26 West Mission St Ste 3 ata Barbara, CA 93101-241

Phone 1-805-687-8727 Toll-free 1-866-687-1118 Fax 1-805-687-2204

Juergen Gulbins · Rainer Gulbins

Photographic Multishot Techniques

High Dynamic Range, Super-Resolution, Extended Depth of Field, Stiching

Photographers are just beginning to realize the potential of HDRI. But with the same techniques, based on a bracketed series of exposures, they can go even beyond high dynamic range: They can increase resolution for ultrasharp, detailed images, or they can extend the depth of field in a way that was never possible before. "Photographic Multishot Techniques" provides a thorough introduction and a hands-on guide to various techniques that are based on a series of images. The authors explain and illustrate the use of each technique in great detail: HDRI, Superresolution, Focus Stacking, and Stitching. Moreover, they also show how to combine

these techniques effectively.
Throughout the book, the authors use tools such as Photoshop, PhotoAcute, Photomatix, FDRTools, CombineZM, and Helicon Focus to illustrate the workflow with step-bystep instructions. Many of these tools (either full or test versions) are on the CD that comes with the book.

Learning these techniques will help to extend the repertoire and photographic skills of the professional as well as the advanced amateur photographer.

January 2009, 235 pages 978-1-933952-38-3 US \$34.95, CAN \$ 34.95

rockynook

"Never have I found the limits of the photographic potential.

Every horizon, upon being reached, reveals another beckoning in the distance.

Always, I am on the threshold."

W. EUGENE SMITH

Rocky Nook, Inc.

26 West Mission St Ste 3

Phone 1-805-687-8727 Toll-free 1-866-687-1118 Fax 1-805-687-2204

www.rockynook.com